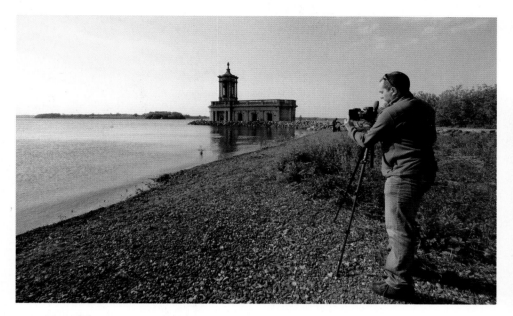

Welcome...

"If you're passionate about photography, then you'll have experienced the joy that comes from taking your time over setting up a shot and getting a result that matches or exceeds your expectations. This involves developing your technical and technique skills so that you know how to set up your camera, choose the best lens and compose to perfection. But what is also important is being able to be inventive and use your imagination to come up with ideas on what to shoot. The easiest way to do this is to try out a variety of techniques, learn from mistakes and build on your successes. This second edition of *50 Photo Projects* provides a completely new set of techniques that aim to test your skills shooting subjects you may not have tried before, with the result that you capture brilliant images. All 50 of our projects have been written in jargon-free language to make them easy to follow and as you'll discover, you don't need expensive equipment to shoot the kind of stunning images produced in this guide. With themes covering Outdoor, Indoor, Lighting and Creative, you've no shortage of photo techniques to try and we've also a selection of Photoshop tutorials to help you create great images in post-production, too. We hope *50 Photo Projects* proves exciting and inspirational, and helps improve your photography. When you've completed them, try out our first edition, too, which has another 50 brilliant ideas for you to master. All the best!"

DANIEL LEZANO, EDITOR

Meet our team of experts

All our experts are team members or regular contributors to *Digital SLR Photography* magazine. For more expert advice and inspiration, pick up the latest issue available on the second Tuesday of every month. For further information, visit the magazine's website at www.digitalslrphoto.com

DANIEL LEZANO
Editor Lezano is passionate about photography and an author of several books. He has been taking pictures for over 25 years and particularly enjoys shooting portraits and still-lifes.

CAROLINE WILKINSON
An avid enthusiast photographer for several years, Caroline uses her in-depth knowledge of Photoshop and creative skills in post-production to add extra impact and polish to pictures.

JORDAN BUTTERS
With his roots in shooting motorsport, Jordan's passion for photography has evolved to include Photoshop. He is highly skilled in creating stunning images in post-production.

ROSS HODDINOTT
A regular contributor to *Digital SLR Photography*, Ross is an award-winning nature photographer, specialising in nature and macro photography.
www.rosshoddinott.co.uk

50 Photo Projects (Vol.2)
Produced by *Digital SLR Photography* at:
6 Swan Court, Cygnet Park,
Peterborough, Cambs PE7 8GX
Phone: 01733 567401. Fax 01733 352650
Email: enquiries@digitalslrphoto.com
Online: www.digitalslrphoto.com

Editorial
To contact editorial phone: 01733 567401
Editor **Daniel Lezano**
daniel_lezano@dennis.co.uk
Art Editor **Luke Marsh**
luke_marsh@dennis.co.uk
Deputy Editor **Caroline Wilkinson**
caroline_wilkinson@dennis.co.uk
Features Writer **Jordan Butters**
jordan_butters@dennis.co.uk
Designer **Luke Medler**
luke_medler@dennis.co.uk
Editorial Co-ordinator **Jo Lezano**
jo_lezano@dennis.co.uk

Editorial contributors:
Michael Bisanko, Ross Hoddinott, Lee Frost,
Luoana Negut, John Patrick, Helen Sotiriadis,
Bjorn Thomassen, Paul Ward & Donna Willingham

Advertising & Production
Display & Classified Sales: 020 7907 6651
Group Advertising Manager
Alex Skinner
alex_skinner@dennis.co.uk
Sales Executive **Peter Smith**
peter_smith@dennis.co.uk
Production Controller **Daniel Stark**
daniel_stark@dennis.co.uk
Digital Production Manager **Nicky Baker**
nicky_baker@dennis.co.uk

Management
MAGBOOK PUBLISHER **DHARMESH MISTRY**
OPERATIONS DIRECTOR **ROBIN RYAN**
MD OF ADVERTISING **JULIAN LLOYD-EVANS**
NEWSTRADE DIRECTOR **DAVID BARKER**
COMMERCIAL & RETAIL DIRECTOR **MARTIN BELSON**
PUBLISHING DIRECTOR **JOHN GAREWAL**
CHIEF OPERATING OFFICER **BRETT REYNOLDS**
GROUP FINANCE DIRECTOR **IAN LEGGETT**
CHIEF EXECUTIVE **JAMES TYE**
CHAIRMAN **FELIX DENNIS**

recycle When you've finished enjoying this magazine please recycle

CONTENTS

37 WIDE-ANGLE FLOWERS

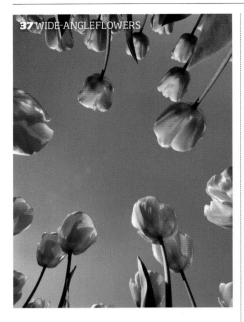

88 SHOOT SMOKE TRAILS

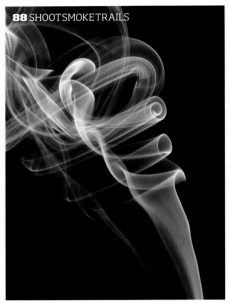

08 MISTY LANDSCAPES

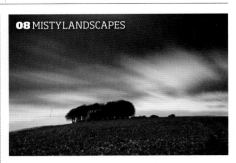

106 SPOT-LIT PORTRAITS

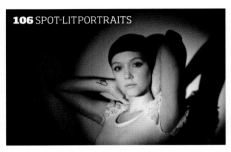

138 FUN WITH BRUSHES

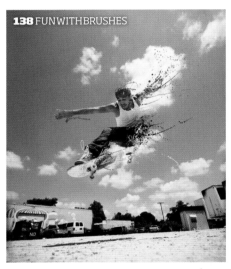

56 MACRO FLOWER SHOTS

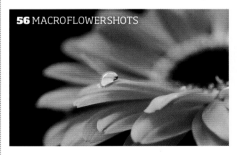

FREE GREY & WHITE CARD! SEE PAGE 146 FOR DETAILS

116 DARK ART

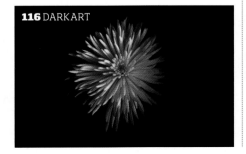

18 CONTROLLING CONTRAST

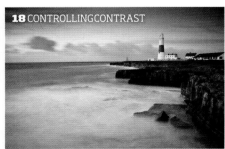

136 SUNSET PORTRAITS

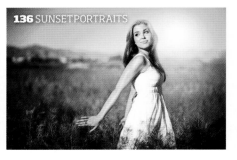

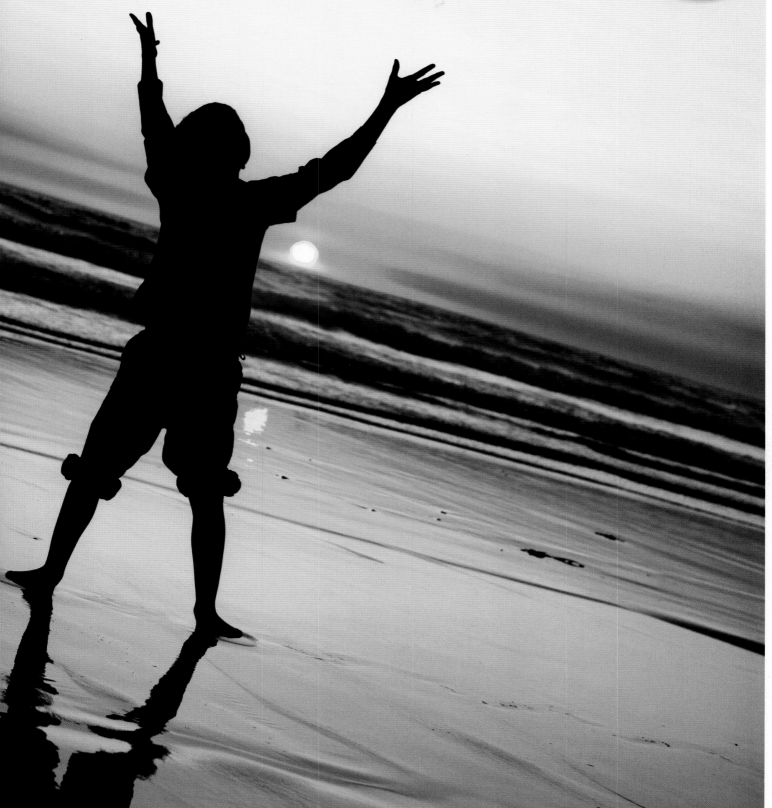

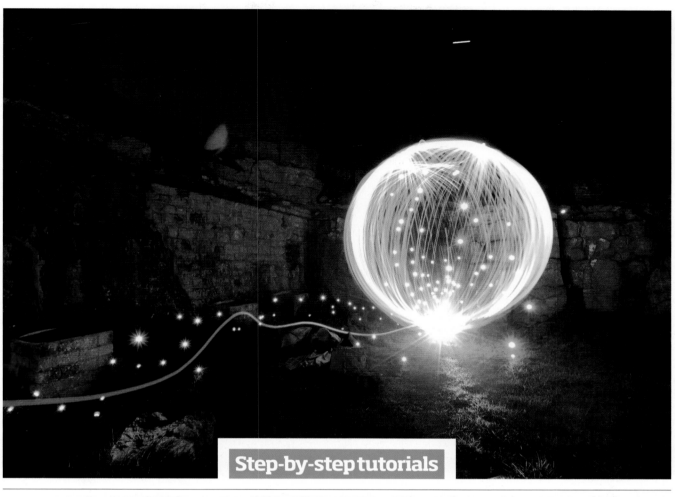

Step-by-step tutorials

OUTDOORPROJECTS

OUR GUIDES HELP YOU TAKE STUNNING IMAGES OF LANDSCAPES, NATURE, CLOSE-UPS AND MORE!

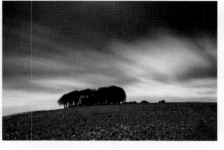
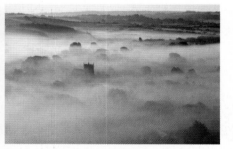
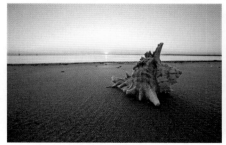
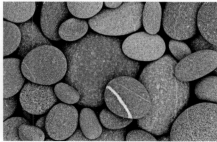
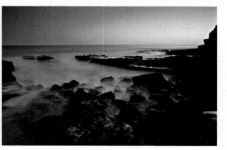

OUTDOOR

INDOOR

LIGHTING

CREATIVE

PHOTOSHOP

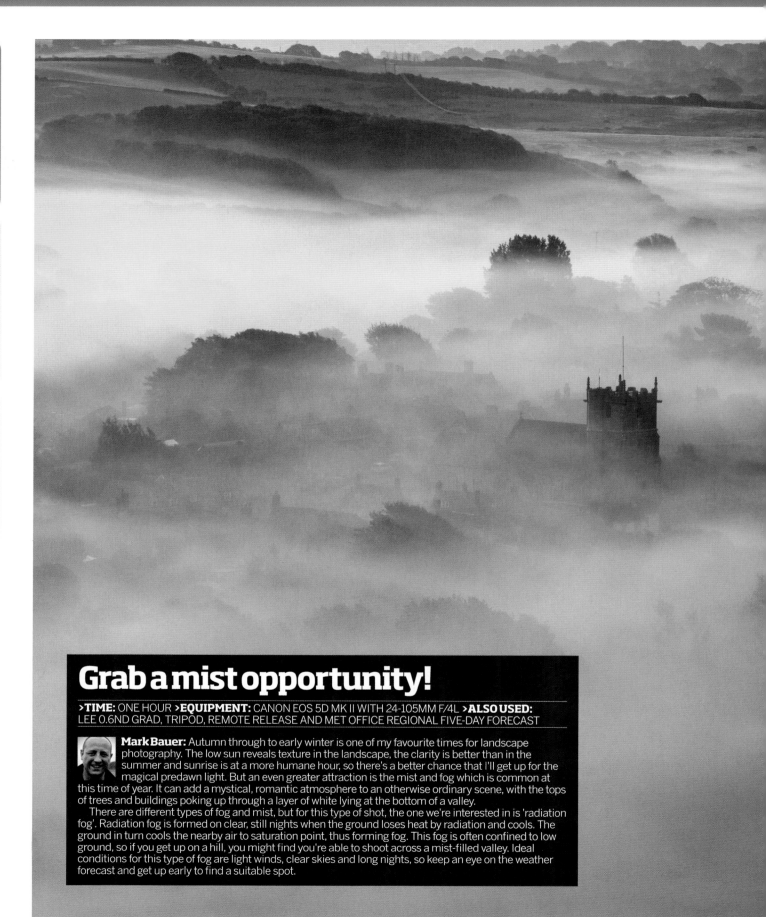

Grab a mist opportunity!

>TIME: ONE HOUR **>EQUIPMENT:** CANON EOS 5D MK II WITH 24-105MM F/4L **>ALSO USED:** LEE 0.6ND GRAD, TRIPOD, REMOTE RELEASE AND MET OFFICE REGIONAL FIVE-DAY FORECAST

Mark Bauer: Autumn through to early winter is one of my favourite times for landscape photography. The low sun reveals texture in the landscape, the clarity is better than in the summer and sunrise is at a more humane hour, so there's a better chance that I'll get up for the magical predawn light. But an even greater attraction is the mist and fog which is common at this time of year. It can add a mystical, romantic atmosphere to an otherwise ordinary scene, with the tops of trees and buildings poking up through a layer of white lying at the bottom of a valley.

There are different types of fog and mist, but for this type of shot, the one we're interested in is 'radiation fog'. Radiation fog is formed on clear, still nights when the ground loses heat by radiation and cools. The ground in turn cools the nearby air to saturation point, thus forming fog. This fog is often confined to low ground, so if you get up on a hill, you might find you're able to shoot across a mist-filled valley. Ideal conditions for this type of fog are light winds, clear skies and long nights, so keep an eye on the weather forecast and get up early to find a suitable spot.

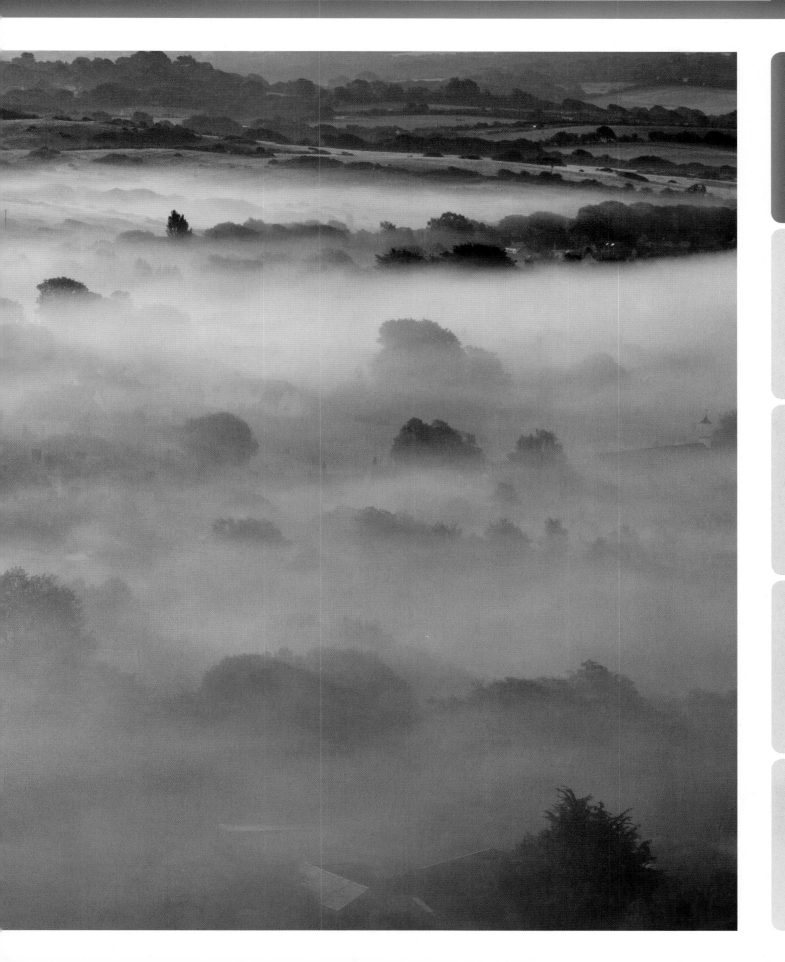

OUTDOOR

INDOOR

LIGHTING

CREATIVE

PHOTOSHOP

OUTDOOR

INDOOR

LIGHTING

CREATIVE

PHOTOSHOP

Exposure & post-processing

Exposure: Because a camera's meter assumes that what it's looking at is a mid-tone (18% grey), if there is a lot of white in a scene, as is the case with misty scenes, this can fool even 'intelligent' metering patterns into underexposing the picture, so it's a good idea to add around +1 stop of exposure compensation. The technique of 'exposing to the right' – ie pushing the exposure as close to overexposure as you can but without actually clipping the highlights – has become popular in recent years and theoretically should create a file with more tonal information and less noise. If you use this technique, you will need to add even more compensation.

Processing: Editing shots of misty scenes in Levels can be a little different from 'normal' scenes, where you would set the black point so that it lines up with the left side of the histogram. Images taken in fog or mist rarely have true blacks, and have a limited contrast range, so to keep the scene looking natural, you should set the black point less aggressively than for most other images.

⚠ Moisture alert!
In misty conditions, condensation can form on your lens and/or filters, which can ruin images. Keep a constant eye on the front element and filters, and wipe them down frequently with a microfibre cloth

1 Arrive at your location Having checked the forecast the night before, I arrive on location in the Purbeck Hills in Dorset 30 minutes before sunrise. A thick fog has formed in the valley overnight; towards sunrise, this starts to burn off, revealing the shapes of trees and buildings in the mist. Time to set up and seek out a composition.

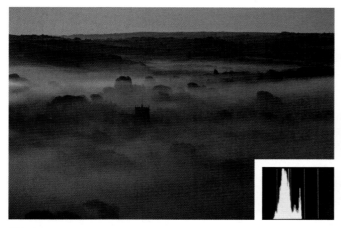

2 Find your focal point Look for elements in the scene that your eye is drawn to – here, the church steeple rising out of the mist seems a natural focal point, so I base my composition around this. If the bright tones of the mist fool the camera's meter into slightly underexposing the scene, 'expose to the right' to maximise image quality.

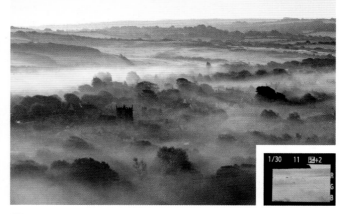

3 Apply exposure compensation To expose to the right, apply positive exposure compensation – here I applied two stops. This keeps the bright tones in the main part of the picture, but results in the sky blowing out. You can see from my image that the sky is far too bright and, subsequently, ruins the image. This problem would need fixing!

OUTDOOR

INDOOR

LIGHTING

CREATIVE

PHOTOSHOP

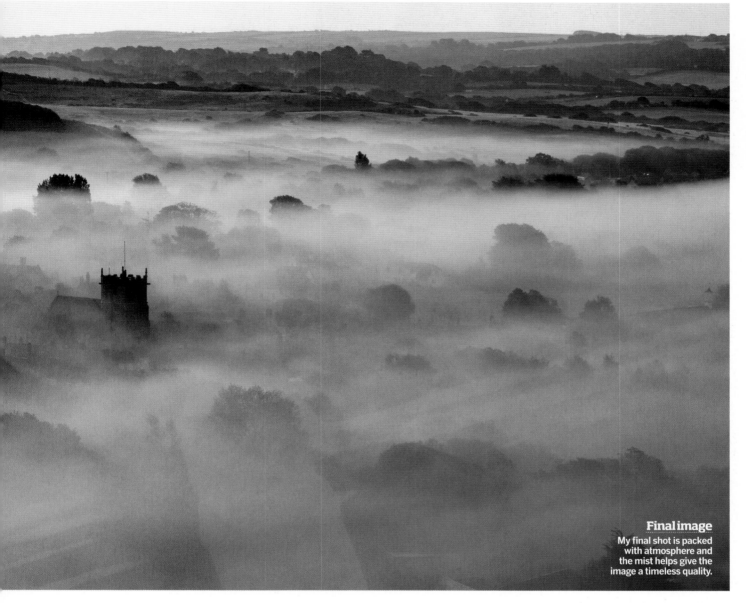

Final image
My final shot is packed with atmosphere and the mist helps give the image a timeless quality.

4 Add an ND grad Add a Neutral Density graduated filter (I used a two-stop) and take the shot again. The addition of the filter allows me to push the exposure to keep the bright tones in the mist as well as retain tone in the sky. But on reviewing the image, I decide that as there is not much interest in the sky, it will be necessary to tweak the composition.

5 Tighten composition Zoom in closer and reshoot. Cropping out the bland sky tightens up the composition nicely, but the mist has moved, revealing a little too much detail. I change position slightly again, and wait for a little more mist to drift into the scene and cover up some of the distracting elements in the frame. After a little while, it all comes together.

OUTDOOR

INDOOR

LIGHTING

CREATIVE

PHOTOSHOP

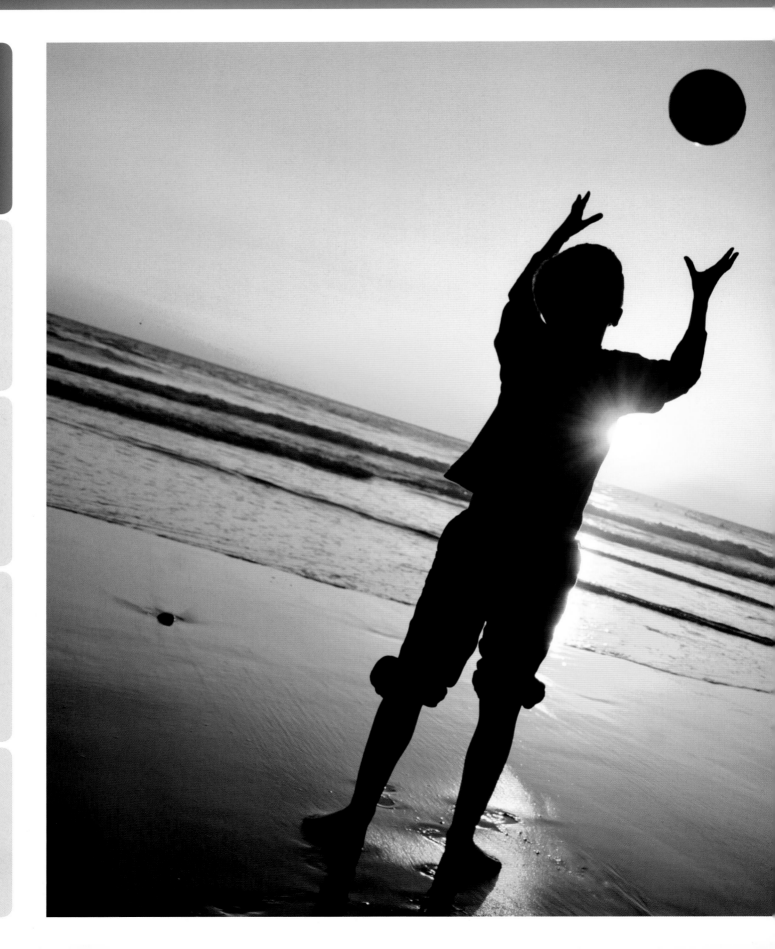

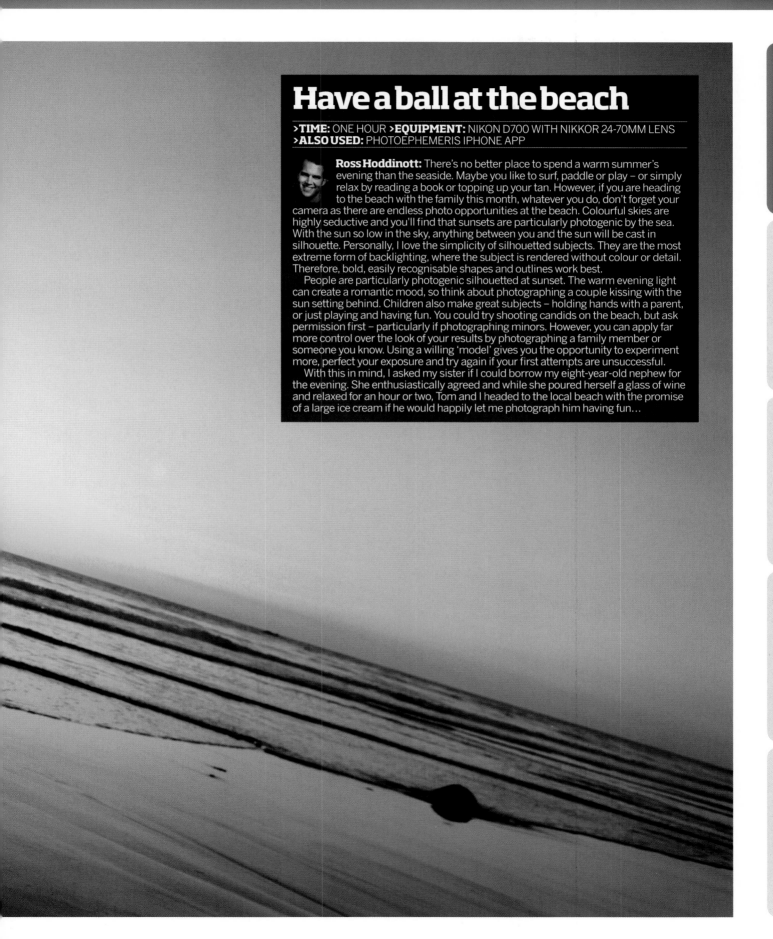

Have a ball at the beach

>TIME: ONE HOUR **>EQUIPMENT:** NIKON D700 WITH NIKKOR 24-70MM LENS
>ALSO USED: PHOTOEPHEMERIS IPHONE APP

Ross Hoddinott: There's no better place to spend a warm summer's evening than the seaside. Maybe you like to surf, paddle or play – or simply relax by reading a book or topping up your tan. However, if you are heading to the beach with the family this month, whatever you do, don't forget your camera as there are endless photo opportunities at the beach. Colourful skies are highly seductive and you'll find that sunsets are particularly photogenic by the sea. With the sun so low in the sky, anything between you and the sun will be cast in silhouette. Personally, I love the simplicity of silhouetted subjects. They are the most extreme form of backlighting, where the subject is rendered without colour or detail. Therefore, bold, easily recognisable shapes and outlines work best.

People are particularly photogenic silhouetted at sunset. The warm evening light can create a romantic mood, so think about photographing a couple kissing with the sun setting behind. Children also make great subjects – holding hands with a parent, or just playing and having fun. You could try shooting candids on the beach, but ask permission first – particularly if photographing minors. However, you can apply far more control over the look of your results by photographing a family member or someone you know. Using a willing 'model' gives you the opportunity to experiment more, perfect your exposure and try again if your first attempts are unsuccessful.

With this in mind, I asked my sister if I could borrow my eight-year-old nephew for the evening. She enthusiastically agreed and while she poured herself a glass of wine and relaxed for an hour or two, Tom and I headed to the local beach with the promise of a large ice cream if he would happily let me photograph him having fun…

OUTDOOR

INDOOR

LIGHTING

CREATIVE

PHOTOSHOP

OUTDOOR

INDOOR

LIGHTING

CREATIVE

PHOTOSHOP

1 Plan ahead If you are visiting the beach to shoot silhouetted portraits, then plan carefully. Check the time of sunset, and its position, by visiting http://photoephemeris.com (or download the app The Photographer's Ephemeris). For safety, also check the time of high tide. Arrive an hour before sunset to set up before the best light and colour appears.

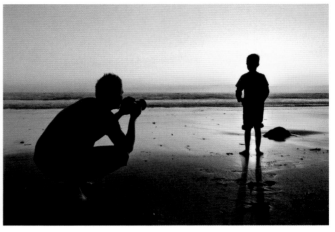

2 Set camera settings Use a standard zoom as it's very versatile. I use a Nikon 24-70mm as its fast maximum aperture of f/2.8 provides a bright viewfinder image, aiding focusing and composition – perfect for low-light photography. Using aperture-priority, set f/8 and opt for a low ISO of 200. Shooting handheld allows you more creative freedom than using a tripod.

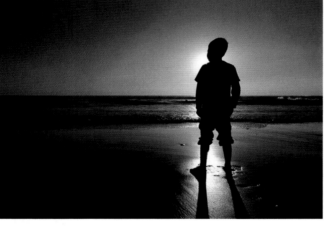

3 Take test shot By adopting a low angle and carefully aligning your model with the sun, you will be able to use your subject to obscure the sun's intensity and create an inky-black silhouette. However, with Tom standing on the wet, reflective sand and looking out to sea, the result is too static and posed. Overall, the shot is at least a stop underexposed.

Exposure compensation

TTL metering systems are highly sophisticated and reliable. However, that doesn't mean that they don't make mistakes. In awkward lighting conditions – for example, backlighting – they can easily be deceived. By regularly viewing the histogram, any exposure error is easy to spot, as there will be a spike of data at one end of the graph. Correcting under- or overexposure is easy

using your camera's exposure compensation button. If your images are too light, dial in negative (–) compensation; this will make the image darker. If your images are too dark, dial in positive (+) compensation to lighten results. You do this by pressing the +/– (exposure compensation) button and rotating the command dial until you have set the desired level of compensation. However, the way you select compensation will vary from camera to camera. Most cameras allow you to set compensation at up to three or five stops in 1/3 or 1/2-stop increments. Note: it doesn't automatically reset itself to '0' when you switch the camera off. Therefore, remember to reset compensation after you have finished shooting. Fail to do so and you will apply the compensation to future images too.

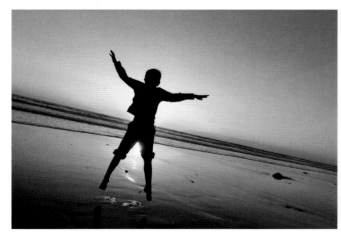

4 Apply exposure compensation When shooting backlit subjects, the sun's intensity can fool multi-zone metering patterns into believing the scene is brighter than it is. The camera then selects a faster shutter speed than required, resulting in underexposure. To compensate, I dial in a stop of positive (+) exposure compensation. I also ask Tom to jump to add motion.

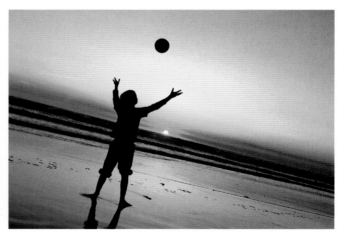

5 Composition Use trial and error, or your DSLR's histogram, to fine-tune the amount of exposure compensation needed. Once you're happy, turn your attention to the composition. Props work well when photographing kids and help them to relax. I ask Tom to play catch with a ball, tilting the camera at a slight angle to add energy to the composition.

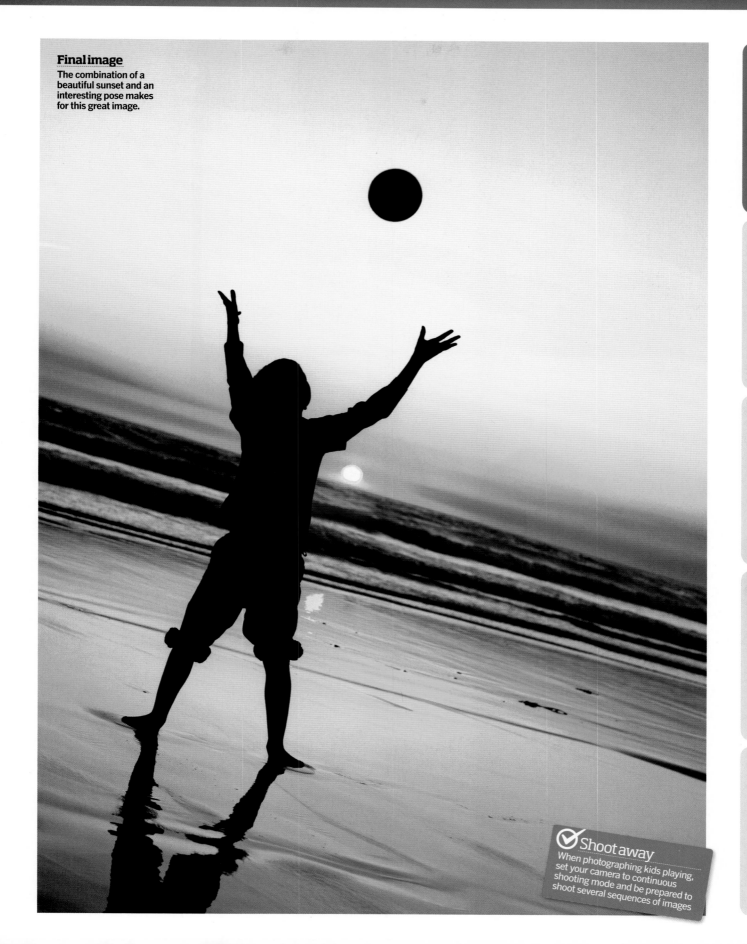

Final image
The combination of a beautiful sunset and an interesting pose makes for this great image.

OUTDOOR

INDOOR

LIGHTING

CREATIVE

PHOTOSHOP

Shoot away
When photographing kids playing, set your camera to continuous shooting mode and be prepared to shoot several sequences of images

The sky's not the limit!

>**TIME:** 30 MINUTES >**EQUIPMENT:** CANON EOS 5D MK II WITH 17-40MM F/4L
>**ALSO USED:** POLARISER, LEE 0.6ND GRAD AND LEE 1.2 SOLID ND FILTERS

Mark Bauer: The sky is one of the most important elements in a landscape photograph; it is a major factor that defines the mood of a scene. Try taking a shot of the same scene taken under a plain blue sky and then under one that's more threatening to see the difference it makes.

A strong sky and the right light can transform even the most featureless landscape, but sometimes you need extra interest – using a long exposure to capture movement is one way to do this. Most of us are familiar with this technique when it's used with moving water or foliage, but it can also be used to good effect with skies.

The ideal conditions for capturing moving skies are stormy or showery weather, with broken cloud and a blustery wind to blow them around. If there's low sun breaking through the clouds, that's even better, as this will help to bring out the texture of the land. Results are hard to predict as it depends on the speed and direction the clouds are moving in. Generally, though, the most pleasing results are when clouds move towards the camera as they fan out across the frame.

To put all this technique to the test, I grabbed my camera kit and some filters and travelled to Wiltshire, to photograph a scene on the Ridgeway, near Hackpen Hill.

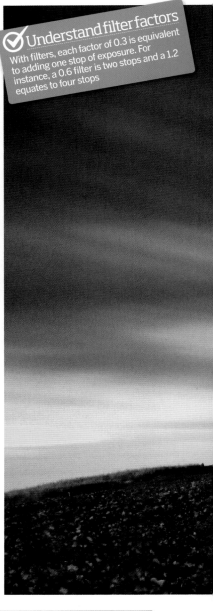

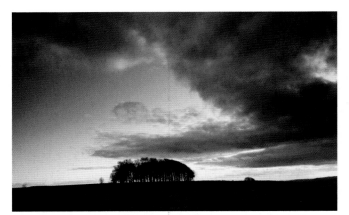

1 Find your focal point Simple compositions that have plenty of space around the focal point work best for this technique as it provides plenty of room for moving elements to enable them to contrast with the static subjects. With this in mind, I decide to use a clump of beech trees as the focal point in the scene, placed right at the bottom of the frame, to make the most of the dramatic sky that is forming towards sunset.

Technique watch

During long exposures, it's vital that your camera remains steady to avoid any camera shake from ruining the image. A solid tripod used with a good head is essential, as is a remote release. Avoid extending the centre column of the tripod as this will hinder stability and try to set it up as low to the ground as you can. Some tripods have a hook on the bottom of the centre column to hang your camera bag from for extra stability. For exposures longer than 30 seconds, you'll need to set your camera to Bulb mode. On some cameras this is a separate setting on the exposure mode dial, but for others you'll need to access manual exposure mode and then scroll down through the shutter speeds until you reach Bulb mode.

2 Review your composition If your composition isn't strong enough – ie if the skyline lacks impact and is too far away – try adding a little filtration. Here I used a (two-stop) 0.6ND grad to even out the contrast between the sky and the land, and a polarising filter to add some drama to the sky by making the clouds stand out.

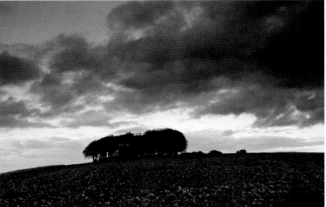

3 Assess your shot After some more searching, I find the right trees with a strong sky and an angle on the hill that make a more dynamic composition. I shoot at f/11 at about half a second. Despite the strong sky, the scene still lacks energy and drama; this can be added simply by capturing some movement in the sky with a slower shutter speed.

OUTDOOR

INDOOR

LIGHTING

CREATIVE

PHOTOSHOP

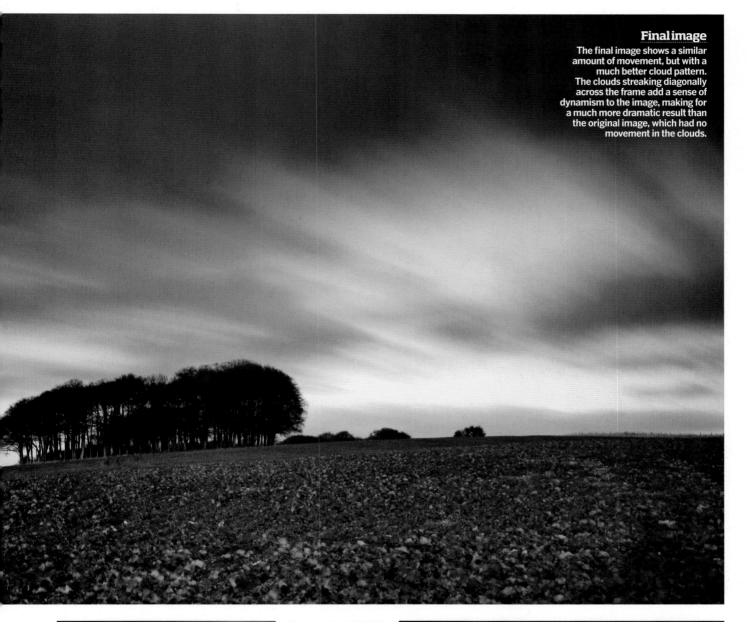

Final image
The final image shows a similar amount of movement, but with a much better cloud pattern. The clouds streaking diagonally across the frame add a sense of dynamism to the image, making for a much more dramatic result than the original image, which had no movement in the clouds.

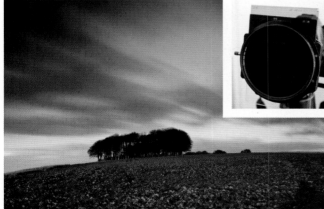

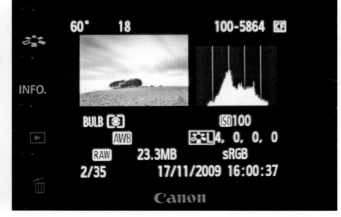

4 Stop down To achieve the desired shutter speed, you may need to stop the aperture down to f/22 and add an ND filter. I used a four-stop ND here. Set the camera to Bulb mode and open the shutter for 60 seconds. There seems to be the right amount of movement in this shot, but there is too much empty space in the top right, breaking the cloud pattern.

5 Check histogram Before shooting again, review the histogram; mine shows that the image has been exposed reasonably well. But to allow for the lowering light levels, I add half a stop to the exposure; this time opening the shutter for 90 seconds. With your exposure set correctly, take a few shots to see what the cloud looks like with the new settings.

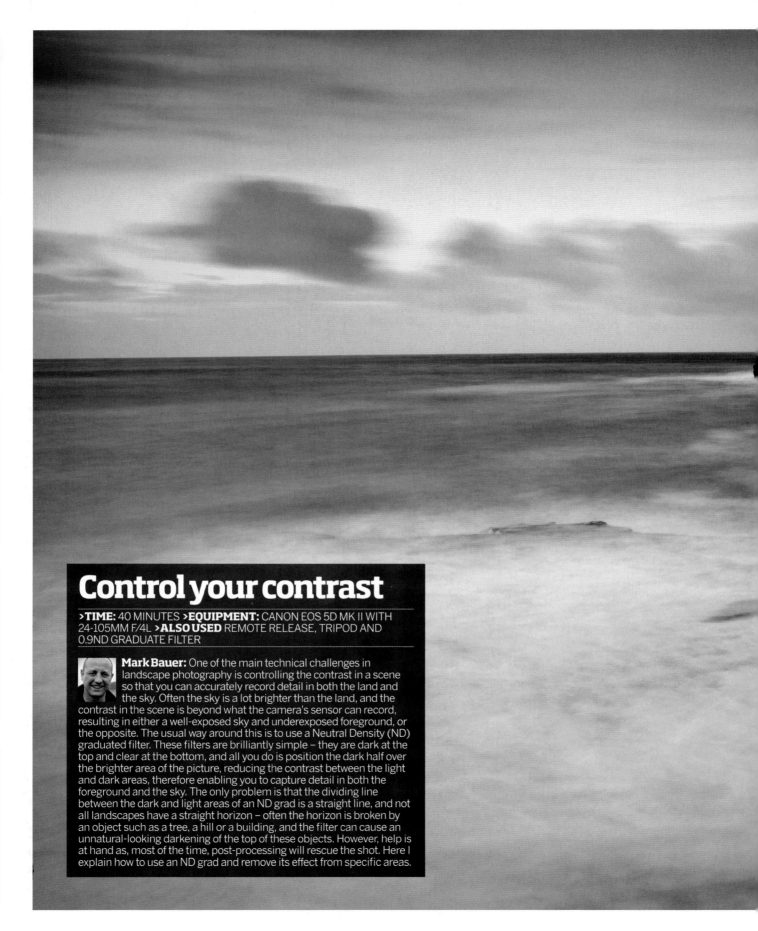

OUTDOOR

INDOOR

LIGHTING

CREATIVE

PHOTOSHOP

Control your contrast

>TIME: 40 MINUTES **>EQUIPMENT:** CANON EOS 5D MK II WITH 24-105MM F/4L **>ALSO USED** REMOTE RELEASE, TRIPOD AND 0.9ND GRADUATE FILTER

Mark Bauer: One of the main technical challenges in landscape photography is controlling the contrast in a scene so that you can accurately record detail in both the land and the sky. Often the sky is a lot brighter than the land, and the contrast in the scene is beyond what the camera's sensor can record, resulting in either a well-exposed sky and underexposed foreground, or the opposite. The usual way around this is to use a Neutral Density (ND) graduated filter. These filters are brilliantly simple – they are dark at the top and clear at the bottom, and all you do is position the dark half over the brighter area of the picture, reducing the contrast between the light and dark areas, therefore enabling you to capture detail in both the foreground and the sky. The only problem is that the dividing line between the dark and light areas of an ND grad is a straight line, and not all landscapes have a straight horizon – often the horizon is broken by an object such as a tree, a hill or a building, and the filter can cause an unnatural-looking darkening of the top of these objects. However, help is at hand as, most of the time, post-processing will rescue the shot. Here I explain how to use an ND grad and remove its effect from specific areas.

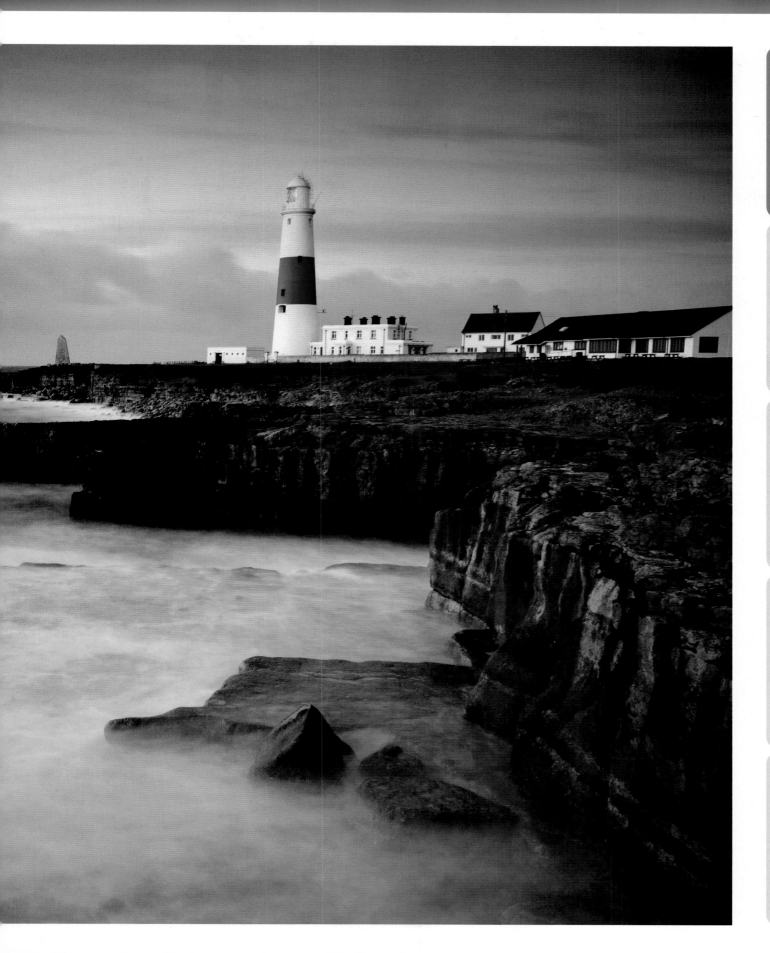

OUTDOOR

INDOOR

LIGHTING

CREATIVE

PHOTOSHOP

Technique watch

Hard and soft grad filters
Neutral density graduated filters come in two varieties: hard and soft. Hard grads have a very obvious and sudden transition from the dark to clear areas, whereas soft grads have a much more gradual transition. Hard grads are useful in situations where the horizon line is fairly straight and doesn't have any large objects breaking it. Soft grads, on the other hand, are a better option when you have an uneven horizon. Also, opt for a hard grad if you intend to shoot a scene with a straight horizon at sunset or sunrise, as the horizon line will be the brightest part of the scene, and soft grads won't hold back enough light. So what do you do when you're shooting a scene at sunrise/sunset, which has a large object such as a tree or building breaking the horizon? Here's my way around this.

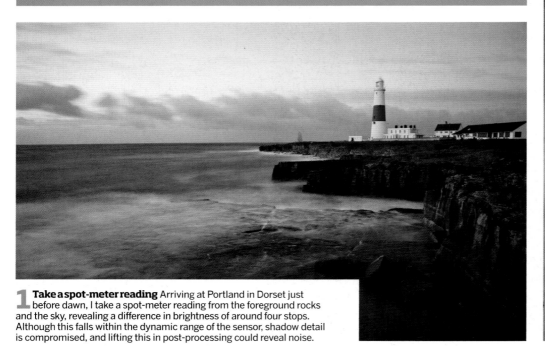

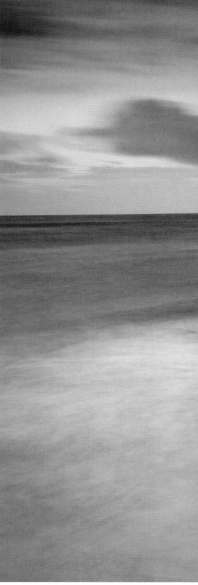

1 Take a spot-meter reading Arriving at Portland in Dorset just before dawn, I take a spot-meter reading from the foreground rocks and the sky, revealing a difference in brightness of around four stops. Although this falls within the dynamic range of the sensor, shadow detail is compromised, and lifting this in post-processing could reveal noise.

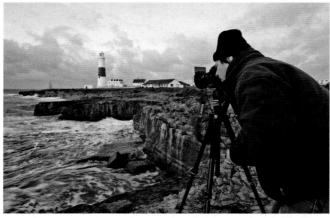
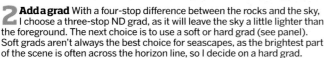

2 Add a grad With a four-stop difference between the rocks and the sky, I choose a three-stop ND grad, as it will leave the sky a little lighter than the foreground. The next choice is to use a soft or hard grad (see panel). Soft grads aren't always the best choice for seascapes, as the brightest part of the scene is often across the horizon line, so I decide on a hard grad.

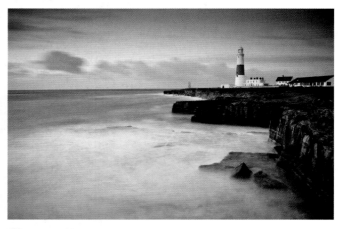

3 Spot problems Using the hard grad filter has resulted in a much more even exposure, but there is a problem. The top half of the lighthouse, where the filter has cut into it, is a bit too dark. The effect is fairly subtle, but it's definitely there and doesn't look natural. Fortunately, this common problem can be easily sorted out with a spot of post-processing work.

OUTDOOR INDOOR LIGHTING CREATIVE PHOTOSHOP

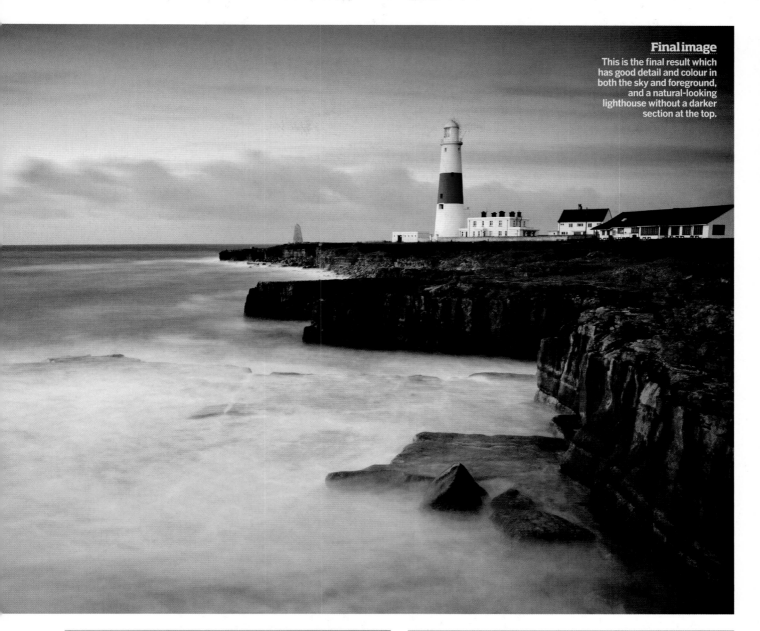

Final image
This is the final result which has good detail and colour in both the sky and foreground, and a natural-looking lighthouse without a darker section at the top.

OUTDOOR

INDOOR

LIGHTING

CREATIVE

PHOTOSHOP

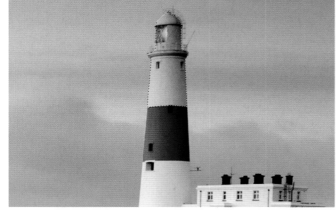

4 **Post-processing** Using the *Magnetic Lasso Tool* in Photoshop, I select the darker top half of the lighthouse so that I can work on the problem area without affecting any other part of the image. I decide not to apply any feathering to the selection, as this could leave a 'halo' around the lighthouse once I've finished lightening the selection.

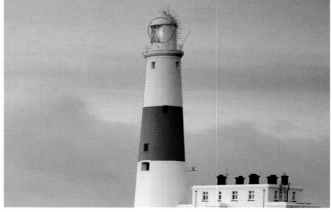

5 **Lighten selection** There are various ways of lightening or darkening images, such as Curves and Levels, but for this selection I decide to use the *Dodge Tool*, as I can paint the effect on gradually and build it up in the areas that need it the most. I set the *Exposure* value to *10%*, which enables me to work gradually on lightening the selection.

Using foreground interest

> **TIME:** 30 MINUTES > **EQUIPMENT:** CANON EOS 5D MK II WITH CANON EF 17-40MM F/4L
> **ALSO USED:** 0.9ND GRAD FILTER, SPIRIT LEVEL, TRIPOD AND REMOTE RELEASE

Mark Bauer: We all love being on sandy beaches, but from a photographic point of view, finding a good composition when there's so much empty space around can be difficult. One approach that helps to overcome this problem is to concentrate on details such as seaweed, pebbles and shells, framing the picture tightly, to make the most of the patterns and textures. Another approach is to use a wide-angle lens and, with careful focusing, make an object loom large in the foreground with the beach stretching out into the distance. This is a technique that works particularly well at sunset or sunrise, so I headed off to a local beach early one morning to experiment in the dawn light.

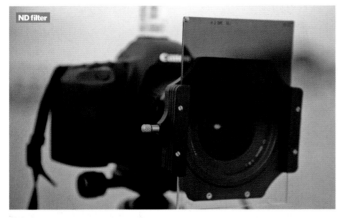
ND filter

A graduated Neutral Density filter (often called an ND grad) is the best way to even out the light differences between the foreground and sky.

Essential kit

Tripods and other camera supports
For this type of shot, it's essential that you can position your camera as low as possible. Several tripods, such as the Manfrotto 055 or 190 series, make it possible to get down as low as ground level. If your tripod doesn't have this facility, and you don't want to spend lots of money for a new one, you could rest your camera on a small beanbag. The Gorillapod is another inexpensive tool that will provide good support low to the ground.

Technique watch

Hyperfocal distance
Accurate focusing is critical for this technique, and you can maximise depth-of-field by setting the hyperfocal distance on your lens. Put simply, the hyperfocal distance is the setting that produces the greatest depth-of-field for a particular focal length and lens. More precisely, everything from half the hyperfocal distance to infinity will fall within the area that's in sharp focus. So, if the hyperfocal distance is 1.2m and you set that on the lens, everything from 60cm to infinity will be sharp. So, how do you calculate the hyperfocal distance? Well, if you have a prime (fixed focal length) lens, it's easily done using the depth-of-field scales. With zooms, you need to use a hyperfocal distance chart or calculator. You'll find several at www.dofmaster.com including one for your iPhone, iPod Touch, iPad or PDA, but the online depth-of-field calculator is as good as any – and it's free!

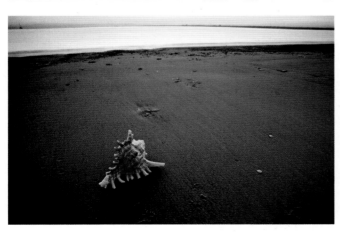

1 Find your foreground Okay, I cheated a bit – this type of shell isn't native to Dorset, but I need one that will have a bit of impact! I place it in the foreground so that it will lead in to the frame, but this first attempt doesn't really work. This is because my viewpoint isn't low enough to get the shell big enough in the frame, or to get the beach stretching into the distance the way I want it to.

2 Use a tripod The Manfrotto 055 tripod has a centre column that can be positioned at 90°, giving you an incredibly low viewpoint without too much hassle. For this shot, I was able to set up more or less at ground level. If, like me, you're not as flexible as you used to be, using a right-angle finder or LiveView, with better still a vari-angle LCD, can help you compose the shot without causing yourself any damage.

OUTDOOR

INDOOR

LIGHTING

CREATIVE

PHOTOSHOP

OUTDOOR

INDOOR

LIGHTING

CREATIVE

PHOTOSHOP

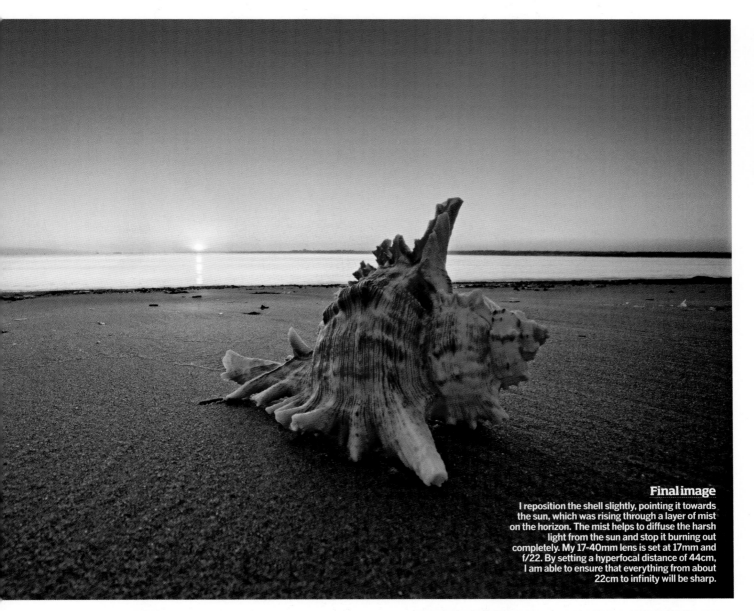

Final image

I reposition the shell slightly, pointing it towards the sun, which was rising through a layer of mist on the horizon. The mist helps to diffuse the harsh light from the sun and stop it burning out completely. My 17-40mm lens is set at 17mm and f/22. By setting a hyperfocal distance of 44cm, I am able to ensure that everything from about 22cm to infinity will be sharp.

3 Check your spirit level With wide-angle lenses, such as the 17-40mm I am using (at its widest setting), it can be difficult to judge whether or not everything is level. Because of this, sloping horizons are a common problem. I like to use a hotshoe-mounted spirit level to help me keep everything straight. You can buy one for between £5 and £10 online or at your local photo store, and they save a lot of time in post-processing.

4 Assess your shot There's more sky in this shot, which is an improvement. However, I still haven't got a low enough viewpoint, or got close enough to the shell to give it some impact. The predawn light has a lovely tranquil quality, but there is no interest in the background. The shell, despite angling into the frame, doesn't actually point to anything. I decide that I still have to adjust a number of elements a little more.

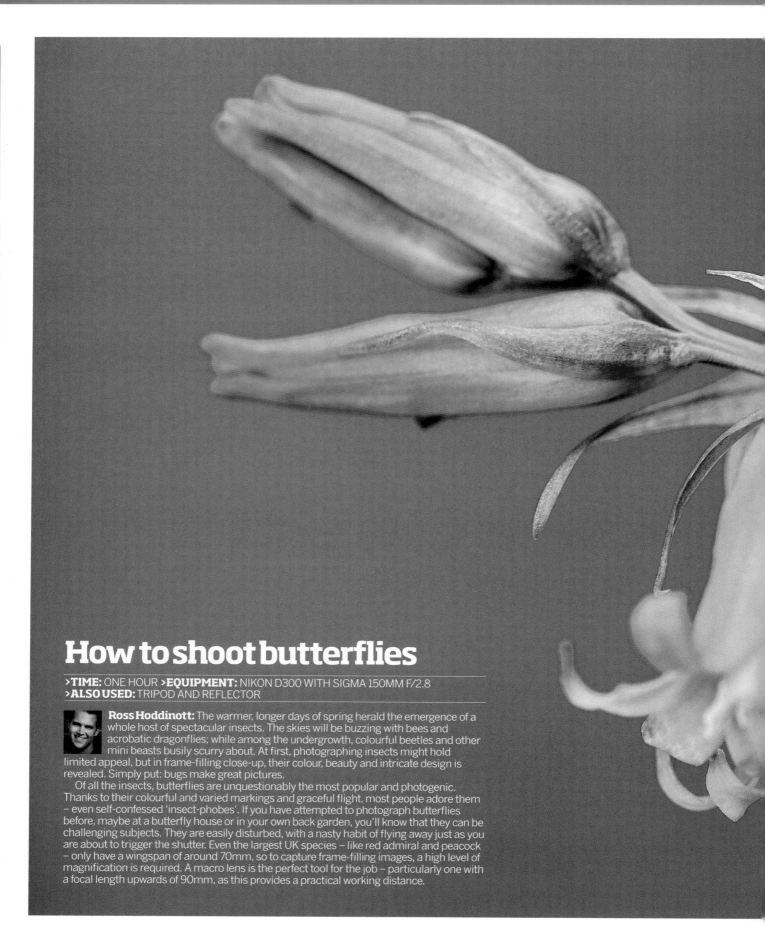

OUTDOOR

INDOOR

LIGHTING

CREATIVE

PHOTOSHOP

How to shoot butterflies

>TIME: ONE HOUR **>EQUIPMENT:** NIKON D300 WITH SIGMA 150MM F/2.8
>ALSO USED: TRIPOD AND REFLECTOR

Ross Hoddinott: The warmer, longer days of spring herald the emergence of a whole host of spectacular insects. The skies will be buzzing with bees and acrobatic dragonflies; while among the undergrowth, colourful beetles and other mini beasts busily scurry about. At first, photographing insects might hold limited appeal, but in frame-filling close-up, their colour, beauty and intricate design is revealed. Simply put: bugs make great pictures.

Of all the insects, butterflies are unquestionably the most popular and photogenic. Thanks to their colourful and varied markings and graceful flight, most people adore them – even self-confessed 'insect-phobes'. If you have attempted to photograph butterflies before, maybe at a butterfly house or in your own back garden, you'll know that they can be challenging subjects. They are easily disturbed, with a nasty habit of flying away just as you are about to trigger the shutter. Even the largest UK species – like red admiral and peacock – only have a wingspan of around 70mm, so to capture frame-filling images, a high level of magnification is required. A macro lens is the perfect tool for the job – particularly one with a focal length upwards of 90mm, as this provides a practical working distance.

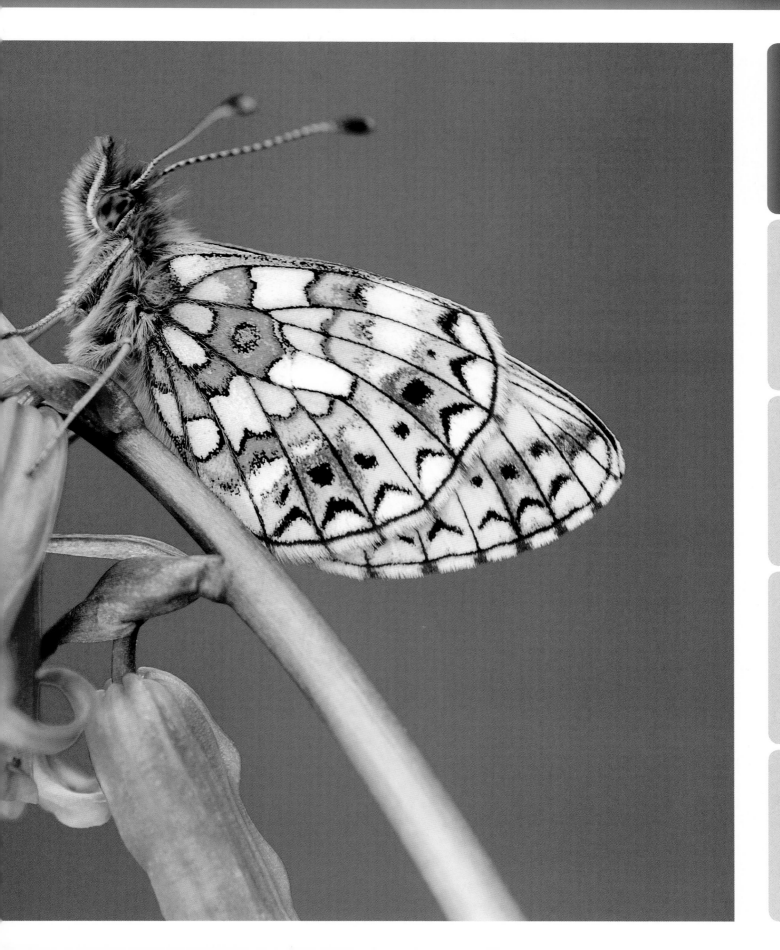

OUTDOOR

INDOOR

LIGHTING

CREATIVE

PHOTOSHOP

OUTDOOR

INDOOR

LIGHTING

CREATIVE

PHOTOSHOP

The perfect choice of optic is a macro lens – but as this is a costly item, it may make more sense to opt for an inexpensive close-up attachment instead, unless you are a dedicated close-up enthusiast. While cost-effective, the big drawback of using either a close-up filter or extension tube is that you have to get closer to the subject, increasing the risk of frightening the flighty insects away. They do, however, provide a great introduction to the fascinating world of close-ups.

At the risk of stating the obvious, before you can photograph butterflies, you first need to locate them. Butterfly numbers are sadly in decline, so you may have to travel a few miles in order to find suitable environments. Different butterflies require different habitats and food plants – some enjoy grassland, while others prefer heathland, woodland or chalky downs. Research is the key. Spend time reading about butterfly types, where to find them and when. Search the internet for suitable local reserves, or better still, join your local Wildlife Trust and mix with the experts.

It is easiest to find butterflies during the day when they are most active. However, you will probably find they rarely settle or allow you close enough to take pictures. Instead, it is better to visit habitats early in the morning, or during the evening, when butterflies are less active or roosting among vegetation or tall grasses. Search carefully – always watching where you tread. Still days are best as even the slightest breeze will move the subject about.

Having located a butterfly, move yourself into position slowly. Avoid disturbing the surrounding vegetation or casting your shadow across the insect – doing so will frighten it away. On cool mornings, before it's warm enough for the insect to fly, it may be possible to use a tripod. This is hugely advantageous, aiding both pinpoint focusing and considered composition. If you have to shoot handheld, switch on the image stabiliser if you have it, or employ a workable fast shutter speed, upwards of 1/200sec, to eliminate camera movement. Before releasing the shutter, search the background for anything distracting. If necessary, adjust your shooting position to exclude anything that might draw the eye away from your subject. Alternatively, select a wider aperture to help throw background detail quickly

Close-up attachments

You can quickly and cheaply transform your standard lens (or a short telephoto) into one capable of capturing great insect images by using a close-up attachment.

Auto extension tubes
These are hollow rings that fit between the camera and lens to reduce the minimum focusing distance. Being constructed without optical elements, they do not degrade image quality. However, they do incur a degree of light loss. Auto extension tubes are compact, light and retain all the camera's functions. Tubes can be bought individually or in a set. The most common lengths are 12mm, 25mm and 36mm – the wider the tube, the larger the reproduction ratio.

Close-up filters
These screw onto the front of the lens and act like a magnifying glass. They are inexpensive, lightweight and available in varying filter diameters. Most are a single element construction and available in a range of strengths, typically +1, +2, +3 and +4. The higher the number, the greater their magnification. They do not affect normal camera functions, like metering or autofocus, or restrict the light entering the camera. However, edge sharpness can suffer, and they are prone to 'ghosting', and spherical and chromatic aberration. Maximise image quality by selecting an aperture no smaller than f/8.

out of focus. Do bear in mind that at high magnifications depth-of-field is naturally shallow. Therefore, in order to keep the insect sharp throughout – and maximise the depth-of-field available at any given f/stop – keep your camera parallel to the subject.

Admittedly, photographing butterflies can prove a fiddly and frustrating business. Be prepared to crawl through the undergrowth and put up with lots of 'near misses'. However, with good preparation and perseverance, you too will soon be taking great butterfly images.

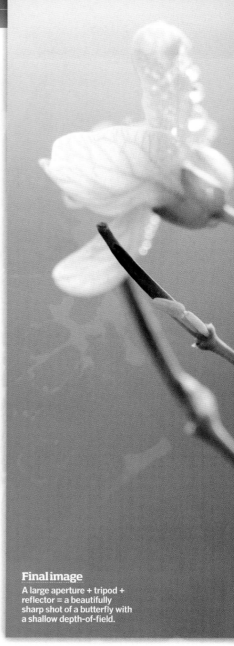

Final image
A large aperture + tripod + reflector = a beautifully sharp shot of a butterfly with a shallow depth-of-field.

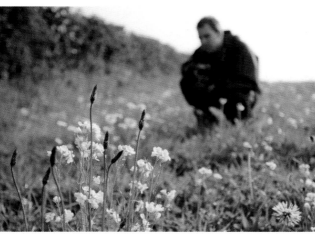

1 Locate the subject To photograph butterflies, you first need to know where, when and what to look for. For example, a local reserve close to me is home to hundreds of cuckoo flowers – a food plant of orange-tip butterflies. I set my alarm for daybreak and, after careful searching, find a butterfly clinging to one of the blooms.

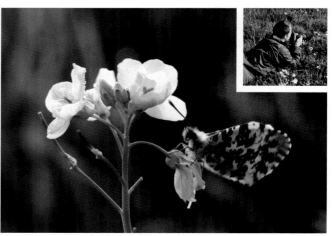

2 Get into position I slowly move into picture-taking range, being careful not to disturb surrounding vegetation. A low viewpoint will often provide the most natural-looking results, so I lay on the ground and use my elbows as support. I select a small aperture of f/16 to help generate a wide depth-of-field, but doing so creates a distracting, messy background.

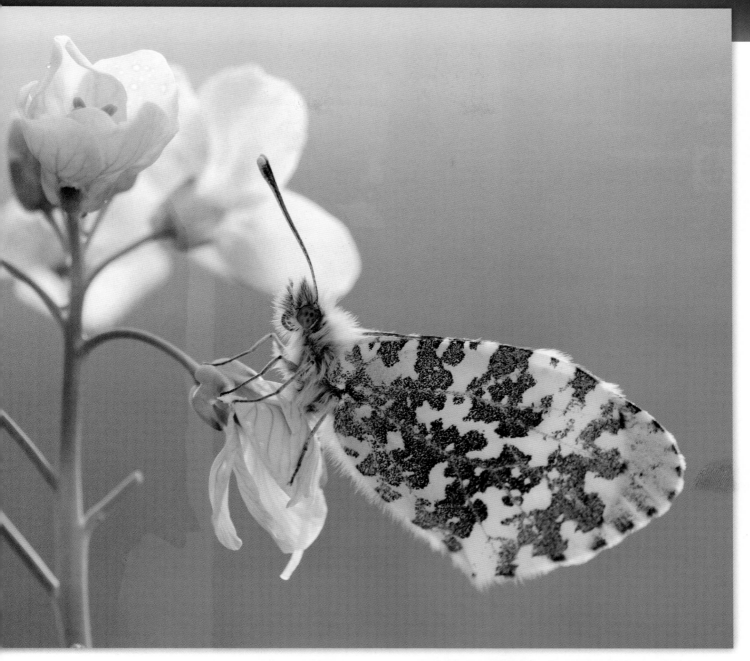

OUTDOOR

INDOOR

LIGHTING

CREATIVE

PHOTOSHOP

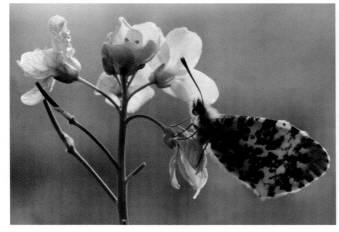

3 Blurred background To help the butterfly stand out from the rest of the scene, I set a wide aperture of f/5.6 to render the background as an attractive blur. The disadvantage of employing a larger aperture is that focusing has to be very precise due to the limited depth-of-field. To aid focusing, I carefully set up my tripod nearby and use LiveView.

4 Lighting Although the result is better, detail in the wing is obscured by shade. To relieve the shadows, I use a small reflector to angle light onto the butterfly to reveal the beauty and detail in its under-wing. In situations like this, when the subject is static, a reflector gives more control than using flash, and the final result still looks natural.

OUTDOOR

INDOOR

LIGHTING

CREATIVE

PHOTOSHOP

Dandelion fun

>**TIME:** 30 MINUTES >**EQUIPMENT:** NIKON D700 WITH NIKKOR 24-70MM LENS >**ALSO USED:** REFLECTOR AND DANDELION

Ross Hoddinott: Being a professional photographer, friends just presume that our two little girls will be the most photographed kids on the planet. In truth, I'm regularly in trouble with my 'better half' for not photographing them enough! If, like me, you are not normally a people photographer, it is easy to neglect photographing your own family. However, by doing so, you are not only missing the chance to capture photographs that you will be able to look back on in years to come and enjoy; but also the opportunity to be creative and have fun with your photography.

Arguably, summer is the best time of year to shoot great shots of your kids. The sun is shining and days spent on the beach or out in the countryside will provide countless opportunities to shoot bright and interesting portraits. With this in mind, I recently decided it was time for me to shoot some good, fresh portraits of my eldest daughter, Evie. A helping hand is often required when photographing younger children; so Grandad kindly offered to lend a hand and, together with all my camera kit, we headed to a nearby meadow in search of dandelions and some inspiration…

Working with kids

The saying goes 'never work with animals or children', but photographing kids can be great fun – if you have the patience. Most younger kids don't have a long attention span and often do the exact opposite of what you ask them to. They just want to have fun, so let them. Actively encourage them to run about and play. Doing so will help them burn some energy before you begin and might also provide some extra opportunities for photographs – attach a longer focal length to capture their play and antics. Once they've calmed down, you can begin applying more control to the shoot. Plan ahead and be organised so you can work quickly and efficiently. Begin with a clear idea of what type of shot you want to achieve. At the very least, this will provide a good starting point, but be prepared to be flexible due to the light conditions or child's behaviour; the shoot might evolve into something completely different. Props are a good idea – for example, a ball, balloons or bubble machine. Not only will they help retain the child's attention, but they will give your images added interest and ensure results don't look static. Communication is also important; keep talking and praising them. Most kids love having their picture taken, so keep showing them the results on the LCD monitor.

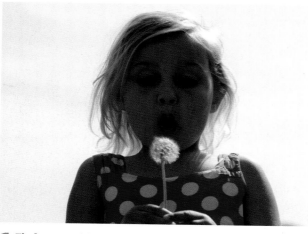

1 Find your position It's very important to begin with an idea of the image you wish to take. I want to photograph Evie blowing a dandelion clock along with the seeds as they float away. After having a lot of fun collecting clocks, I position her where I can shoot her against the sky, thinking this will create a nice clean backdrop.

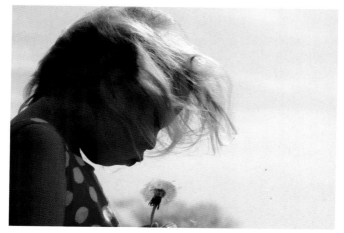

2 Take a test shot Set your DSLR to aperture-priority. To capture the seeds in flight, I need to photograph Evie from a side angle. To generate a fast shutter speed and a shallow depth-of-field, select a large aperture – I choose f/4 (ISO 200). I position her with the sun behind so that her hair will be attractively backlit, but this results in harsh and ugly shadows.

3 Use a reflector To relieve the shadows, you will need to use either fill-in flash or a reflector. I opt to use a reflector, as you can view the effect of the light through the viewfinder. I ask my dad to hold it in place, angling it so light reflects onto the side of Evie's face. When using a reflector, be careful that the light isn't too bright for children's eyes.

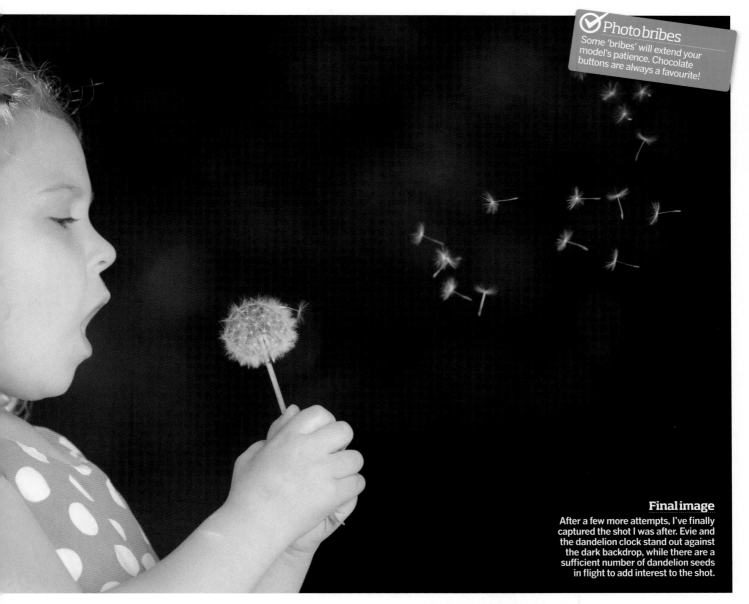

☑ Photo bribes
Some 'bribes' will extend your model's patience. Chocolate buttons are always a favourite!

OUTDOOR

INDOOR

LIGHTING

CREATIVE

PHOTOSHOP

Final image
After a few more attempts, I've finally captured the shot I was after. Evie and the dandelion clock stand out against the dark backdrop, while there are a sufficient number of dandelion seeds in flight to add interest to the shot.

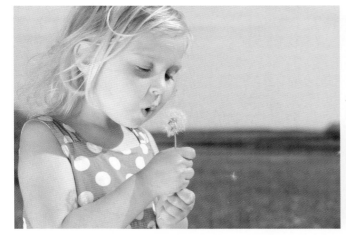

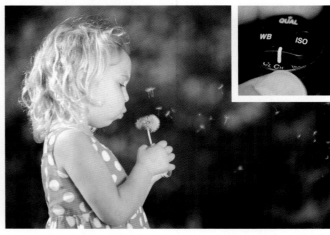

4 **Review your shots** The reflector remedies the problem of the ugly shadows on Evie's face, and looking at the replayed images on the LCD monitor, I can see that the results are better and the lighting looks natural. However, the dandelion clock lacks definition against the bright sky. Also, there are too few seed heads in frame to be significant.

5 **Find a new backdrop** I adjust Evie's position so that some nearby trees form a darker background. This helps the dandelion to stand out in the photograph. I also switch the camera to its continuous shooting mode. By doing so, I can shoot a rapid burst of images, greatly increasing my chances of capturing the seed heads as intended.

OUTDOOR

INDOOR

LIGHTING

CREATIVE

PHOTOSHOP

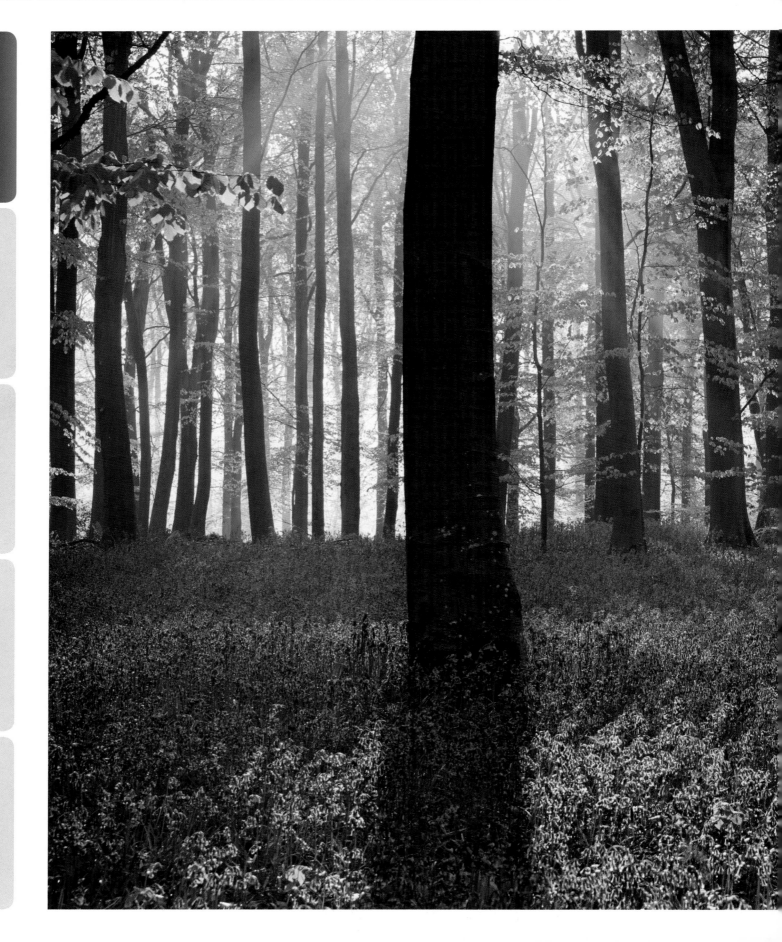

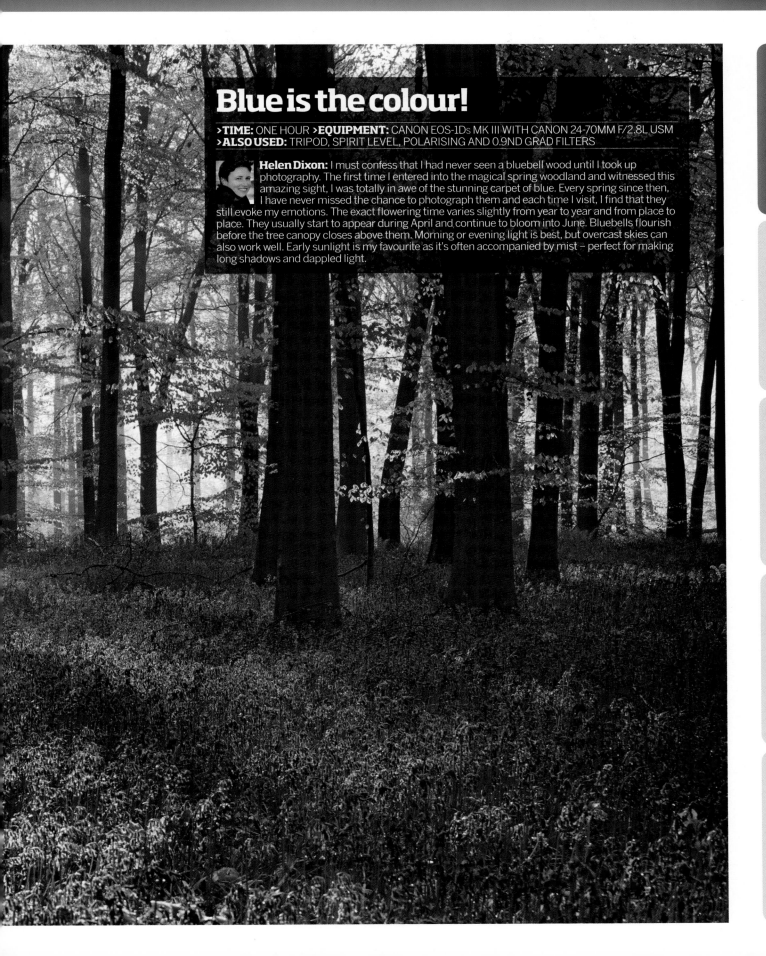

Blue is the colour!

›TIME: ONE HOUR **›EQUIPMENT:** CANON EOS-1Ds MK III WITH CANON 24-70MM F/2.8L USM
›ALSO USED: TRIPOD, SPIRIT LEVEL, POLARISING AND 0.9ND GRAD FILTERS

Helen Dixon: I must confess that I had never seen a bluebell wood until I took up photography. The first time I entered into the magical spring woodland and witnessed this amazing sight, I was totally in awe of the stunning carpet of blue. Every spring since then, I have never missed the chance to photograph them and each time I visit, I find that they still evoke my emotions. The exact flowering time varies slightly from year to year and from place to place. They usually start to appear during April and continue to bloom into June. Bluebells flourish before the tree canopy closes above them. Morning or evening light is best, but overcast skies can also work well. Early sunlight is my favourite as it's often accompanied by mist – perfect for making long shadows and dappled light.

OUTDOOR

INDOOR

LIGHTING

CREATIVE

PHOTOSHOP

OUTDOOR

INDOOR

LIGHTING

CREATIVE

PHOTOSHOP

✓ Diffused lighting
Don't rule out overcast days. There's a silver lining to the cloud as it creates a huge diffuser, giving an even and intense colour to the scene

1 **Pack essential accessories** A spirit level is helpful for keeping the horizons level and I always use one. A polariser is the best filter to use as it enhances colour and also minimises reflections on flowers and leaves. You should use a tripod and remote release for sharp results, keep an ND grad handy and take along a bin liner to kneel on. As for lenses, zooms covering 24mm right through to 200mm are most useful.

Find bluebells near you!

find local bluebell woods

GET A LIST OF FAVOURITES IN YOUR AREA

name

email

postcode

Finding the best bluebell woods used to be difficult as it's impossible to plan where and when they'll appear. However, there are now several websites where the public update when bluebells are in bloom. We'd suggest you start with these: www.woodlandtrust.org.uk (click on the Bluebells panel) or www.nationaltrust.org.uk (type 'bluebell watch' in the search box).

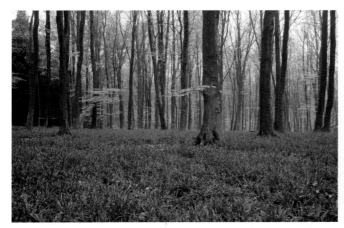

2 **Take test shots** I arrive pre-dawn to prepare for the sunrise and try out a few shots in the low light to experiment with compositions. I start with my zoom set at 24mm, but the wide focal length hasn't worked well, as the bluebells become lost and the green foliage is too far away to add any impact. Using a wide-angle also includes too much of the bare overhead branches.

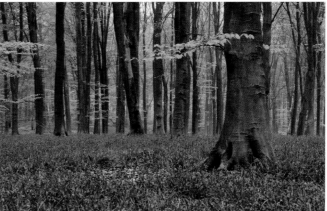

3 **Get closer** Zooming to 70mm helps compress the bluebells, giving a richer colour, losing the bare canopy and simplifying the scene. The telephoto setting is good for isolating small parts of the wood, but you lose depth-of-field, so take care with focusing. This shot is an improvement, but is not quite right. I try to find a better scene before the best light arrives.

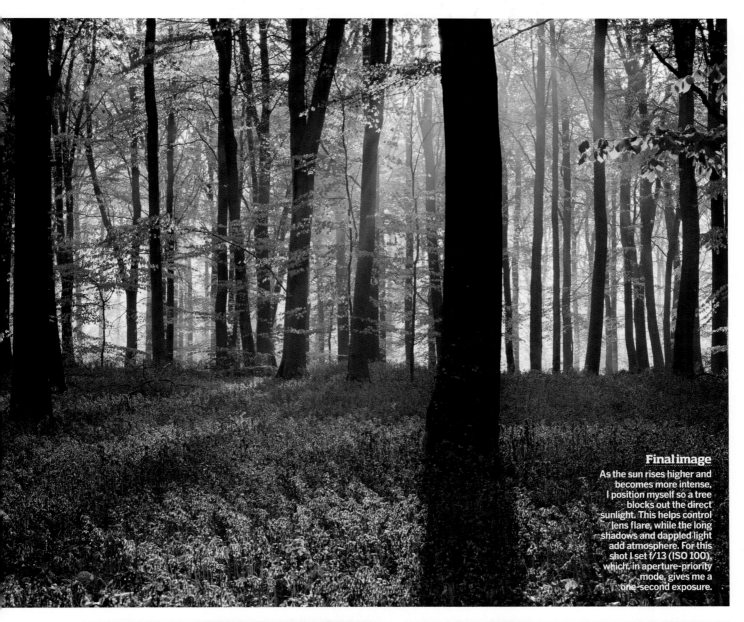

Final image
As the sun rises higher and becomes more intense, I position myself so a tree blocks out the direct sunlight. This helps control lens flare, while the long shadows and dappled light add atmosphere. For this shot I set f/13 (ISO 100), which, in aperture-priority mode, gives me a one-second exposure.

OUTDOOR

INDOOR

LIGHTING

CREATIVE

PHOTOSHOP

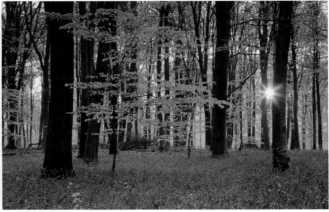

4 Find a different viewpoint I find taking the camera off the tripod and looking through the viewfinder while turning 360º can help spot new viewpoints. Once you find a good composition, reattach the camera. LiveView can also help as you can turn on the grid lines to aid composition, but it's not essential. Some viewfinders also have this option.

5 Set ISO and aperture I find a scene I like and wait for the sun to rise. Its golden light transforms the scene, with the colours of the foliage and the bluebells taking on a new intensity. The sun is hidden behind a trunk at first, so I move slightly so that it appears between the trees. To capture as much detail as possible, I set my DSLR to ISO 100 and an aperture of f/11.

Stony still-lifes

>**TIME:** ONE HOUR >**EQUIPMENT:** NIKON D300 WITH NIKKOR 24-85MM >**ALSO USED:** TRIPOD AND REMOTE RELEASE

Ross Hoddinott: When you live on an island like the UK, you are never too far from the seaside. Many of us live within an hour or so's drive, making the coast one of the most accessible places to visit and photograph. There is no shortage of picture potential at the beach, and I'm not just talking about dramatic seascapes and sweeping views of rugged coastline. Don't just look for the big picture when you're at the seaside, look for smaller details, too – the images hidden within the landscape. Swap your wide-angle for a standard lens, short telephoto or macro, and isolate detail, such as patterns in the sand, shells, seaweed, pebbles, rocks and interesting geology. These types of subjects don't rely on great light and weather – even on dull, drab days you can take interesting pictures. Therefore, on the next overcast day, when you might otherwise be thinking of giving the camera a day off, why not take a drive to the seaside instead?

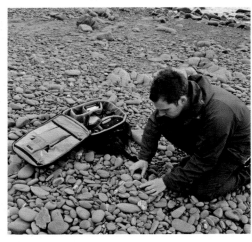

1 Plan your shoot I live close to the beach and often visit to take pictures, even when it's dull and overcast; it's perfect for pictures of detail and texture. When choosing a time to visit, try to coincide it with low tide as you'll have no shortage of interestingly shaped pebbles, or various colours, to shoot. As the tide comes in, not only can it become dangerous, but you'll find a lot of the beach is underwater, limiting your options.

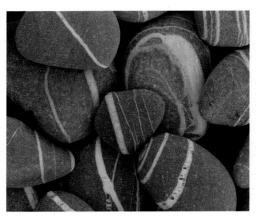

2 Trial compositions Gather some stones and try to arrange them in to a pleasing composition. Here I use striped blue and white pebbles, but it was a struggle to find a good arrangement as the stripes were distracting. The result is messy and lacks a focal point.

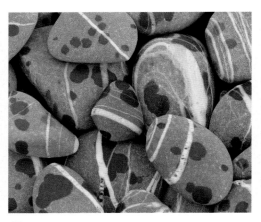

3 Experiment To try to create more interest, I sprinkle the stones with water to simulate the effect of raindrops. This created some needed contrast, but the shot isn't a great improvement. Time to search the beach for some other stones.

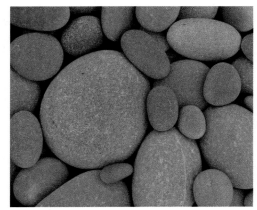

4 Take a test shot Search for pebbles of varying size and tone to create contrast. When you're happy with your selection, set your camera to aperture-priority mode and a mid-aperture, position your camera on a tripod, parallel overhead, and fire the shutter.

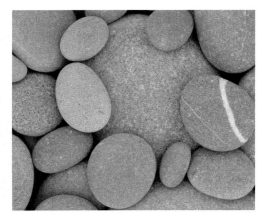

5 Improve the composition You need to include a focal point – in this case I used a striped stone to contrast with the other pebbles. It is an improvement, but the balance of the shot isn't right and the arrangement looks deliberate and unnatural.

Protect your kit! Saltwater is corrosive and can be damaging to tripod legs. Therefore, after a visit to the beach, always clean your tripod carefully and ensure sand is removed from springs and catches

Watch the tide!

Before you visit the seaside with your digital camera, remember to check tide times. The coast can be a dangerous place and it is easy to get caught out by a rogue wave or get stranded by a quickly rising tide, especially when you are concentrating on taking pictures. If you misjudge the tide, you can get soggy feet, ruined equipment or worse – so be careful. To shoot beach detail, it is best to time your visit to coincide with a low tide, which will reveal interesting pebbles, sand patterns, seaweed and shells. When you are on the beach itself, always be aware of whether the tide is coming in or going out. I always keep a local tide table in my camera bag, but you can visit www.tidetimes.org.uk.

Sidebar nav: OUTDOOR INDOOR LIGHTING CREATIVE PHOTOSHOP

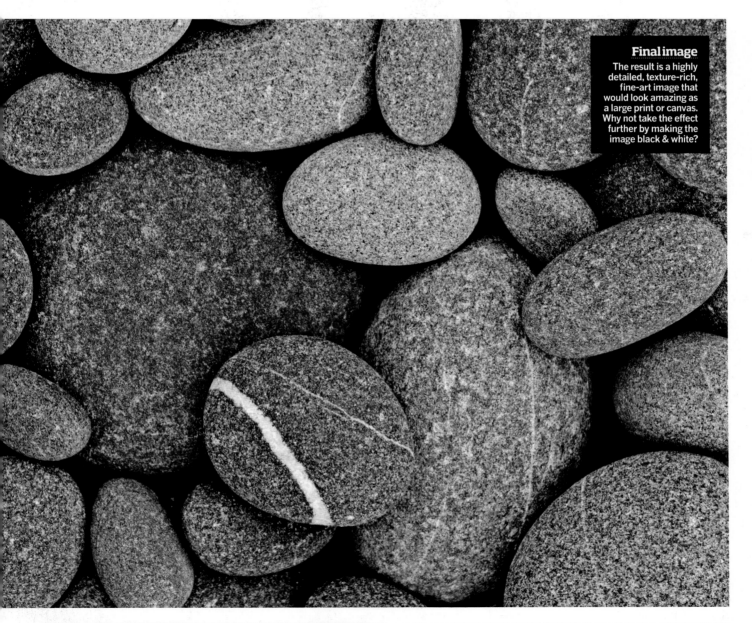

Final image
The result is a highly detailed, texture-rich, fine-art image that would look amazing as a large print or canvas. Why not take the effect further by making the image black & white?

OUTDOOR

INDOOR

LIGHTING

CREATIVE

PHOTOSHOP

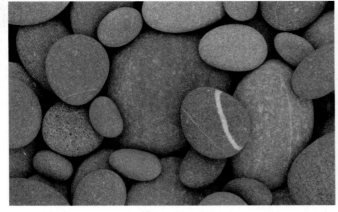

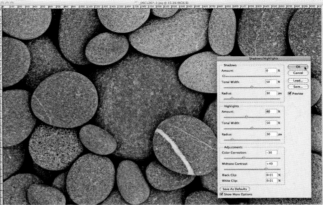

6 Be different Using a stone that's different from the rest is an effective way of introducing a focal point. Here, I was drawn to a large pink stone, as it contrasted nicely against the others, and using just one striped stone helped give the composition interest. After a few more fine adjustments to the way the stones were arranged, I had an image I was happy with – a simple still-life of beach detail, easy to take, but restful and commercial.

7 Add contrast Finally, to give the shot some punch, open the image in Photoshop. Using *Image>Adjustments>Shadow/Highlights*, adjust the *Highlights* and *Midtone Contrast* to add gritty detail to the pebbles, then use *Color Correction* to reduce the saturation. Next, go to *Image>Adjustments>Levels* and, using the *Black Point* slider, boost the blacks, increasing the depth and contrast of the shot.

Inspirational Photography Workshops

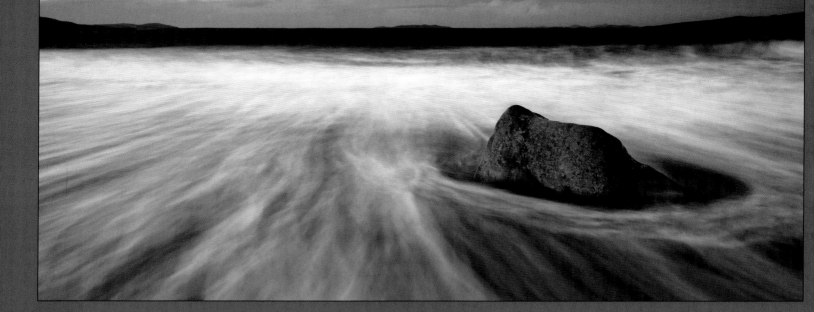

 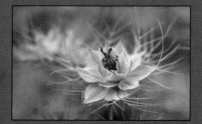 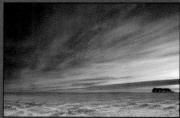

We work with you
In the class or in the field, we work with you, side by side to make sure you are getting the best out of your time with us and master your photography.

Workshops led by professionals
You will learn from photography masters that are expert tutors and know how to show you what you want to learn in a friendly and practical way.

It's all about you and your photography
We want to help you develop your hobby and passion. Small workshop groups geared towards your level, abilities and interests. The full journey of photography from seeing to printing, in the class or in the field. We have a workshop for you.

MASTER YOUR PHOTOTGRAPHY

Visit www.aspect2i.co.uk or call 0845 505 1455

Blue-sky thinking

>**TIME:** 30 MINUTES >**EQUIPMENT:** CANON EOS 5D MK II WITH CANON EF 16-35MM F/2.8L
>**ALSO USED:** REMOTE RELEASE AND A PLASTIC BAG

Helen Dixon: Tulips are hugely popular flowers to photograph, which is perhaps why a lot of the images we see published in magazines or on greetings cards can be described as 'samey'. It's not surprising, though, as the stem shape and petal structure is so uniform that you have to find an unusual way to approach the photograph for it to look different.

If you really want your tulip images to stand out from the crowd (or in this case, the bunch) then think about including some blue sky and changing your usual viewpoint for one less conventional.

Most photographers, for instance, shoot these lovely flowers from overhead or from the side, so it got me thinking about how they might look shot from the flower bed. Could I get an image where

the bright-blue sky dominates the centre of the frame, bordered by tulips?

To capture such a view, you need to give a little consideration to what equipment to use and the shooting conditions. A wide-angle lens is a must – using anything over around 24mm will only allow you to capture the heads of the tulips rather than their stems and the distorted effect created by the wide-angle lens will be lost. Shooting at different times of the day will also present different problems – at first light or sunset, the light levels will be lower, but at midday there is an increased risk of lens flare, so you need to decide what will work best for your image and find solutions to any light problems. Using a lens hood is advisable if you're shooting in strong sunlight.

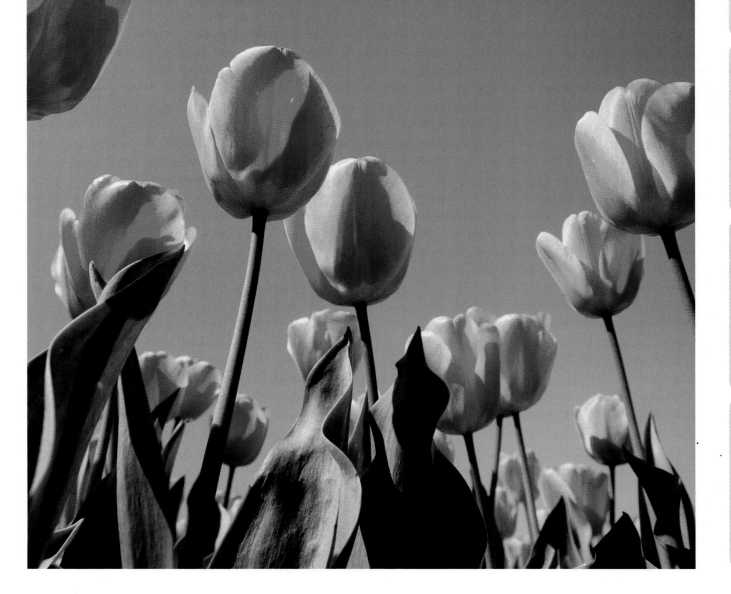

OUTDOOR

INDOOR

LIGHTING

CREATIVE

PHOTOSHOP

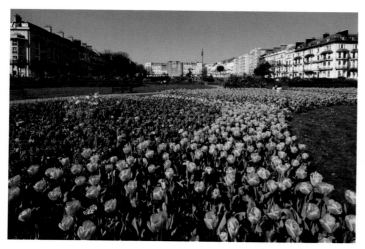

1 Pick a spot Your choice of location is important. First off, you have to have permission to be there, so please don't go trampling over someone's prize-winning tulip garden. Also aim to find patches of densely populated tulip beds as this will add to the circular border effect. Public gardens are often a good bet to find a suitable and quiet location.

Go wide!

To really make the most of this type of shot, a wide-angle lens will be required. Those using digital SLRs with APS-C sensors should remember that their focal length will increase by 1.5x (1.6x for Canon users), so try to get your hands on an ultra wide-angle lens. If you find that this lens is out of your budget, why not hire one for the weekend?

Do you need the polariser?

Polarisers saturate colours and are perfect for red tulips and blue skies, but a polarising filter cuts out two stops of light reaching the sensor and means the image requires a slower shutter speed, leading to blur if the tulips sway, which is likely if there's any wind. You also need to take care to use it properly to avoid uneven polarisation of the sky.

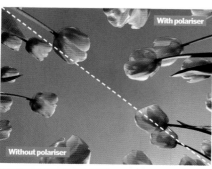

With polariser

Without polariser

2 Set up With the DSLR in aperture-priority mode and set to f/11 for good depth-of-field, it's time for a lie down on the grass. With your camera tilted backwards and fitted with a remote release, take a few test shots to see what you can achieve. I choose to protect my camera from the dirt by covering the back of it with a plastic bag.

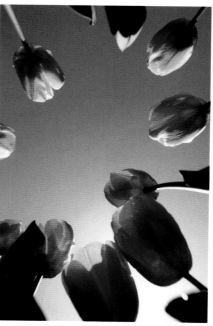

3 Take a test shot My test shots aren't quite right. With the aperture set at f/11, the camera selects a slow shutter speed that allows the stems to sway while the shutter is open, resulting in a little blur. Also, the central AF point struggles to focus because it's pointing straight at the sky and has nothing to lock on to.

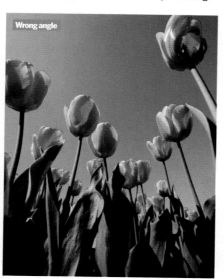

Wrong angle

Too much flare

4 Focus accurately An aperture of f/8 raises the shutter speed. Change the camera from central AF to multi-point AF if you're struggling to focus, as it will allow the camera to search the frame and find a subject to lock on to.

5 Experiment There's a lot of trial and error involved in finding the best composition, so you should manoeuvre the camera around to find the best results. Tilting the camera even a little can make a huge difference to the composition, so be steady as you go. As our test shots reveal, lifting the camera too high loses the circular border of tulips. Those of you with a vari-angle LCD monitor can tilt it and use LiveView, making composition far easier. Use an LCD shade to see the screen in bright sunlight.

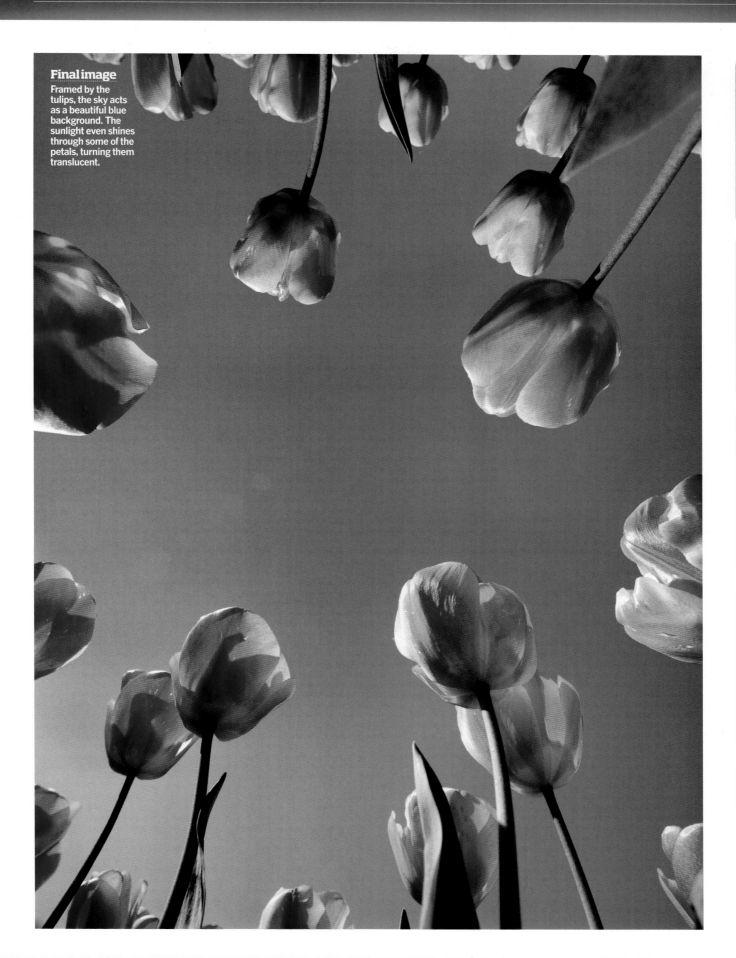

Final image
Framed by the tulips, the sky acts as a beautiful blue background. The sunlight even shines through some of the petals, turning them translucent.

OUTDOOR

INDOOR

LIGHTING

CREATIVE

PHOTOSHOP

OUTDOOR

INDOOR

LIGHTING

CREATIVE

PHOTOSHOP

Coastal creations

>TIME: ONE HOUR **>EQUIPMENT:** CANON EOS 5D MK II WITH ZEISS 21MM F/2.8
>ALSO USED: ND GRAD & ND FILTERS AND A CAMERA-MOUNTED SPIRIT LEVEL

Mark Bauer: Seascapes are a hard subject to resist photographing, especially during a sunset when you can get beautiful blue and purple hues from the sky and silky water from a long exposure. When planning your shoot, remember that location and composition are important elements to determine the success of a seascape image. I try to pick places where there are rocks, so the bold shapes and jagged edges contrast with the softness of the water. Leave plenty of space around the static objects, too, to allow you to capture movement in the water. I try to shoot low-light seascapes with an incoming tide, so that the waves wash up around the foreground, adding brighter tones. If you shoot when the tide is falling, you could end up with rocks being rendered as dark masses in the foreground because there is not enough light to show their wet, shiny surfaces. Getting the timing right for individual waves is important, too; time the exposure so that there is water movement in the frame for at least some of the time the shutter is open.

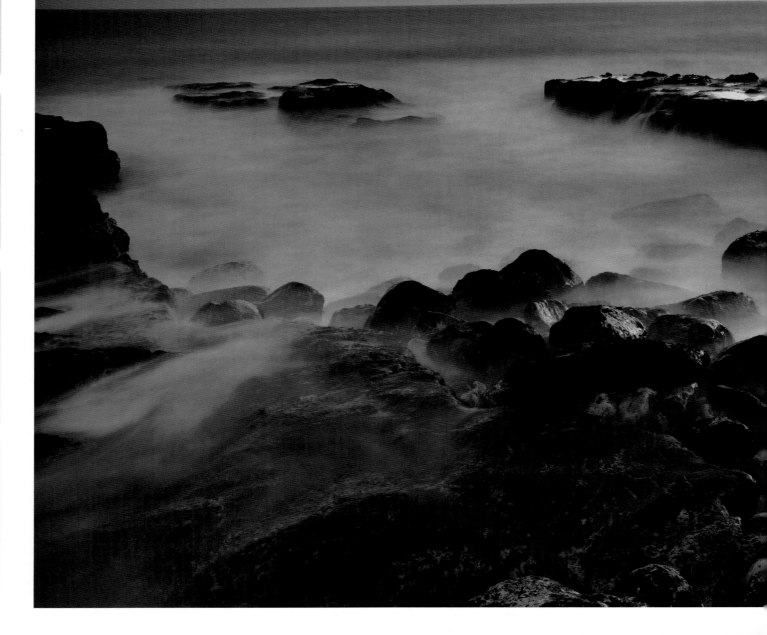

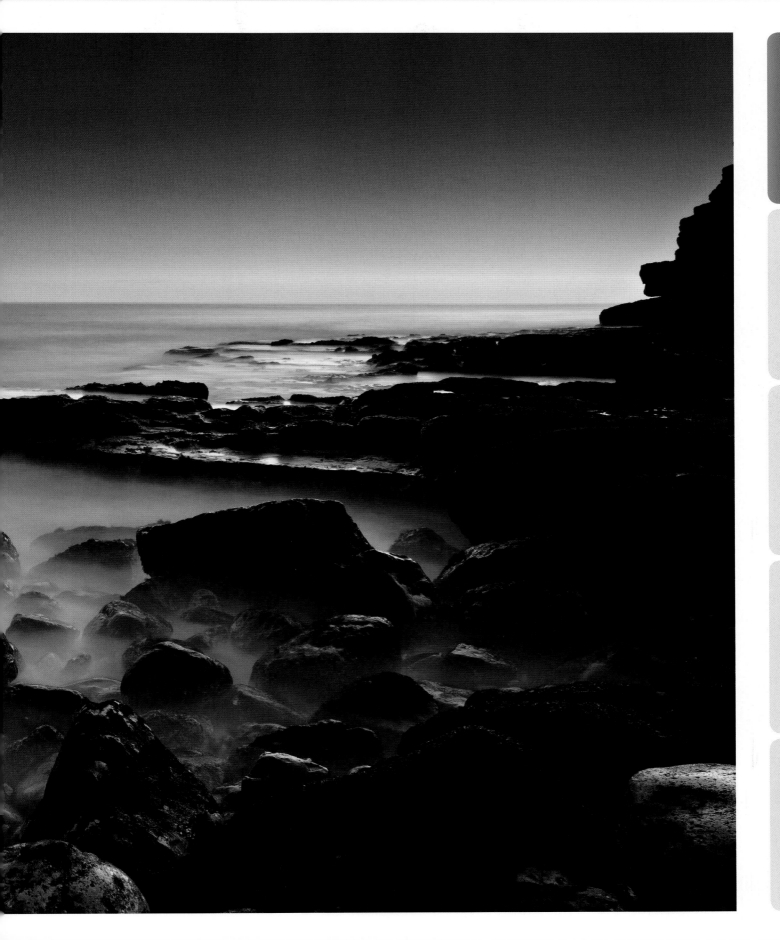

OUTDOOR

INDOOR

LIGHTING

CREATIVE

PHOTOSHOP

OUTDOOR

INDOOR

LIGHTING

CREATIVE

PHOTOSHOP

Calculating exposure

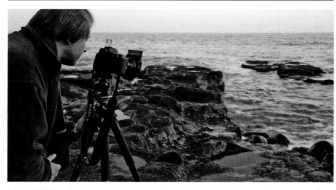

Most DSLRs allow you to set a maximum exposure time of 30 seconds. You could raise the ISO to stick within this limit, but to get the best image quality, stick to ISO 100 and switch to the Bulb setting, which allows you to keep the shutter open for as long as you want. To calculate how long that should be, in aperture-priority mode, increase the ISO until you get a meter reading. Then work out what the equivalent exposure is at ISO 100, switch to Bulb and take the shot. For example, if at ISO 400 the correct exposure is 30 seconds, the equivalent at ISO 100 is two minutes. At dusk, light levels drop, so keep checking and adjust accordingly.

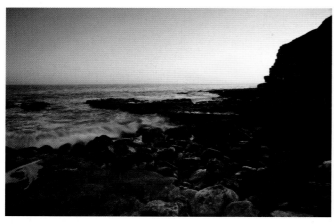

1 Find your spot This isolated cove on the Purbeck coast is ideal for low-light seascapes, with its jagged, rocky ledges and boulders. However, with the sun only just below the horizon, the light is still a little harsh, and the tide is too far out and would be too far away in the frame.

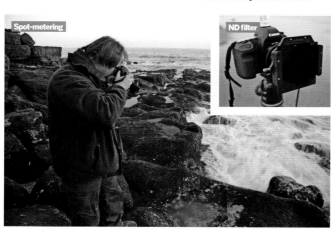

2 Add an ND grad Spot-meter readings from the foreground and the sky tell me that there is a five-stop difference between them. A three-stop ND grad brings it all within the camera's sensor range. I add an ND filter as well to lengthen the exposure.

Three safety rules

If you're shooting by the sea in near-darkness with an incoming tide, you need to take certain precautions:

1) Keep in touch
Tell someone where you're going and what time you expect to be back. Take a mobile phone with you, and, if possible, don't go alone – perhaps a photographer friend would like to accompany you.

2) Check the tides
Make sure you know how high the tide will rise, and when, so that you don't get cut off. Keep an eye on it while you're shooting and leave in plenty of time – even if you miss the shot.
 Stand further back than you think you need to – the water will soon be where you want it and you'll be able to get your shot without having to beat a hasty retreat halfway through the exposure.
 Watch out for rogue waves. Every so often a big one is likely to come in. At worst, it could knock you off your feet, putting you in danger, and it certainly won't be good for your camera equipment.

3) Protect your gear
Protect your equipment with a rain cover. You can improvise by using a freezer bag, or there are several which are commercially available. I favour the Op/Tech Rainsleeve – they're cheap, do the job well and you can see all your camera settings properly, which isn't true of some more pricey alternatives.

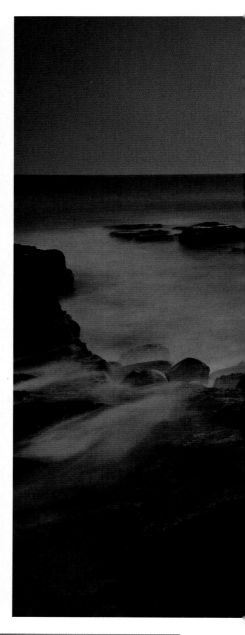

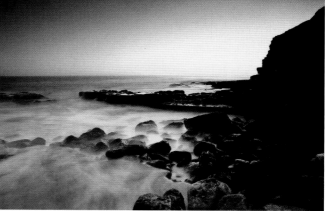

3 Tweak composition Even with the waves protruding into the foreground, there are still too many dark tones, especially to the right of the frame, so I move the camera's view to the left. Now it's just a case of waiting for the light to drop further and the right waves to come in.

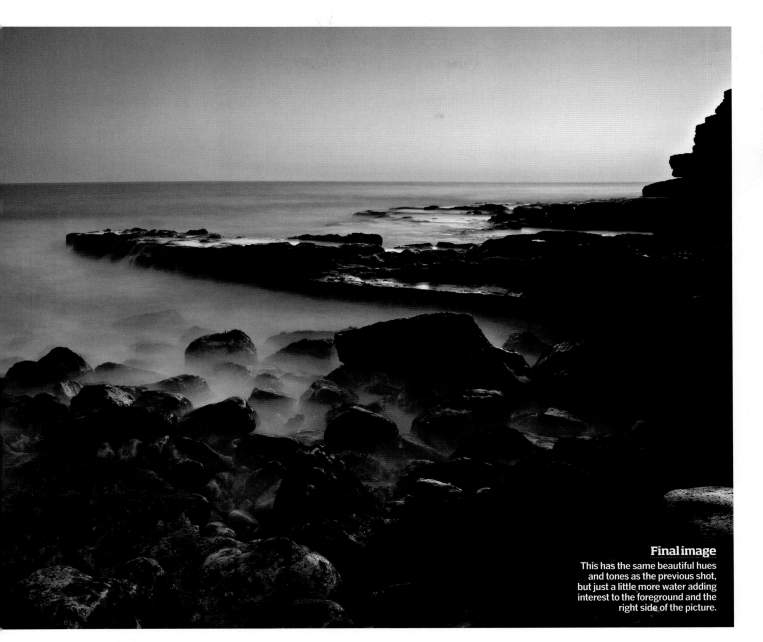

Final image
This has the same beautiful hues and tones as the previous shot, but just a little more water adding interest to the foreground and the right side of the picture.

OUTDOOR

INDOOR

LIGHTING

CREATIVE

PHOTOSHOP

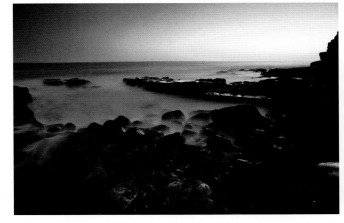

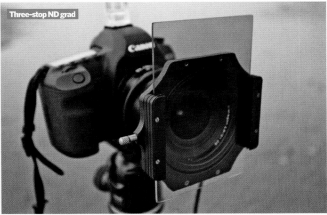

Three-stop ND grad

4 Wait for the tide The low-light levels produce a lovely blue-purple in the sky and the sea. This one's almost there but just needs a little more water washing up on the right-hand side of the picture to break up the dark tones and to help balance out the foreground interest.

5 Adjust filters The incoming tide forces a change of position. The light is now low enough to allow a 45-second exposure (ISO 100 and f/16) without having to use an ND filter. A three-stop ND grad is still necessary as no direct light is falling onto the land or sea, but the sky is lit from below.

Light up the night

>TIME: TWO HOURS **>EQUIPMENT:** CANON EOS 5D MK II WITH CANON EF 16-35MM F/2.8L II **>ALSO USED:** TRIPOD, STRING, LED TORCHES AND FLASH GELS

Michael Bosanko: Cast your mind back to when you were a child. It's a bonfire night. It's dark, cold and you're wearing more layers than a mature onion. In a way, there seemed little incentive being out in these conditions, but then someone hands you a sparkler, and when it's lit, for that golden minute, you forget all about the climate and become completely lost in that moment of joy, moving the sparkler around to create amazing shapes and circles. Painting light orbs is an extension of this technique. By using a few household torches, a DSLR and tripod, you can relive the wonder years and capture beautiful effects without any need for post-processing. This technique works best in areas with low light pollution, so I headed out late one evening on to the moors to see what shapes I could create.

LED light fantastic!

Though we chose to create light orbs in this photo project, the technique works just as well to create virtually any shape. You could use the torches to create wavy lines through the frame, draw around the outlines of objects like cars or even create some light painted 'models' by drawing people with the torches into the image. Like the majority of photographic techniques, the only limitation is your imagination and once you learn the basics of this technique, you may choose to start using multiple light sources to create dynamic, multicoloured paintings that light up the sky.

1 Colour your torches Give the torches a bit of 'zing' by covering the front glass with coloured gels; coloured acetate or sweet wrappers work just as well, too. The first two are easily obtainable from art stores or online. If you have a really bright torch, you might want to layer the gels to make sure that enough colour is produced by the beam.

2 Bundle the torches If you have more than one torch, bundle them together with tape to get multiple lines of light. I fasten the bundle to a dog's lead, but a long piece of string will do. Make a final check that everything's secure and unlikely to come loose. The last thing you want is for the torches to break free and fly off into the dark night or, worse still, into the camera's lens.

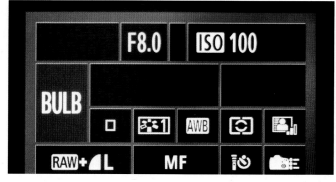

3 Set camera settings As you will be dealing with long exposures, a tripod is essential to keep the camera steady. Choose one with independent moving legs for those rough terrains. If you have a remote release, bring it along for shake-free operation. Camera settings vary according to ambient light, but a good starting point is to set the aperture to f/8, use a low ISO rating and set your camera to Bulb mode. Trying to use autofocus at night is a challenge. Where possible, aim to focus manually. Alternatively, shine a bright light where you will be 'painting' and use autofocus to lock on to that point. Make sure you switch back to manual focus to stop the lens 'hunting' for a focus point.

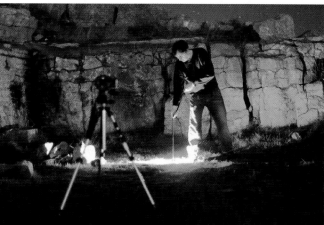

4 Set the self-timer I've found a great spot to paint with a background of jagged rocks so we're nearly at the fun bit. After composing the shot, I position myself at a safe distance from the camera and other obstacles. Have a friend operate the remote release or, if you're alone like me, use the camera's self-timer facility.

OUTDOOR

INDOOR

LIGHTING

CREATIVE

PHOTOSHOP

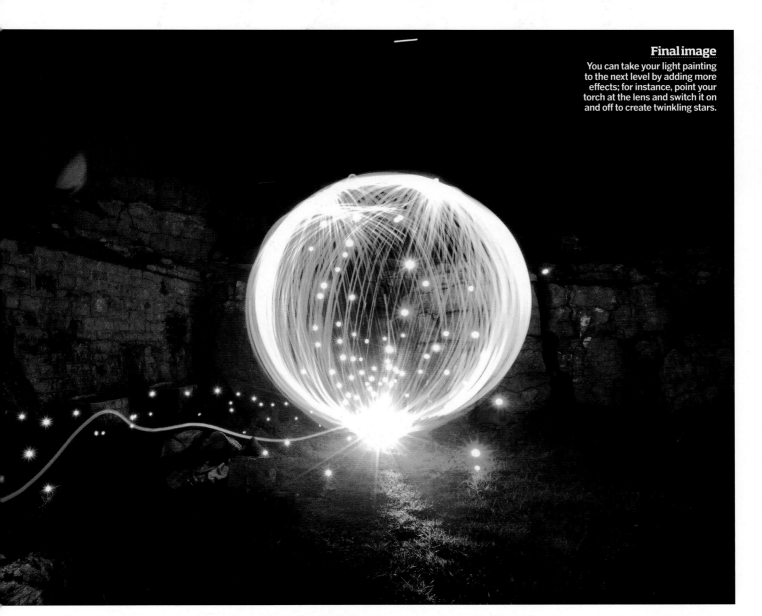

Final image
You can take your light painting to the next level by adding more effects; for instance, point your torch at the lens and switch it on and off to create twinkling stars.

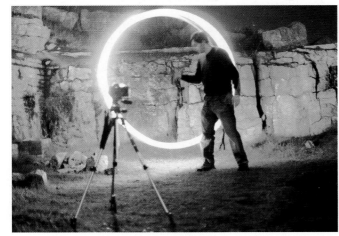

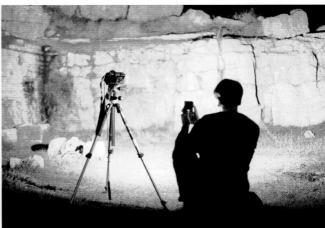

5 Swing your torches Holding the lead, when the camera's shutter opens, start to swing the torch in a circular motion. Next, start twisting your whole body on the spot slowly. Once you have completed 360°, switch off the torches. It's important to keep moving all the time so you are not recorded in the shot.

6 Light your backdrop It is likely the background will appear dark, even after your lighting antics. To light the backdrop, I step behind and to the side of the camera, grab a flashgun and manually fire off a couple of flashes by pressing the Pilot button. Take your time with your exposures; this shot took 17 minutes.

OUTDOOR

INDOOR

LIGHTING

CREATIVE

PHOTOSHOP

Photographing beautiful garden birds

>TIME: FOUR HOURS **>EQUIPMENT:** NIKON D800 WITH NIKKOR AF-S 70-200MM F/2.8 & 2X CONVERTER **>ALSO USED:** HIDE, FEEDER

Ross Hoddinott: You often don't have to venture further than your own garden to capture great images of small birds. Gardens are an important environment for wildlife, and even the most modest backyard is typically home to a good few species. Blackbirds, finches, tits, woodpeckers and robins are among the UK's most common garden birds. They can grow quite accustomed to human activity, making them easier to get within picture-taking range. However, if you plan to simply wander out into your garden with your camera in the hope of taking great shots, you are likely to have limited success with too much left to chance. For best results, a little more thought, effort and planning is required.

When photographing garden birds, the best approach is to entice them to a pre-defined spot using bird feeders filled with seeds and nuts. This is a technique known as 'baiting'. Place your feeder in a suitable position for photography, where it will receive good light at the time of day you will be shooting, and also a fair distance from its background – at least 5m. This is an important consideration; if there is lots of clutter behind your feeding station, you will end up capturing images with messy, distracting backdrops. Avoid objects like fencing and the kid's trampoline from appearing in the background! Alternatively, you could hang some sort of cloth backdrop behind your feeding station – darker shades of green and brown look most natural.

Photographing birds feeding from fat balls and seed feeders is fine, but the shots won't look very natural. Therefore, introduce props or perches close to the feeders that the birds will naturally use to rest on between feeding. A simple lichen-covered twig will do, or try different 'props' depending on the season – in spring, a blossom-covered branch works well, and a sprig of colourful berries in autumn. You could try using a spade handle, flower pot or washing line.

You can photograph garden birds throughout the year, whatever the season. However, autumn and winter often prove the

best times – when the days are shorter and cooler, birds will visit feeders more regularly, providing more photo opportunities. Traditionally, summer is the worst time, as there is more natural food about, meaning birds are less reliant on feeding stations.

One of the biggest considerations is how to conceal yourself. You'll need to be 3-5 metres away from your subject if you wish to capture frame-filling images – and at distances this close the subject can easily be frightened away. A hide is the best option. Portable, collapsible versions can be bought for around £100 – www.wildlifewatchingsupplies.com has an excellent range. You could also make your own hide or use a tent or even a child's playhouse. Whatever you use, place it 3-4 metres from your feeding station, and be careful that its shadow doesn't cast your subject into shade. Alternatively, position your feeders close to a household window or garden shed and take photos from indoors. Just hang some camouflage netting over the window or door you are shooting from, popping your lens through one of the holes.

In terms of kit, a focal length of 300mm is a minimum requirement. The long end of a 70-300mm telezoom will be fine, particularly

if combined with a digital SLR with an APS-C sensor, as this increases the effective focal length of the lens (1.5x with most brands, 1.6x with Canon). A shorter focal length coupled with a teleconverter is another good option. However, telezooms typically have a slowish maximum aperture of f/5.6. To capture the movement of birds, you'll require a shutter speed upwards of 1/500sec. To help generate this, increase the ISO rating to 800 or more if required. Garden birds are very active and rarely pose for long. Opportunities are brief, so you need to work quickly. Rather than track movement, it is normally better to focus on your perch and wait for the birds to appear in your viewfinder. Have your camera set to continuous shooting mode, so that you can shoot a quick burst of images and maximise your chances of capturing the right shot.

Top tip

The noise of your camera's shutter and mirror action may frighten birds away at first, but they will quickly get accustomed to the sound of you taking photos, so just persevere.

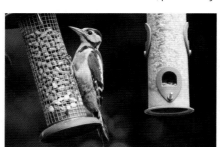

1 Baiting Use suitable food – like wild birdseed and peanuts – to entice birds regularly to a pre-defined spot. This is known as 'baiting'. In this instance, I hung a couple of feeders on a bracket. I positioned my 'feeding station' over five metres away from the nearest background object in order to help me achieve a clean, diffused background.

2 Set up your hide Once birds are feeding regularly, you can introduce your hide. I placed a dome hide (which can be erected in just a couple of minutes and folds away again into a small bag) a couple of metres from the feeders. The feeding station was placed where I knew it would receive good light from mid-afternoon onwards, so I positioned the hide accordingly.

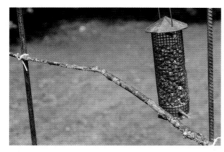

3 Introducing a prop Photos of birds clinging to feeders aren't very exciting. To capture more natural-looking wildlife images, introduce a 'prop' that the birds can use as a perch between feeding. In this instance, I opted for a very simple lichen-covered branch that I found in nearby woodland, and tied it to the feeding brackets close to where the feeders were hanging.

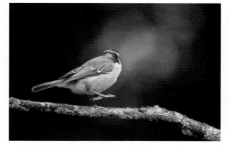

4 Shutter speed too slow I coupled a 70-200mm with 2x converter to give me an effective focal length of 400mm. However, if your lens's maximum aperture is only f/5.6 or f/8, the corresponding shutter speed is often too slow to freeze movement. To compensate, increase ISO to 800 or higher. This should generate a fast enough speed.

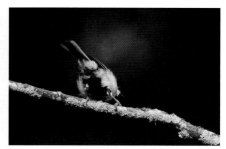

5 Composition Little birds move quickly, so the best tactic is to concentrate on one area rather than try to follow the birds around. Pre-focus on your perch and wait for birds to land just where you want them. However, it can be frustrating waiting for one to land in just the right place. Expect to take lots of poorly composed images before you get it right!

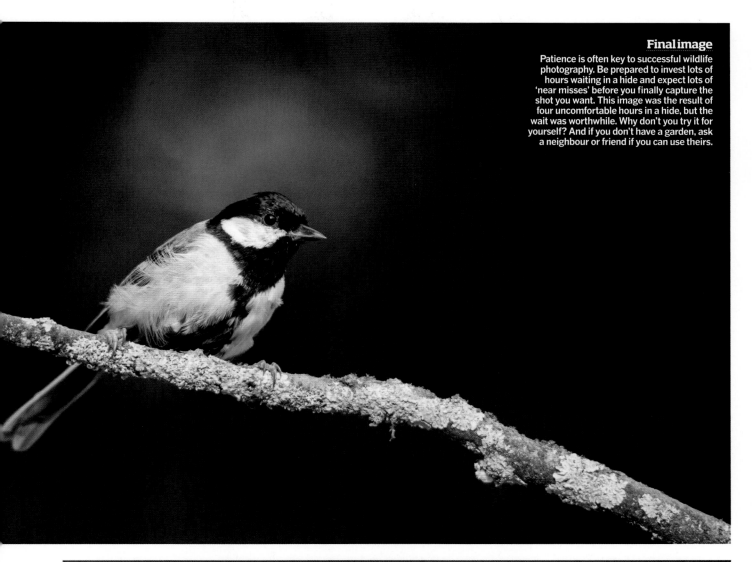

Final image
Patience is often key to successful wildlife photography. Be prepared to invest lots of hours waiting in a hide and expect lots of 'near misses' before you finally capture the shot you want. This image was the result of four uncomfortable hours in a hide, but the wait was worthwhile. Why don't you try it for yourself? And if you don't have a garden, ask a neighbour or friend if you can use theirs.

OUTDOOR

INDOOR

LIGHTING

CREATIVE

PHOTOSHOP

Breeds to look out for...

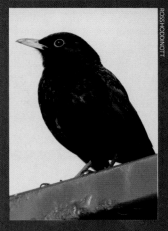

■ Spring:
Blackbirds are very photogenic. They can be seen collecting nesting material and will often search for worms and grubs on lawns. Use mealworms to entice them close.

■ Summer:
Blue tits and great tits are common garden visitors throughout the year. Both species are small, so a close approach or long lens is needed to capture good shots.

■ Autumn:
If you're lucky, goldfinches may visit your garden. They like sunflower and niger seed. You could also try growing teasels to help attract them. They look beautiful in warm evening light.

■ Winter:
Robins are friendly, approachable garden birds, particularly in winter when natural food is scarce. Take photos in the morning after a heavy frost in order to capture seasonal-looking images.

OUTDOOR

INDOOR

LIGHTING

CREATIVE

PHOTOSHOP

Get the kids in a spin!

>TIME: 30 MINUTES **>EQUIPMENT:** NIKON D80 WITH NIKKOR 18-70MM F/3.5-4.5 **>ALSO USED:** TWO CAMERA STRAPS

Luke Marsh: Ah, summer! As if it wasn't hard enough to get your kids to sit still for five minutes to have their picture taken, out pops the sun to whip them into a fresh-air fuelled frenzy. Unless you're shooting at ridiculously high speeds while constantly on the move, you may as well forget about capturing amazing summer family shots and switch to the still-lifes, right? Well, not necessarily. I got to thinking: 'What if I could combine a shot with a fun game my little boy is always nagging me to play, that's bound to keep him interested for more than the usual 30 seconds?' And that's precisely what I did. Any parent who's ever span around while holding their child will know that once you've started this game, be prepared for 'just one more time' for at least half an hour – plenty of time to get a great shot. Just don't try this straight after lunch, unless you've got a bucket handy!

Creating a body harness

My homemade harness consists of two camera straps. The first is the neck strap already attached to my DSLR, the second is a spare strap that goes around my back to prevent the camera swinging from side to side. The most important aspect of this makeshift body harness is getting the height of the camera via the neck strap right so that the subject is positioned correctly in the frame. I found that placing the camera in the tummy region gave the most consistent results. I attached the second strap to where the first strap meets the camera, making it tight enough to prevent major movement, but not so tight that it is uncomfortable or prevents me accessing the controls. You can also buy a ready-made harness from brands such as Op/Tech (www.newprouk.co.uk).

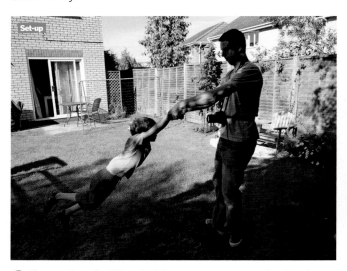

1 Choose a location When deciding on your spot, remember that the background will be blurred, so you won't need to worry too much about clutter – often a busier background helps with a sense of movement. A garden or local park is ideal, as long as there's enough space for you to spin without posing a threat of injury to your subject or innocent bystanders.

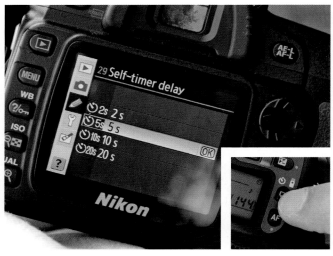

2 Set the self-timer For this shot, I'm going to use the camera's self-timer function to fire the shutter. All DSLRs have a self-timer, with most having the option to adjust the delay time in the menu settings. Set the timer to fire five seconds after the shutter release is pressed, allowing ample time to get a decent spin going once I've pressed the shutter button.

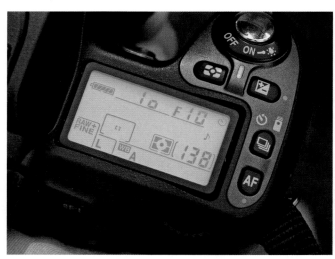

3 Set your aperture With your DSLR set to aperture-priority mode, set an aperture of f/10. As the subject will be moving constantly in relation to the camera, it should allow enough depth-of-field to give a better chance of a sharp result, and this aperture will naturally give a slightly longer exposure, ideal for capturing the background movement.

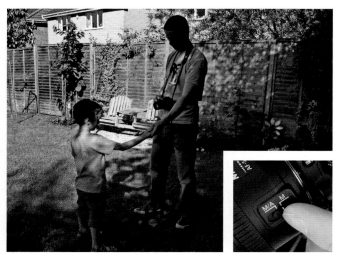

4 Pre-focus on your subject Set your lens to its widest focal length to capture both the subject and the background. With the subject at arm's length in front of you, press the shutter release halfway to pre-focus, then switch to manual focus so the DSLR won't hunt around trying to focus. Now fully depress the shutter release, setting off the timer.

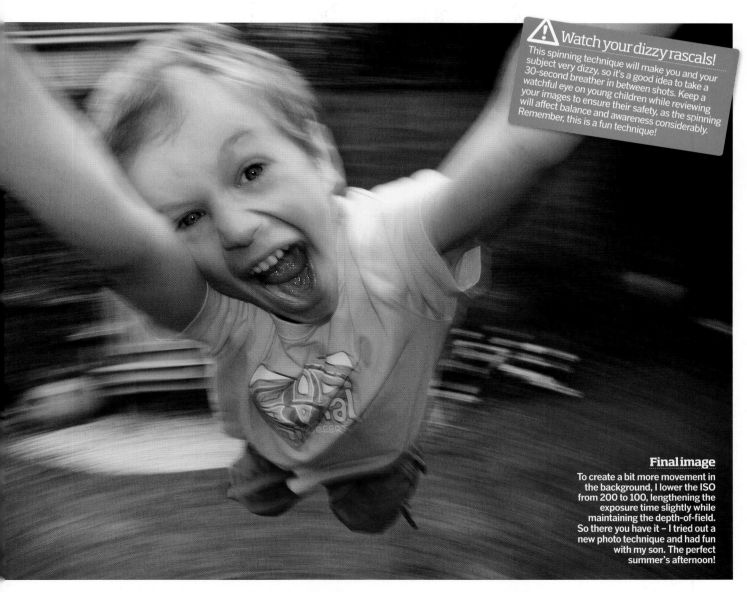

Watch your dizzy rascals!
This spinning technique will make you and your subject very dizzy, so it's a good idea to take a 30-second breather in between shots. Keep a watchful eye on young children while reviewing your images to ensure their safety, as the spinning will affect balance and awareness considerably. Remember, this is a fun technique!

Final image
To create a bit more movement in the background, I lower the ISO from 200 to 100, lengthening the exposure time slightly while maintaining the depth-of-field. So there you have it – I tried out a new photo technique and had fun with my son. The perfect summer's afternoon!

OUTDOOR

INDOOR

LIGHTING

CREATIVE

PHOTOSHOP

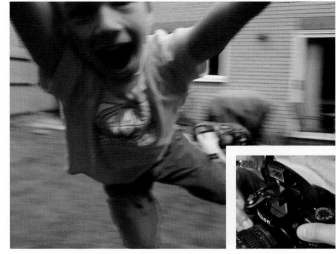

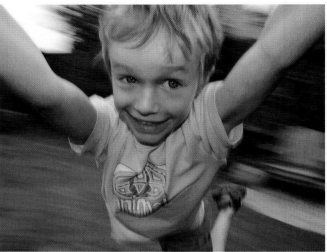

5 Take some test shots The first attempts are promising, and while there's an element of luck that dictates where the subject will be in the frame when the shutter fires, my positioning improves with each spin. What I do notice is that my moving subject is blurred during the long exposure. To resolve this issue, pop up the DSLR's integral flash to freeze the action.

6 Set flash mode To fire the flash at the end of the exposure, set it to rear-curtain (also called second-curtain) sync. It's ideal as the slow shutter speed captures movement in the scene while the flash freezes the action for a split second. It's a major improvement and I continue shooting until I get a shot I like or until the subject gets bored (or sick!).

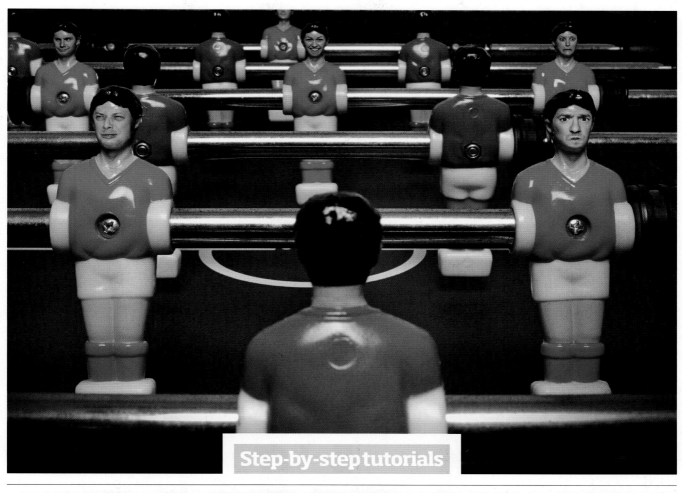

Step-by-step tutorials

INDOOR PROJECTS

SHOOT STUNNING PORTRAITS, STILL-LIFES AND CLOSE-UPS IN YOUR HOME AND OTHER INTERIORS

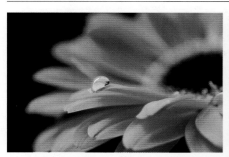

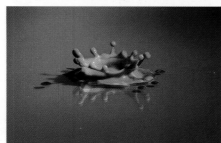

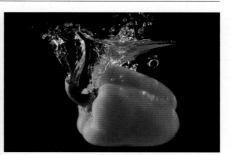

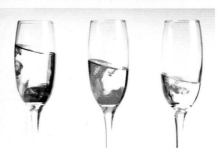

Capture a refracted scene

> **TIME:** 20 MINUTES > **EQUIPMENT:** CANON EOS 40D WITH CANON EF 50MM F/1.4
> **ALSO USED:** CRYSTAL BALL

Helen Sotiriadis: Crystal balls aren't just for predicting the future: they can make interesting props, or lens aids, for pictures, too. Transparent balls, whether glass, crystal or acrylic, are great for photography as part of an image or to simply shoot through for interesting wide-angle results. Their dramatic refractions replicate a similar look to a fisheye lens as their wide field-of-view means you can include large areas within a small frame.

You can incorporate them in to a number of scenes, whether landscapes, architecture, everyday items such as flowers, or even portraits. They cost around £10-£20, depending on the size, and can be bought online from sites like Amazon or eBay. You may find one in a New Age store, too. A 50mm or 60mm diameter ball should work well in most situations.

If you use the sphere as a prop, it works well to blur the background so the subject or scene is only visible in the ball. Where there's plenty of distance between the background and the lens, like a landscape, you can use a standard zoom, as f/3.5-f/5.6 should give you

sufficient blur. But for portraits where you're restricted by the length of someone's arm, for instance, a lens with a maximum aperture of f/2.8 or wider works better. Here I've used a Canon EF 50mm f/1.4, but the cheaper 50mm f/1.8 is also suitable.

Round objects roll and glass is fragile, so you need to find a way of stabilising the ball for the shot. Most balls come with their own stands, but you could have someone hold it, or if you're trying to balance it on a flat surface, try using a small metal or rubber washer, or some double-sided sticky tape underneath to keep it stable. And, if shooting outdoors, obviously avoid windy conditions. You may need to refine your position or the position of the subject's arm, too, until you get a clear reflection in the ball.

For this technique to be effective, your focusing has to be spot-on and that's trickier than you might think. As you're working with a wide aperture and a spherical surface, your depth-of-field will be extremely shallow, so getting the whole reflection sharp can be difficult. You could ask the model to remain very steady and manually focus, with the camera set on a tripod, but usually the most

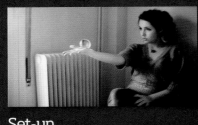

Set-up

To give the image depth, the ball needs to be brighter than the rest of the frame, so I positioned my model so her outstretched hand overlapped with a window, and the wall blocks some of the light falling on her body. On the opposite side, I used a large sheet of Styrofoam as a reflector to bounce light back on to the hand. You can use any type of reflector or reflective material, though, for the same effect. Skew the camera slightly to make the composition more dynamic, select aperture-priority mode and single-point AF and zoom in close enough so that the ball is large in the foreground but the person is still visible behind, and focus on the ball.

successful option is to use single-point AF and place an AF point over the reflection. Lock focus and shoot, defocus and then recompose. Burst mode can help improve your chances of a sharp result, too.

Changing apertures

Depending on how 'fast' your lens is (distinguished by the maximum aperture), the camera-to-subject distance and the subject's face-to-hand distance, you can get various degrees of blur. This technique works particularly well if the emphasis is placed on the ball in the foreground and the person's face behind is blurred beyond recognition. But the level of blur is dependent on personal taste. Here are three examples of the same shot taken at f/1.4, f/2.8 and f/5, from the same distance. Remember: the wider the aperture, the closer you are to the foreground subject; and the further the background is from the foreground, the heavier the blur.

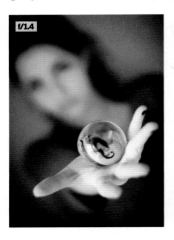

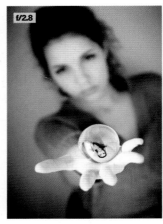

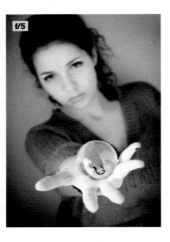

Try it with a landscape

Landscapes, seascapes and cityscapes with beautiful rich colours are perfect for this style of image: sunsets, twilight and city lights work great. If you do want to shoot in the evening, aim for the magic hour, just as the sun sets and there is enough ambient light to expose for the ball and surroundings. Use a tripod to avoid camera shake in low light and bring a platform to balance the glass ball on (you may want to use a suction cup for added stability).

Use single-point AF or manually focus on the scene within the ball and experiment with apertures, starting with your widest and closing it down gradually until the scene and outline of the sphere is sharp but the background is blurred, preferably with a good level of bokeh. As the glass ball flips the scene inside, you'll need to flip the image in Photoshop so it's upside down. Give it a go.

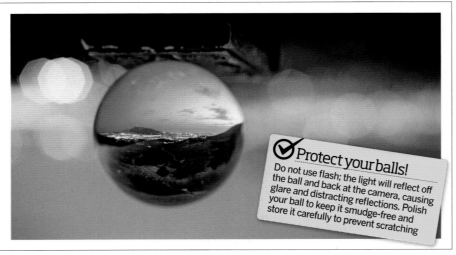

Protect your balls!
Do not use flash; the light will reflect off the ball and back at the camera, causing glare and distracting reflections. Polish your ball to keep it smudge-free and store it carefully to prevent scratching

OUTDOOR

INDOOR

LIGHTING

CREATIVE

PHOTOSHOP

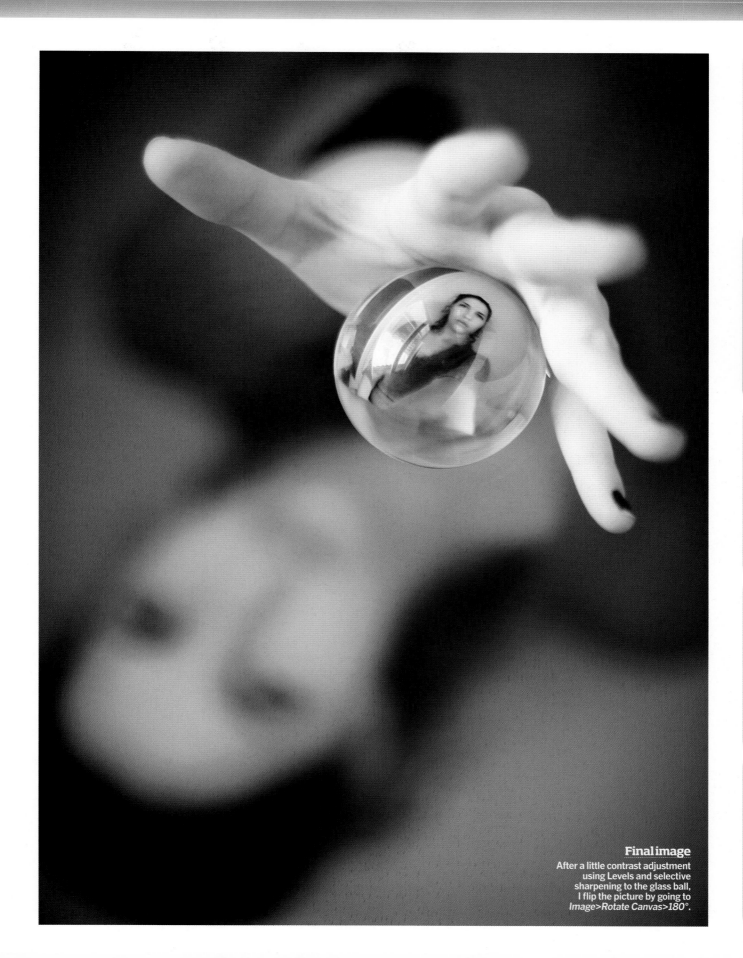

Final image
After a little contrast adjustment
using Levels and selective
sharpening to the glass ball,
I flip the picture by going to
Image>Rotate Canvas>180°.

OUTDOOR

INDOOR

LIGHTING

CREATIVE

PHOTOSHOP

Bottoms up!

>TIME: 30 MINUTES **>EQUIPMENT:** NIKON D300 WITH NIKKOR 18-55MM **>ALSO USED:** ELINCHROM D-LITE 4 IT, GLASSES, FOOD COLOURING, CARDBOARD AND TABLETOP STUDIO

Caroline Wilkinson: When I first saw a similar image to this one, the first thing I thought was, 'How is the water slanted? Has it been Photoshopped? Can it even be done in-camera?' Well, it can and once you realise how it's done, you'll be kicking yourself like we were because it's so simple and obvious when you know how.

We like to think that we're a pretty smart bunch on the *Digital SLR Photography* magazine team, but it took three men and I a couple of minutes to figure out that the puzzling illusion was a simple twist of the camera and the strategic positioning of glasses. Now, if you're shaking your head at us in despair, we probably deserve it, but I guarantee that this bit of trickery will have your friends and family asking how it was produced too, if only for a few seconds. To add extra visual interest to the image, I also decide to drop different coloured food dyes into the water, too.

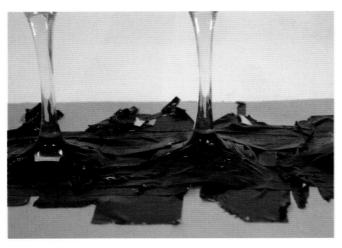

1 Secure the glasses To create the illusion that the glasses are tilted, use strong tape to secure the bottom of the glasses to a sturdy piece of cardboard. Then place something with adjustable height, like a stack of magazines or books, on one side of the tabletop and lean the cardboard on them, at an angle. The more dramatic the slant, the better the overall effect.

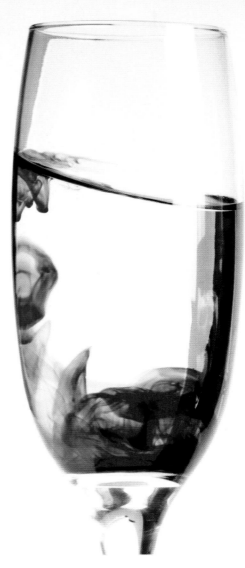

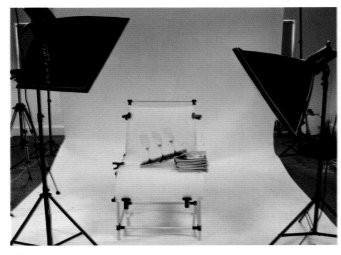

2 Get the lighting right I position one Elinchrom softbox either side of the table to illuminate both ends and to fill in any shadows on the background. Then with my camera set to manual mode and to its flash sync speed of 1/250sec, I dial in the aperture for the right exposure.

3 Angle your kit Position the lights so the catchlights are to the edges and don't distract from the dye. To get the slanted glasses looking straight, twist the camera so the tops of the glasses are level with the top of your viewfinder. Attach the angled camera to a tripod to keep the position.

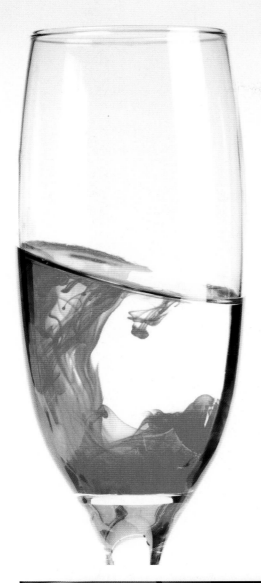

OUTDOOR

INDOOR

LIGHTING

CREATIVE

PHOTOSHOP

✅ **Cheap as chips!**
Pick up some cheap champagne glasses from a supermarket, rather than risk your best. My set cost £4. Also wear plastic gloves when doing this tutorial: trust me, food colouring stains your hands!

Final image
Lastly, I tweak the Levels and Saturation (*Image>Adjustment>Levels or Hue/Saturation*) in Photoshop to make the colours really pop! If you fancy getting a little more creative, adjust the *Hue* sliders to change the ink colours or go for a graphic black & white.

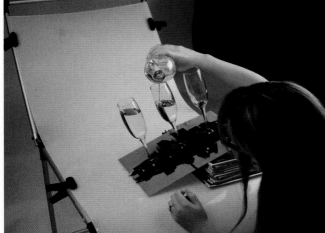

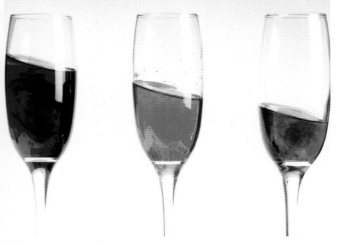

4 Add water Now carefully fill the glasses with water using a funnel or bottle, making sure the levels are aligned at a slant, then wipe any stray water drops off the glass. Take a test shot to make sure the lighting works and you don't have any unwanted reflections in the glass and water.

5 Add food colouring Next, put a drop of food colouring in each glass and shoot it as it disperses. If you put too much in, the water will turn a block colour before you press the shutter button. It's easy to splash dye on the glass, too, so be careful; it's a pain to get rid of in Photoshop.

A macro marvel

>**TIME:** 75 MINUTES >**EQUIPMENT:** NIKON D300s WITH NIKKOR AF-D 60MM MICRO F/2.8 >**ALSO USED:** GERBERA, TRIPOD, BLACK CARD, SALINE SOLUTION, EYEDROPPER OR DRINKING STRAW AND GLASS

Luoana Negut: When it comes to taking great macro photographs, composition and focusing are critical. The smallest detail can make or break a picture, so when trying this photo project, make sure you're equipped with your eye for detail and loads of patience. Including droplets in your flower pictures adds the interest factor to a standard still-life shot. Contrary to popular belief, water isn't the best medium to use for this technique as it's difficult to control and the slightest movement can cause the droplet to spread. Saline solution (available from an optician), or a clear liquid that's thicker than water, keeps its droplet form better (see over the page for more info). While you could try practically any flower, gerberas are an ideal choice for this technique as their flat petals make it easier for the droplet to stay still.

Once you've mastered balancing the droplet on a petal, you need to be aware of how the light reflects and refracts in the water and position the camera, or flower, so it's not too distracting. A macro lens with at least a 1:2 (half life-size) reproduction ratio, or even better 1:1 (life-size), and a short focusing distance works well. I used a 60mm, but a 100mm would be even easier because you won't have to work so close to the flower to get frame-filling shots. Using a black background can yield some striking results as it keeps the focus on the brightly coloured flower, but you could use any complementary colour to your flower to give your shots a different look. There is a lot of experimentation involved in this technique, but when you get it right, it can result in some striking still-lifes.

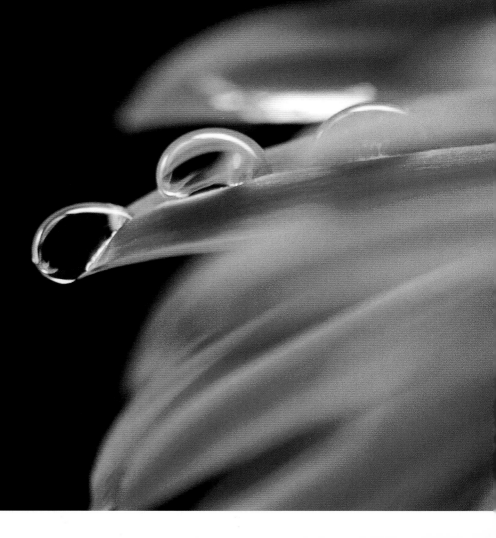

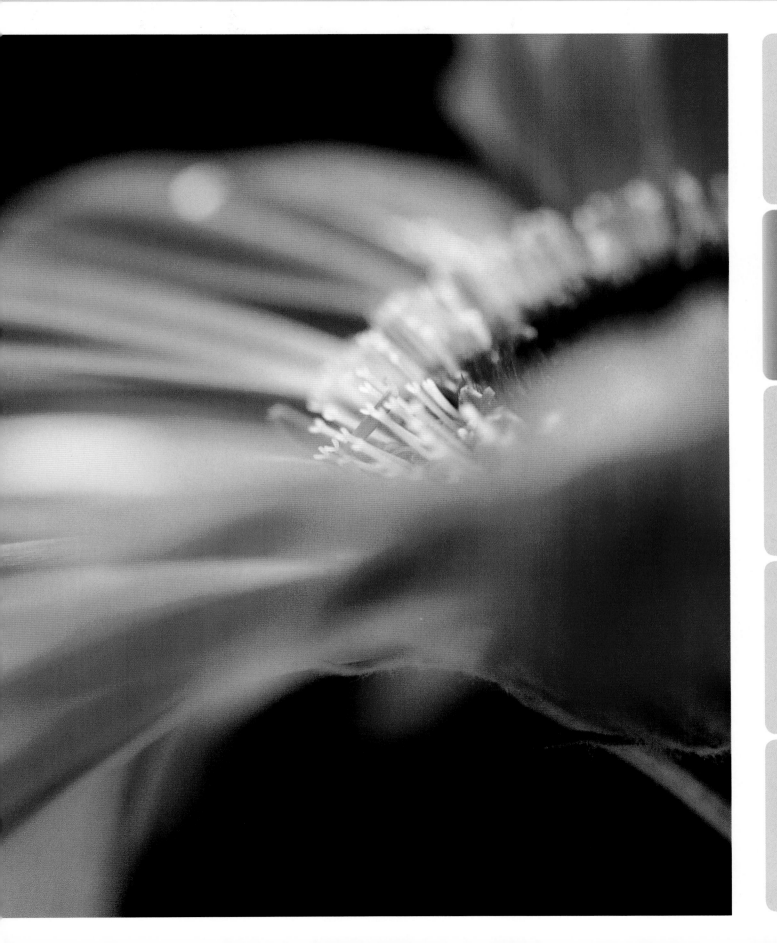

OUTDOOR

INDOOR

LIGHTING

CREATIVE

PHOTOSHOP

H20 just won't do

Water is too thin to use for this technique; as soon as you drop it on a petal it quickly changes form and it's difficult to get a perfect sphere. You need a liquid that's thicker and can hold its droplet form; sugared water is okay, but saline solution for contact lenses, as used here, is ideal.

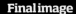

Set-up: Using window light is one of the easiest ways to do this technique. Luckily, it's a cloudy day so the light is really diffused, but I have a reflector at the ready in case the light gets a bit stronger and I need to fill in some shadows. Lining part of the window with black card provides the dark background, but make sure you position the flower so it's well illuminated. Here I raised it a little and placed it about 15cm away from the background.

Final image
Getting the centre of the flower in the picture adds context and the shallow depth-of-field places extra emphasis on the droplet.

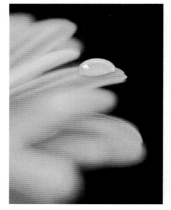

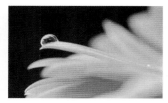

1 Focus on a droplet Use a syringe or eyedropper to carefully place a droplet on the tip of a petal. If you do it in the middle it can get lost among the petals. Set aperture-priority mode and single-point AF, and get as close as you can to the droplet for a frame-filling shot. As there is a very shallow depth-of-field with close-ups, and the droplet curves away from the camera, you may need a mid-aperture like f/6.3 just to get the droplet in focus.

2 Correct exposure By using a black background, your camera may compensate for the dark tones by overexposing the shot. Correct it by dialling in one or two stops of negative exposure compensation.

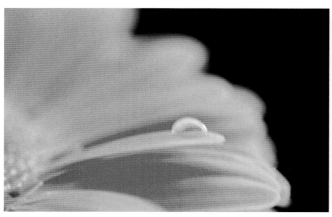

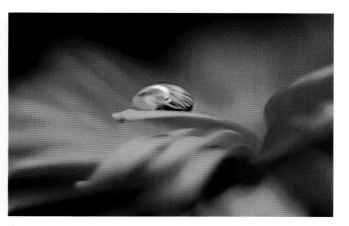

3 Get perfect focus Make sure the point of focus is on the water droplet to render it pin-sharp. If the lens struggles to focus, you may be too close to the flower or there may not be enough contrast. If it's the latter, switch to manual focus. If your shutter speed is slower than 1/30sec, you may find pressing the shutter causes shake. Minimise this risk by using the mirror lock-up facility if available, as well as the self-timer or a remote release.

4 Look for the best highlights As water refracts and reflects light, you may find that the droplet adopts some distracting highlights. Ideally, the highlight should run along the top edge of the droplet with minimal reflections. By backing the droplet against the flower, you should get a reflection of the flower, or at least its colour, in the droplet. Experiment with the positioning of the flower and your camera angle.

OUTDOOR

INDOOR

LIGHTING

CREATIVE

PHOTOSHOP

OUTDOOR

INDOOR

LIGHTING

CREATIVE

PHOTOSHOP

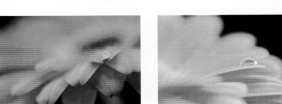
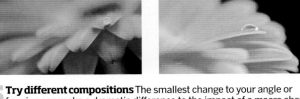
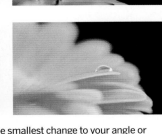
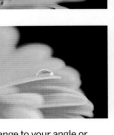
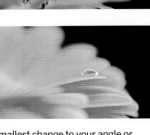

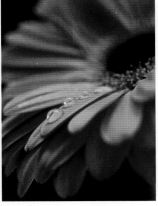
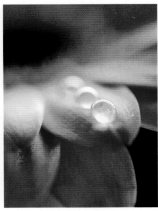

5 Try different compositions The smallest change to your angle or framing can make a dramatic difference to the impact of a macro shot. Try different viewpoints, petals and angles to get the best composition: you may want to skew the camera to get more in the frame. Getting some of the gerbera's centre in the picture can give the picture context, or try a very shallow depth-of-field to blur the petals for an extreme close-up.

6 Add interest Try putting more than one droplet on a petal for more interesting results. It's tricky, but the best pictures are when the droplets are relatively the same size. You could try using a wide aperture and focusing on one of the droplets or use a narrower aperture to get all the beads in focus. The more direct the lighting, the darker the shadows may be, so be ready with a reflector or a piece of white card to fill them in.

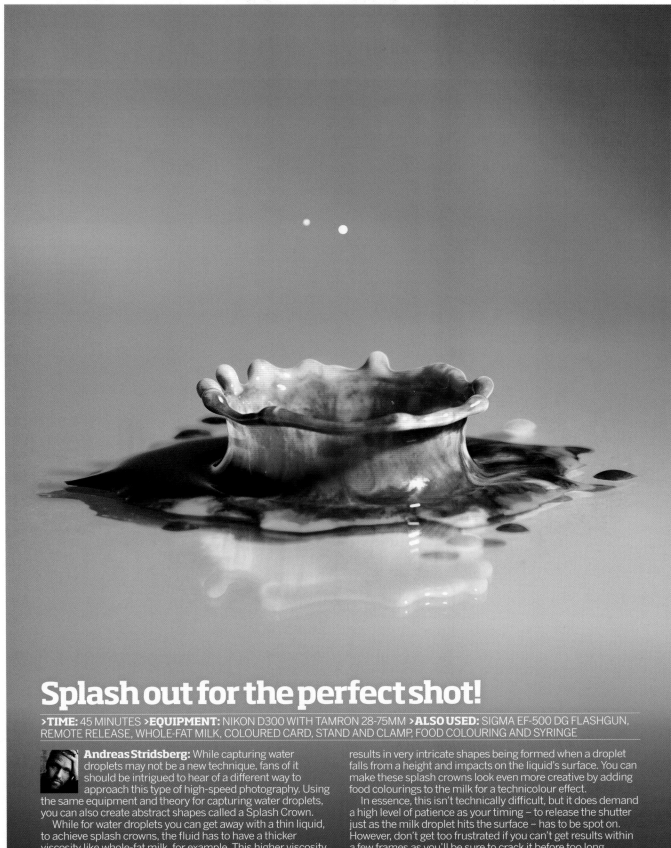

OUTDOOR

INDOOR

LIGHTING

CREATIVE

PHOTOSHOP

Splash out for the perfect shot!

>**TIME:** 45 MINUTES >**EQUIPMENT:** NIKON D300 WITH TAMRON 28-75MM >**ALSO USED:** SIGMA EF-500 DG FLASHGUN, REMOTE RELEASE, WHOLE-FAT MILK, COLOURED CARD, STAND AND CLAMP, FOOD COLOURING AND SYRINGE

Andreas Stridsberg: While capturing water droplets may not be a new technique, fans of it should be intrigued to hear of a different way to approach this type of high-speed photography. Using the same equipment and theory for capturing water droplets, you can also create abstract shapes called a Splash Crown.

While for water droplets you can get away with a thin liquid, to achieve splash crowns, the fluid has to have a thicker viscosity like whole-fat milk, for example. This higher viscosity

results in very intricate shapes being formed when a droplet falls from a height and impacts on the liquid's surface. You can make these splash crowns look even more creative by adding food colourings to the milk for a technicolour effect.

In essence, this isn't technically difficult, but it does demand a high level of patience as your timing – to release the shutter just as the milk droplet hits the surface – has to be spot on. However, don't get too frustrated if you can't get results within a few frames as you'll be sure to crack it before too long.

OUTDOOR

INDOOR

LIGHTING

CREATIVE

PHOTOSHOP

Macro magic

Dedicated macro lenses are perfect for this type of shot as they have a life-size (1:1) reproduction ratio, so the object appears as wide on the sensor as it is in real life, resulting in frame-filling shots. However, if you don't have a macro lens, consider buying a set of close-up filters or extend your zoom to its maximum focal length and move in as close as you can, stopping when the lens can no longer focus.

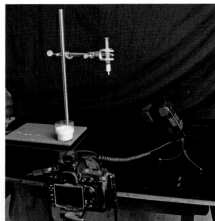

1 Set up With my DSLR secured on a tripod and in position, I place my stand and clamp on a clean black table with a dark sheet as the background. Next, I pour some whole-fat milk into a glass, ready to use as my viscous liquid.

2 Set the flash I position my flashgun side-on, around 10-20cm away from the splash zone, setting the unit to manual mode and adjusting its power to 1/64. The flash needs to trigger while off-camera, so use a corded or wireless trigger.

3 Create a puddle Using the syringe, I create a small puddle of milk on the glass-topped table. This will give my lens something to focus on and also help create a splash later. If your lens is struggling, place a pencil in the milk puddle, establish focus and then switch to manual focus.

4 Dial in camera settings You'll need to adjust your settings depending on how much light is in the room, but a good starting point is 1/125sec at f/8. I also stick with a low ISO rating of 200, but again, you may want to adjust this depending on your set-up.

5 Take a test shot Here's the tricky part. With your remote release in the one hand and the syringe fixed in its clamp (around 30cm above your surface), release a drop of milk and fire the shutter as it lands on the milk puddle you placed in step three. I triggered this shot too early.

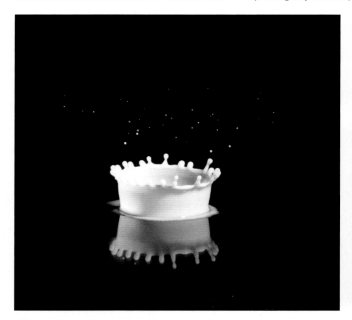

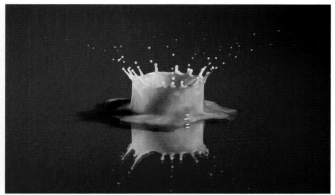

6 Get your timing right With a bit of patience, you'll soon get the hang of it. To maximise your chances, increase your target by adding more milk to the table. After three or four attempts, I finally get it right.

7 Add interest To bring more colour to the shot, I dry my table and then position coloured card under a sheet of glass. I then reapply the milk drop and also add some food colouring. The results are quite dynamic.

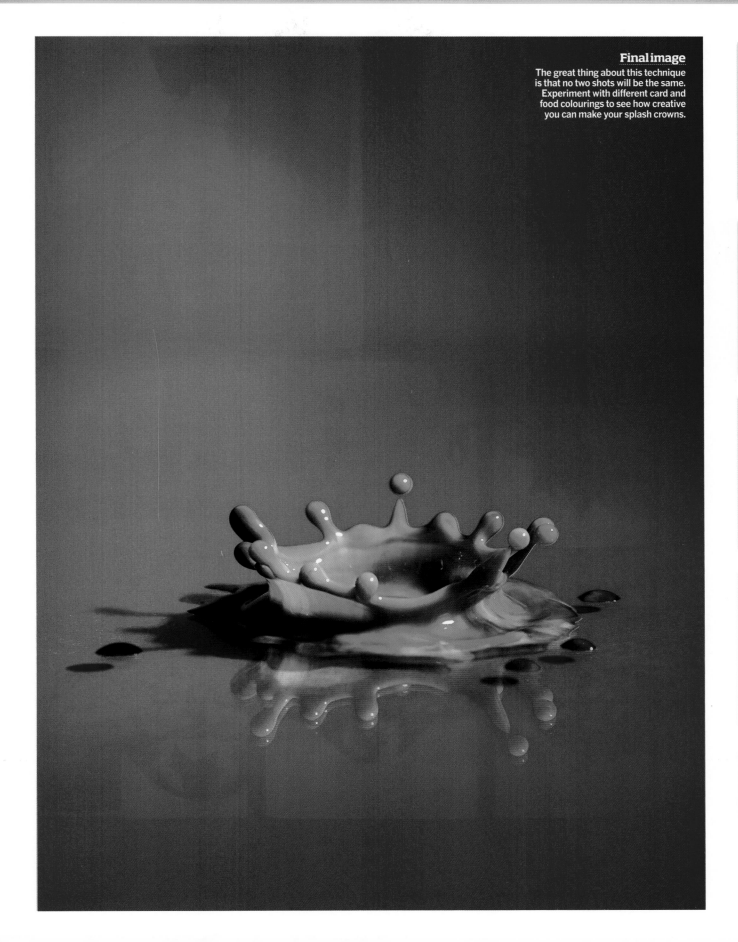

Final image
The great thing about this technique is that no two shots will be the same. Experiment with different card and food colourings to see how creative you can make your splash crowns.

OUTDOOR

INDOOR

LIGHTING

CREATIVE

PHOTOSHOP

Take a closer look at fall foliage

>TIME: ONE HOUR **>EQUIPMENT:** NIKON D300 WITH SIGMA 150MM F/2.8 **>ALSO USED:** BLACK SHEET, PLAMP AND SPRAY

Ross Hoddinott: Autumn colour is spectacular. Every October and November, Mother Nature treats us to a season full of picture potential from landscapes to still-lifes. Leaves are a typical subject to shoot at this time of year, but finding an unusual way to capture them is the test of a creative photographer. We also love water droplets; they're like tiny lenses reflecting miniature, reversed images of objects positioned behind them, which is why we thought we'd try to combine the two.

To capture the leaf in the droplet, a close-up attachment or a macro lens is necessary to get the magnification. Even the slightest camera movement is exaggerated when working at high magnifications, so a tripod is essential and a remote release can be helpful, too. Depth-of-field will also be exceptionally shallow, so the smallest movement of the subject can ruin a shot. Setting up indoors, in a brightly lit room, preferably by a window, means you not only have more control over lighting, background and the leaf's position, but you don't have to fight the wind either. Now, time to pop down to the woods to find a suitable autumnal leaf…

Essential kit

Tripod and head: To get enough depth-of-field to keep the water droplet, twig and refracted image in focus, you need to select a small aperture. This will mean your shutter speed will be slow, therefore a tripod is essential to keep your images shake-free – it also allows you to position your point of focus precisely. I favour a geared tripod head for close-ups as it allows me to make very fine adjustments to the composition – something that's often necessary when shooting frame-filling images.

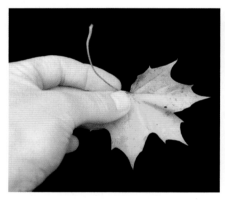

1 Pick your subject I opt for a yellow maple leaf as they have a great colour in autumn and a very distinctive, attractive shape. Hang a black background like a piece of black paper or cloth, and attach your subject to it upside down so it appears the right way round when it's refracted in the droplet.

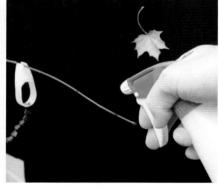

2 Set up I use a colourful dogwood twig to suspend the water droplet from. The warm red colour adds to the autumnal feel of the image, but you don't have to use a dogwood twig: any twig or grass will do. Using a clamp, hold the twig in position around 30cm in front of the leaf and background.

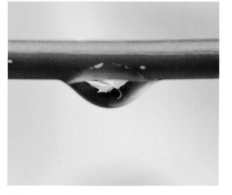

3 Apply the droplet Once the twig is parallel, using a spray bottle, spray the twig until small droplets form. Next, focus on the refracted image in the droplet: you may find manual focus is easier and more precise than autofocus. Make adjustments to the height of your tripod if you can't get the entire subject in the droplet.

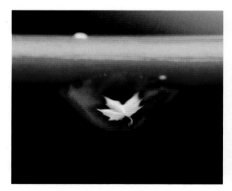

4 Make sure it's central To get the leaf central in the droplet, carefully tweak the camera's position, adjusting the height of the tripod slightly. Just a few millimetres can make all the difference. Finally, with the leaf central in the drop, take another shot and in aperture-priority mode, try different f/stops. My first aperture of f/5.6 means depth-of-field is too shallow.

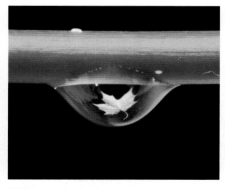

5 Fix the f/stop If you need to, stop the lens down to generate a much larger depth-of-field. We found f/16 sufficient. The corresponding shutter speed will be a lot slower, so use a remote release and the camera's mirror lock-up facility to reduce any chance of camera shake. The result should be stronger, with a good level of sharpness throughout the subject.

6 Clean up The image is simple, yet striking. However, when shooting in close-up, the tiniest imperfections and marks appear more obvious and can be very distracting. Open the image in Photoshop and, using a combination of the Healing Brush Tool and Clone Tool, zoom in to the image and tidy up the pixels to produce a cleaner, more attractive final picture.

OUTDOOR

INDOOR

LIGHTING

CREATIVE

PHOTOSHOP

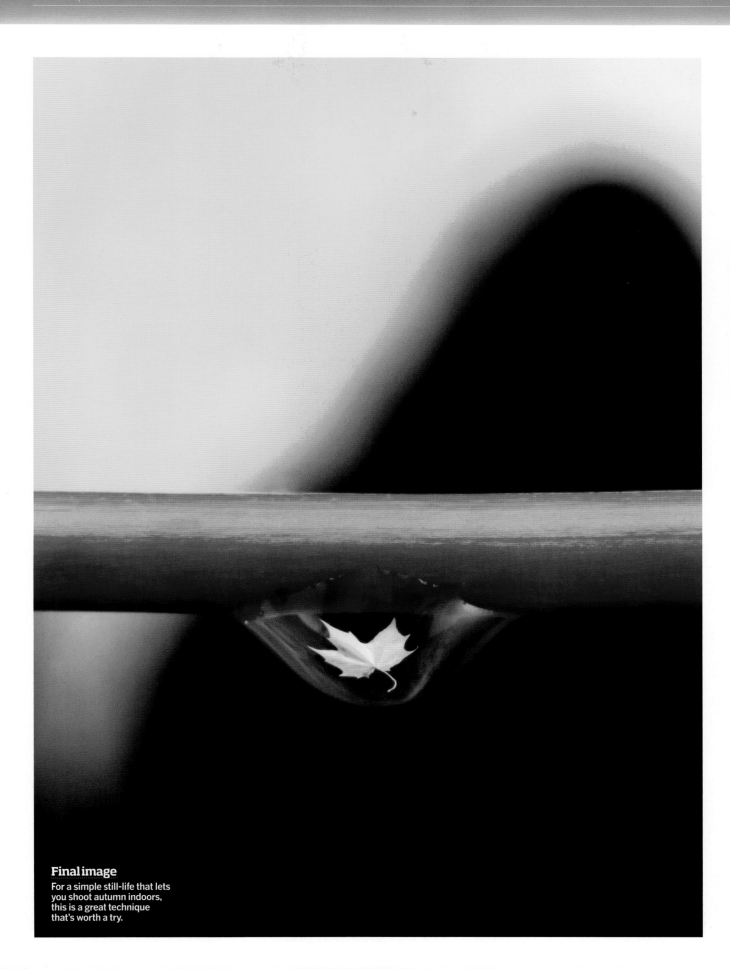

Final image
For a simple still-life that lets
you shoot autumn indoors,
this is a great technique
that's worth a try.

OUTDOOR

INDOOR

LIGHTING

CREATIVE

PHOTOSHOP

Master the art of selective focusing

>TIME: 30 MINUTES **>EQUIPMENT:** NIKON D300s WITH NIKKOR 50MM F/1.4G **>ALSO USED:** REFLECTOR

Caroline Wilkinson: Part of the beauty of digital SLRs and CSCs is arguably the ability to control depth-of-field and determine what areas of a scene you want to appear in focus. You do this by adjusting your camera's aperture (the wider the aperture, the shallower the depth-of-field) and by manually selecting your autofocus point. Unless you take control of the AF system and select an individual point, the camera will automatically use whichever AF point(s) it decides is best, normally to focus on the subject closest to you. By being selective about what you focus on and how much depth-of-field you use, you can greatly improve your images, especially if it's a busy scene and you want to isolate a point of interest. It's a useful, aesthetically pleasing technique when done right, but very unforgiving if done wrong. If you use a wide aperture and your focusing isn't pin-point, the result can look awful.

Selective focus can be used almost anywhere and on anything to highlight the area of interest, by blurring the surroundings. For portraits, you could use this technique to focus on the eyes, but that's rather conventional. Instead, add meaning, context and creativity by making something else the point of interest and the person a secondary feature. Both elements have to work together for it to become a quality portrait, so you need to find the correct aperture that doesn't blur the background (ie the person) out of recognition, but enough depth-of-field to isolate the focal point from the background. It's a tricky balance.

The point of interest doesn't have to be the closest thing to the camera either, but, on this

Camera settings

(Av) **Exposure:** Set your camera to aperture-priority mode so that you can concentrate on finding the right aperture for the scene, letting the camera take care of the shutter speed. If you're handholding the camera, however, be careful that the shutter speed doesn't get too slow, causing camera shake. If this happens, increase the ISO rating and, if possible, place the camera on a tripod for extra stability.

☐ AF-S **Focusing:** Set your camera to single-point AF and One-Shot (AF-S/S-AF) mode so that when you partly depress the shutter release, the lens locks focus and remains locked on the subject until you release the shutter. As long as your subject stays still and you don't move forward or backwards, you'll get a sharp result. As default, the centre focus point is usually activated. It's up to you to use it, focus lock and recompose (see panel) or select a point that's over the area of the frame you aim to keep sharp.

occasion, it suited the image. Hands are very telling, especially those of an elderly person, and can be very photogenic subjects, with great detail and tonal range in the wrinkles and lines. Rarely are they made the focal point of an image, though. Here you can see that, by focusing on the hands with a wide aperture, using a standard 50mm lens and getting close to the subject, it's made them the feature and the person secondary. It's a far more creative and interesting image than if a small aperture was used to give front-to-back sharpness.

Focusing techniques

If your point of focus is off-centre, there are two ways you can handle it. As the central focusing point is the most sensitive, some photographers prefer to place it over the subject, lock focus and then recompose – a technique known as focus-lock. However, if you or your subject move slightly, they'll be rendered out of focus, unless you repeat the process. The alternative is to manually select the autofocus point that covers the point of interest in the scene. With this technique, you can concentrate on the aperture selection as you won't need to recompose the frame once you've set the AF point over the area of the subject you want sharp. Whichever method you use, ensure your camera's set to single-point AF and One-Shot mode.

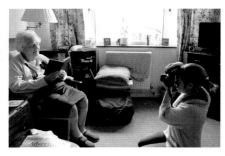

Here, the subject was placed by a window to create soft contrast with side-lighting. If it's too bright, a net curtain will diffuse the sunlight, or use a reflector on the other side of your subject to fill in the shadows. Set your camera to its widest aperture and stop down until you find the right balance for adequate depth-of-field.

X **Depth-of-field:** This is an average snapshot: taken at f/6.3 there's good depth-of-field, making it unclear what is meant to be the focal point. Putting more thought into the composition can also help emphasise the real focal point – in this case, the hands.

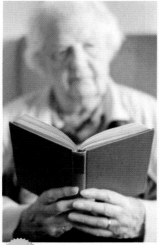

X **Focusing:** By opening the aperture to f/2.8 and distancing the book from the subject, depth-of-field is shallower, but it means the plane of focus is much thinner, too. Here, the focus point is on the book, resulting in the hands appearing unsharp.

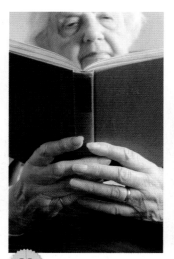

X **Subject distance:** A change of viewpoint makes the picture more interesting but at f/5.6 there's still too much depth-of-field. Alter the aperture, or reduce depth-of-field by putting more distance between the subject and the background.

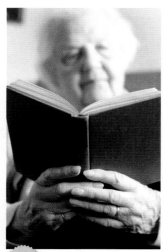

X **Background clutter:** Before you press the shutter, remember to check the background for anything that can distract the eye from the subject. Adjust the viewpoint to exclude any unwanted elements in the frame; in this case, the picture on the wall.

OUTDOOR

INDOOR

LIGHTING

CREATIVE

PHOTOSHOP

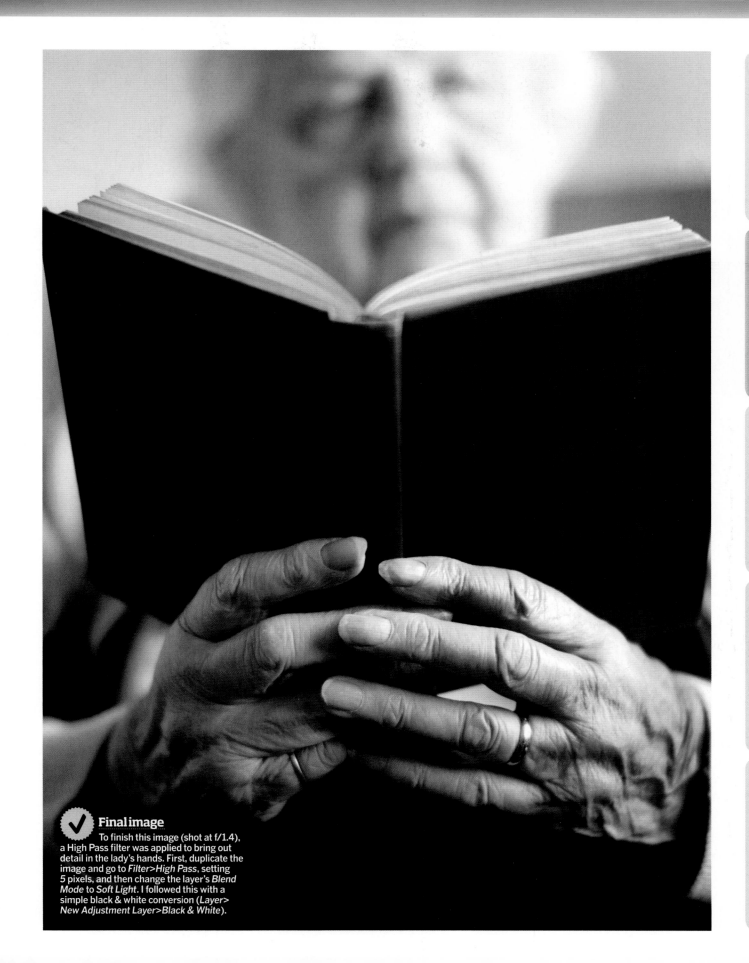

Final image
To finish this image (shot at f/1.4),
a High Pass filter was applied to bring out
detail in the lady's hands. First, duplicate the
image and go to *Filter>High Pass*, setting
5 pixels, and then change the layer's *Blend
Mode* to *Soft Light*. I followed this with a
simple black & white conversion (*Layer>
New Adjustment Layer>Black & White*).

OUTDOOR

INDOOR

LIGHTING

CREATIVE

PHOTOSHOP

OUTDOOR

INDOOR

LIGHTING

CREATIVE

PHOTOSHOP

Play with shadows

>**TIME:** 40 MINUTES >**EQUIPMENT:** CANON EOS 500D WITH A TOKINA 100MM MACRO >**ALSO USED:** TABLE LAMP, COLOURED CARD, LEGO BRICKS, TOY DINOSAUR & PHOTOSHOP

Caroline Wilkinson: If you have children, especially a boy, chances are they have piles of Lego lying around their room and about as many miniature toys to match. This technique was once used in a Lego advert, but is so easy to do and the kids will love you for it too as they get some fun pictures out the deal. Alternatively, if they're not willing to part with their toys for a few minutes, we recommend a bit of bribery.

If you're without children, nip down to your local toy store and invest in a box of Lego. The idea for this technique is to minimise any Photoshop work, or at least to make it easier, by being especially careful of how you light the separate components for the image. And if you fancy getting a bit more creative, why not try different toys like a plane or a ship – or go one step further and change the shadow of a life-size prop like a car or a person?

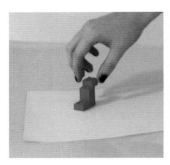

1 Set up Position the Lego dinosaur in the top corner of the camera's frame to leave plenty of room for the dinosaur's shadow. Attach the camera to a tripod to keep the composition and camera angle the same for every shot. This also means you don't need to worry as much about the shutter speed.

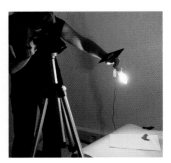

2 Take a test shot Using aperture-priority mode, take a couple of test shots of the Lego piece at f/4, trying to avoid casting any shadow on the card by moving the light over the top of the model. By minimising any shadow at this point, you'll find you save yourself work in Photoshop later.

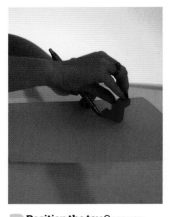

3 Position the toy Once you have the shot, mark the corners of the Lego on the card as markers for placing the toy. The toy is larger than the Lego, so when I position it, I have to move the camera higher to fit the whole toy in the frame, trying to keep it in relatively the same spot and angle as the Lego was.

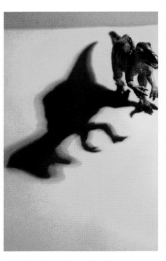

4 Find the best shadow For the shadow shot, lower the light and place it side-on to the toy to cast a strong shadow. This is tricky, as to get the right shape and size of the shadow, you have to play with the angle and distance of the light from the toy. You may find a remote release helps here if you have to hold the light.

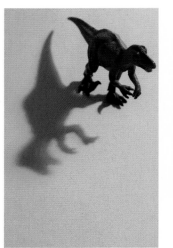

5 Select the shadow Open the best shadow shot in Photoshop and select the *Magic Wand Tool*. This will select any area of the same tone dependent on the tolerance level, so, as you only want to select the shadow, set a tolerance of about *10* and make small selections by clicking areas while holding *Alt*.

6 Feather the edges Before moving the shadow on to the Lego image, you need to soften the edges of the shadow. To do this, click *Select>Modify>Feather* and set it to *30px*. Now open the Lego image and with the *Move Tool* selected, click on the shadow selection and drag it on top of the other image to create a new layer.

7 Merge the images The shadow's feet now need to be erased to make the join look seamless. To do this, go to *Layer>Layer Mask>Reveal All* and then select the *Paint Brush Tool*, and with a soft brush set to *White*, erase the excess shadow. Change the brush to *Black* if you want to bring back parts of the shadow.

OUTDOOR

INDOOR

LIGHTING

CREATIVE

PHOTOSHOP

Final image

To finish up the composite, add a little blur to the shadow. Select the shadow layer, go to *Filter>Blur>Gaussian Blur* and move the slider to a point that suits your picture. Now go to *Layer>Flatten Image*: you're done!

Clock watching

>TIME: 45 MINUTES **>EQUIPMENT:** NIKON D300 WITH SIGMA 60MM MACRO
>ALSO USED: DANDELION, GLASS, BLACK BACKGROUND, LAMP & PHOTOSHOP CS

Caroline Wilkinson: During the spring, and early summer, dandelion clocks transform overnight from unsightly yellow weeds into delicate, white globular heads with tiny parachute seeds that look incredible magnified. Opt for a macro lens with 1:1 reproduction and/or use extension tubes to isolate a single seed or fill the frame with a macro close-up for two of many possibilities.

By varying the background, lighting and introducing colour, there are many different ways to shoot dandelion clocks. As the clock head itself is grey, its details can be barely visible against a light-coloured background, so a dark backdrop may be best. Silhouetting the clock against a backlit sheet of white paper, however, can deliver impactful pictures, too. Here, though, I refrain from black & white, and experiment with White Balance settings and colour adjustments to see what effects can be achieved.

Setting up & camera settings
The most difficult part of this technique is finding a decent dandelion clock – one with a relatively straight stem and full head of seeds – then getting it indoors without damaging it. Take a windbreak, such as a stiff sheet of card or a box, to hold over the clock as you carry it home. For this set-up, I position a black background a foot or so away from the dandelion clock, which is taped to stand straight in a glass. I then compose my picture, with the camera on a tripod for extra stability and consistent composition, and work on perfecting the lighting, focusing and depth-of-field. I set my camera to aperture-priority mode and dial f/8 – a good starting point as depth-of-field is always limited with macro photography. You may need to stop down to as small as f/18-f/22, depending on your magnification and proximity to the subject, but try to find a balance between sufficient depth-of-field and an attractive fall off in focus. I set the White

Balance to Tungsten and focusing to single-point AF. As light levels will be low, you may need to switch to manual focusing to stop the lens from hunting and to ensure pin-sharp results.

Lighting & White Balance
Try experimenting with different light sources and White Balance settings. For this technique, I try a household lamp 2ft to the right of the subject, the LED flashlight on my iPhone held just out of frame and at a 45° angle to the subject, and finally a flashgun bounced off the ceiling. You could also invest in a dedicated macro flash system like Hama's LED ringlight. Each gave different results, varying in colour and contrast, so I greatly advise having a play. For this tutorial, all the images were captured with a halogen household lamp as the light source.

Final image
Using White Balance and adjusting colours using Color Balance can create beautiful results like this.

White Balance effects
You can change the WB in-camera or, for flexibility, shoot in Raw with the WB set to Auto and try changing the colour temperature using the White Balance Tool in your Raw conversion software.

Finishing in Photoshop

1 Process the Raw file Open your image in Photoshop. If you've shot in Raw, first adjust the White Balance as necessary. I'm happy with the blue tinge Tungsten has given me in-camera so I leave it alone. If needed, adjust the *Exposure* and *Contrast* slider and then *Clarity*.

2 Use Color Balance Use the *Crop Tool* to crop your background. Then add a Color Balance adjustment layer (*Layer>New Adjustment Layer>Color Balance...*) and adjust the sliders. I adjust the Blue and Cyan sliders for the Highlights and then Midtones.

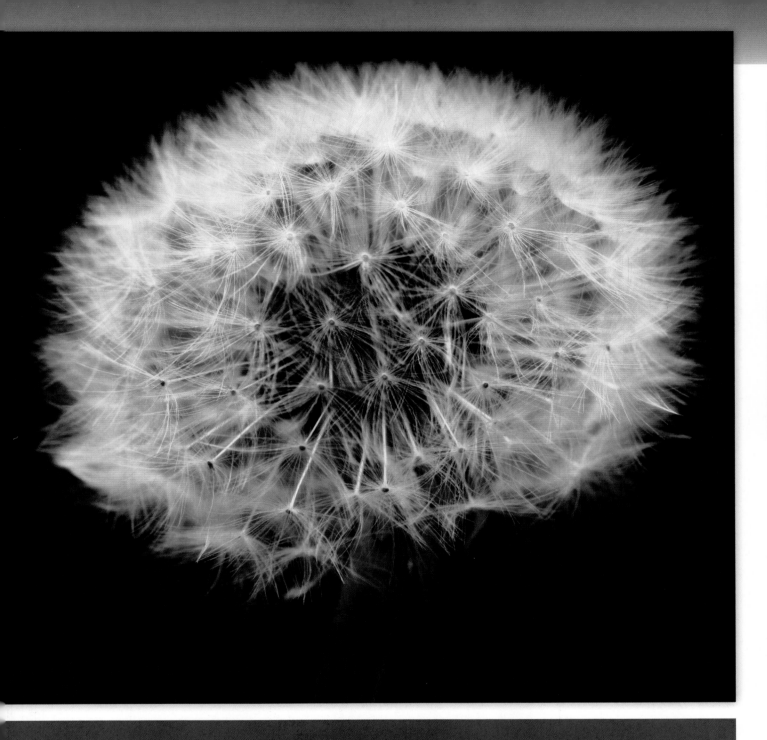

3 Make it glow To make the seeds look luminous, select the image layer and the adjustment layer, then simultaneously click *Cmd*, *Alt*, *Shift* and *E* to create a new layer. Now go to *Filter>Distort>Diffuse Glow*, set the *Amount* to *1* and *Clear Amount* to *8*.

4 Add Levels You may find the background has taken on a blue glow from where the light and WB has affected it. Try adding a *Levels* adjustment layer and darkening the *Shadows* and *Midtones* – don't worry at the moment about the effect it has on the dandelion.

5 Mask off the dandelion Click on the adjustment layer's *Layer Mask* and using the *Brush Tool*, set to a large, soft brush, and the *Foreground Color* set to *Black*, 'paint' over the dandelion to hide the adjustment. You can reduce the brush's *Opacity* to modify its effect.

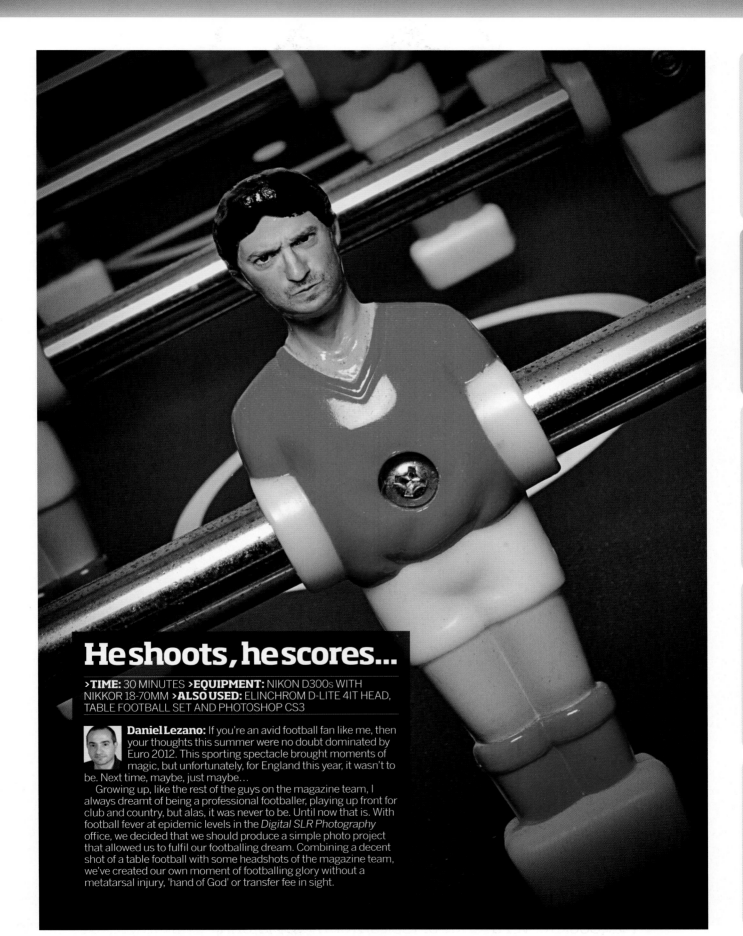

He shoots, he scores...

>TIME: 30 MINUTES **>EQUIPMENT:** NIKON D300s WITH NIKKOR 18-70MM **>ALSO USED:** ELINCHROM D-LITE 4IT HEAD, TABLE FOOTBALL SET AND PHOTOSHOP CS3

Daniel Lezano: If you're an avid football fan like me, then your thoughts this summer were no doubt dominated by Euro 2012. This sporting spectacle brought moments of magic, but unfortunately, for England this year, it wasn't to be. Next time, maybe, just maybe...

Growing up, like the rest of the guys on the magazine team, I always dreamt of being a professional footballer, playing up front for club and country, but alas, it was never to be. Until now that is. With football fever at epidemic levels in the *Digital SLR Photography* office, we decided that we should produce a simple photo project that allowed us to fulfil our footballing dream. Combining a decent shot of a table football with some headshots of the magazine team, we've created our own moment of footballing glory without a metatarsal injury, 'hand of God' or transfer fee in sight.

OUTDOOR

INDOOR

LIGHTING

CREATIVE

PHOTOSHOP

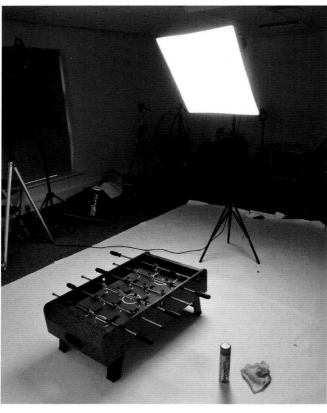

Getting started

This is quite a simple shoot, but there are a few things you need to consider and prepare for. The first is that as you're combining headshots with the table football bodies, you need to ensure that the lighting and colour balance are as similar as possible. So, whether you decide to use ambient light or studioflash, be consistent

with how your subjects are lit. The main factor to think about for the table football shot is how much depth-of-field you require – choose a shallow amount to highlight a particular row or player, or use a smaller aperture to include more than one row in focus. With the headshots, shoot a series with their heads at slightly different angles, so that you can best match them to the figures.

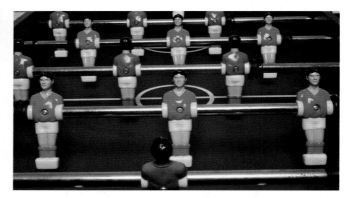

1 Set up lights Find a suitable location for your table football. If you're shooting in ambient light, try near a set of patio doors where there is bright, even light. I'm shooting in our studio and set up a single studioflash head with softbox, raised high and angled downwards at 45°, to evenly light the pitch. I'll be shooting from between the table and light.

2 First team trials I adjust the power of the lights until they provide the correct level of illumination at f/22, as I want to have as many rows of players in focus as possible. Rather than focus on the face of the nearest row of red players, I focus on the rear of the blue player near the centre circle, as depth-of-field extends in both directions from the point of focus.

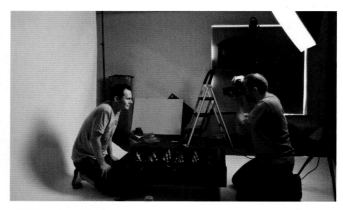

3 Perfect the team formation The previous result was an okay first attempt, but needs improving. I don't feel the composition is strong enough, so I move closer to the table and adopt a lower angle. I zoom in to compress perspective and the image takes on a far stronger composition.

4 Team headshots Now the fun part, time to shoot your teammates. Ask them to sit at the opposite end of the table to ensure that the lighting on their faces match the table. I ask everyone to pull a variety of expressions and the girls to pull back their hair to expose their faces.

✓ **Make your team**
This is a fun tutorial to shoot, so involve colleagues and friends. We decided to pull a number of daft faces and it proved to be great fun

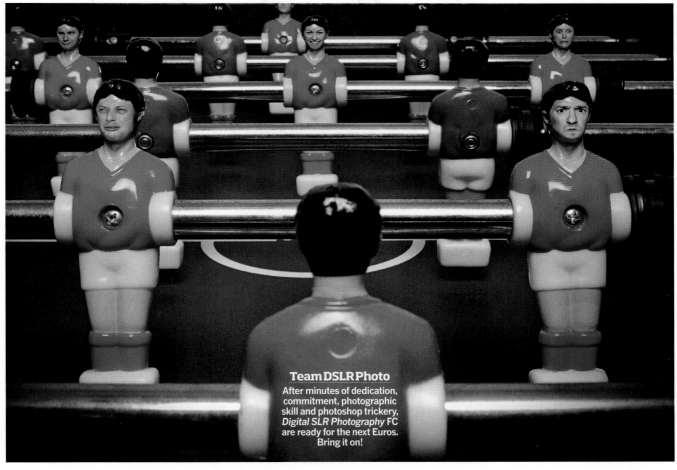

Team DSLR Photo
After minutes of dedication, commitment, photographic skill and photoshop trickery, *Digital SLR Photography* FC are ready for the next Euros. Bring it on!

5 **Cut out headshots** Look through all the headshots you've taken for the best expressions and angles that will work on each of the plastic players. Next, open the first headshot – the captain of the team (me, of course!). Make a very rough selection using the *Polygonal Lasso Tool*, then apply a feather of around *5px* (*Select>Modify>Feather)*. Next go to *Edit>Cut*, which removes the selected area, and copies it to the pasteboard. Cutting is preferred to copying in this instance, as I can clearly see the area taken.

6 **Paste in headshots** With the table shot open, go to *Edit>Paste*, placing the copied face onto a new layer. Go to *Edit>Free Transform* and resize the face while holding *Shift* to keep it in proportion, you may need to rotate it a little, too. When the size of the head looks about right, double-click to apply. Now, with the *Eraser Tool* set to a small brush with a soft edge and an *Opacity* of no more than *20%*, I begin to delete the outside edge of my face, working the two images together.

7 **Adjust skin tones** You need to get the skin tones to match, but first isolate the eyes so they stay white. Select them using the *Polygonal Lasso Tool*, holding *Shift* to make the second selection. Alter the *Feather* to *4px*, then go to *Select>Inverse*, reversing the selections. Next, go to *Image>Adjustments>Color Balance* and move the sliders until the skin tones match. Remember, this is a fun project, so the end results don't need to be overly accurate – the wackier the better!

OUTDOOR

INDOOR

LIGHTING

CREATIVE

PHOTOSHOP

OUTDOOR

INDOOR

LIGHTING

CREATIVE

PHOTOSHOP

Backlighting shells

>TIME: 30 MINUTES **>EQUIPMENT:** CANON EOS 40D WITH CANON 60MM F/2.8 MACRO **>ALSO USED:** TRIPOD, REMOTE RELEASE, PAPER, SHELLS, SHEET OF GLASS AND DESK LAMP

Rob Abram: Is it raining outside? All the natural light disappeared before you've got home from work? Or simply lost for creative ideas? Well, it's at times like these when a lightbox can come to your aid. Not everyone has the luxury of owning one, so this photo project is for those who want to give it a go but lack this useful accessory. We love a lightbox for its ability to make a semi-translucent subject, like sliced fruit, a flower or a shell, glow from within and reveal detail that would otherwise be hidden.

To make your own lightbox, all you need is a sheet of glass from a picture frame, a desk lamp, and something to support the glass at the edges. For this still-life I'm using a macro lens (a standard zoom or a close-up filter is suitable, too) to photograph a shell bought from a local craft store. A tripod and remote release help reduce shake and are recommended as they allow you to concentrate on getting the depth-of-field right without having to worry about shutter speed. All you have to do is find a shell you like and shoot it from every angle. The more extreme-looking the shell, the better!

1 Set up Begin by making a platform for the shell to sit on, with enough room underneath to fit a small desk lamp. To do this, I support the glass from a clip-frame with some food tins. I then put a sheet of white paper over the glass to diffuse the light and add some background texture.

2 Take a test shot With the camera mounted on a tripod, set it to aperture-priority mode, the lowest ISO rating, and set the lens to its maximum aperture (for me, that's f/2.8) for a shallow depth-of-field. Place the shell in the middle of the paper, and take a test shot in Raw.

3 Take two The result is okay, but lacks impact as the shell is too dense to let the light shine through. I choose a more translucent shell and, keeping f/2.8 to throw the paper out of focus, take another shot. This time the shot is more ethereal, with more light being let through.

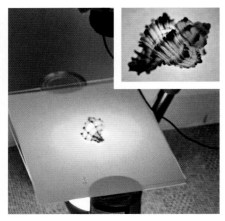

4 Adjust lighting To enhance the effect, reduce the light's diffusion by cutting a hole in the paper so the shell is lit brightly through the glass, while retaining the texture of the paper for added interest. Use manual focus and LiveView for more precise control.

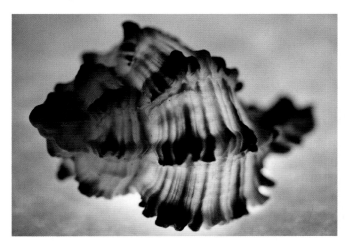

5 Perfect the composition Once you're happy with the settings, concentrate on positioning the shell for a stronger composition. Using a wide aperture (f/2.8) gives a more mystical effect, while a smaller aperture (f/8) yields more detail. Try a variety of shells and background papers until you're happy with the results!

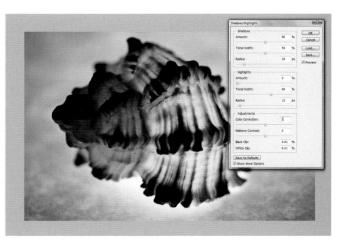

6 Apply a Blending Mode and tweak shadows While this shot looks okay, it could do with a contrast boost. Open the image in Photoshop and duplicate the background layer (*Layer>Duplicate*), then apply a *Soft Light* Blend Mode. To improve the shadow detail, click *Image> Adjustments>Shadow/Highlights* and tweak appropriately.

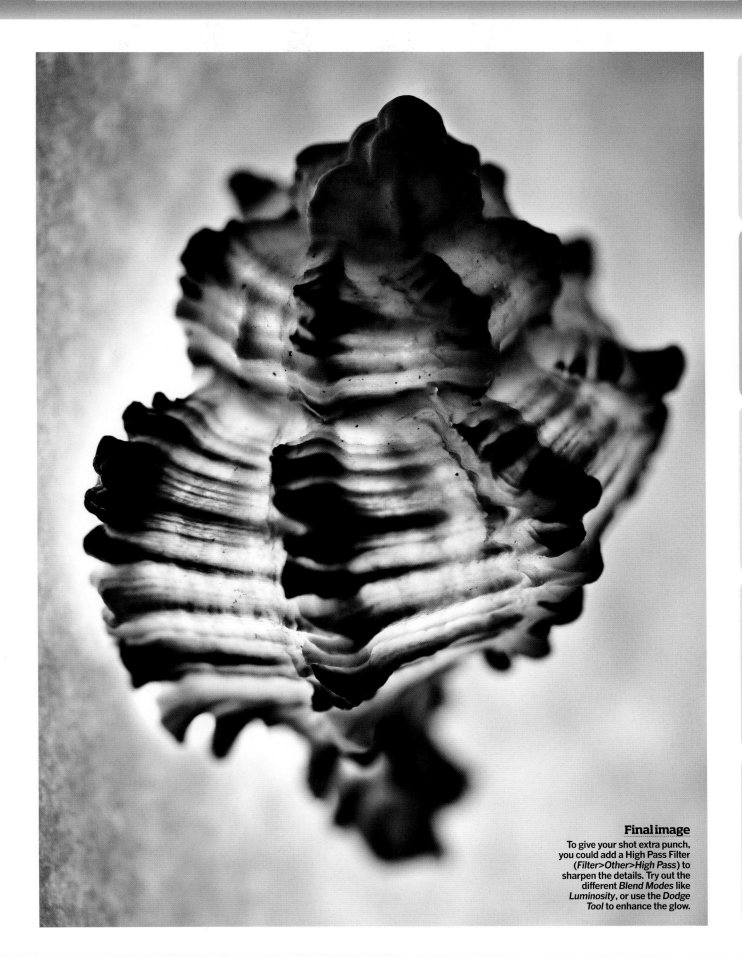

Final image
To give your shot extra punch, you could add a High Pass Filter (*Filter>Other>High Pass*) to sharpen the details. Try out the different *Blend Modes* like *Luminosity*, or use the *Dodge Tool* to enhance the glow.

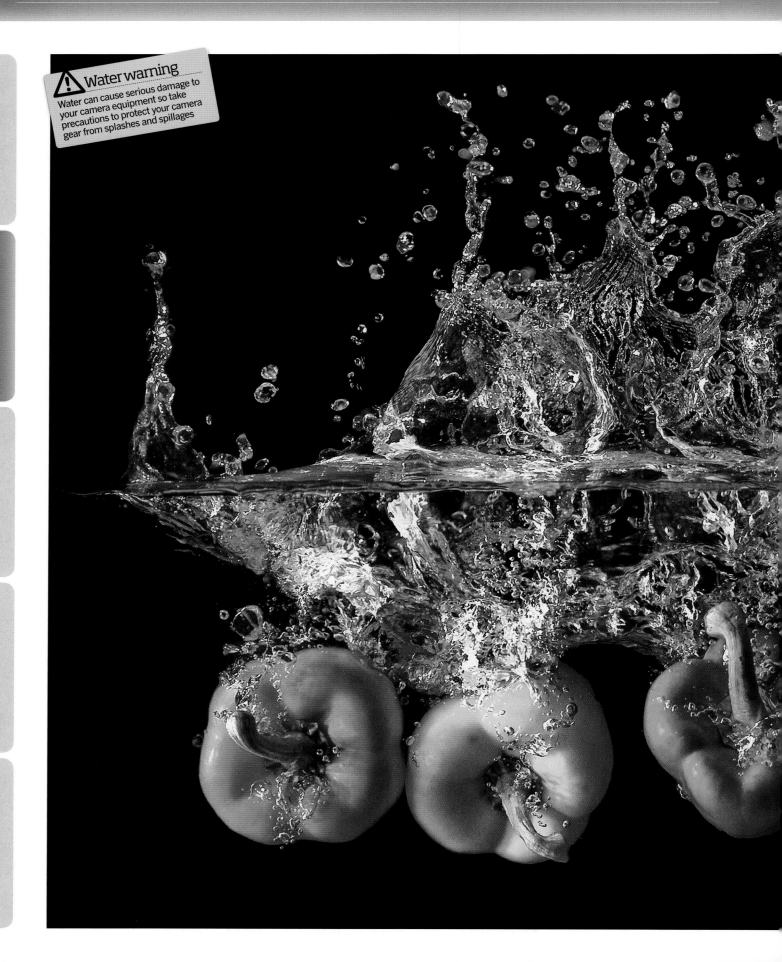

OUTDOOR

INDOOR

LIGHTING

CREATIVE

PHOTOSHOP

⚠ Water warning
Water can cause serious damage to
your camera equipment so take
precautions to protect your camera
gear from splashes and spillages

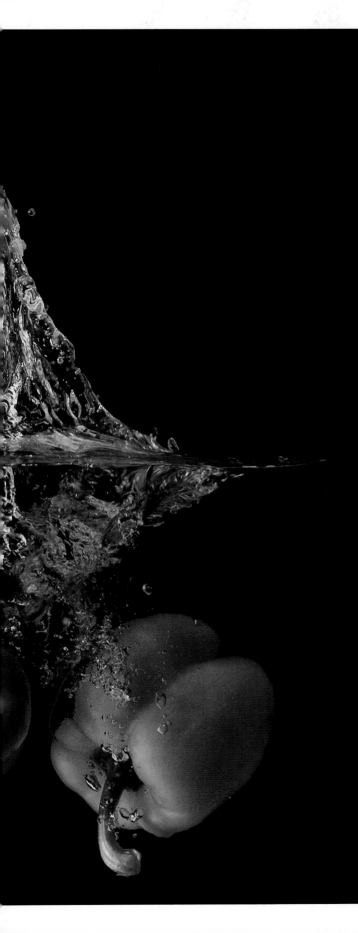

OUTDOOR

INDOOR

LIGHTING

CREATIVE

PHOTOSHOP

Make a splash!

>TIME: 45 MINUTES **>EQUIPMENT:** CANON EOS 7D WITH EF 24-105MM F/4L IS **>ALSO USED:** TRIPOD, REMOTE RELEASE, TWO FLASHGUNS WITH STANDS, SPLASH TRAY, GLASS TANK, BLACK BACKGROUND, PAPER SNOOT, TWO PIECES OF WHITE CARD, A RULER AND PEPPERS

Dave Ovenden: A few years ago, I came across a photograph of a strawberry falling into water, captured using high-speed flash, which amazed me enough to make me want to try the technique myself. The photographer had used a white background but, when I tried to recreate it, I found that a darker backdrop enhanced the details of the splash even more. I also found that other types of food were more photogenic. What's great about this flash technique is that no two shots are ever the same, so you're constantly experimenting and aiming for a better image. To really test your skills, you could opt to drop several items into the water at once for an even more dynamic picture.

OUTDOOR

INDOOR

LIGHTING

CREATIVE

PHOTOSHOP

Equipment: Apart from my camera and flashguns, a lot of the kit needed to make this shot can be found lying around the house. If you don't have the larger bulldog clamps, standard clothes pegs can be used instead.

High-speed flash sync

High-speed sync (HSS) is a useful function that allows flash to be used at any shutter speed above your DSLR's normal sync speed. However, although there are flashguns for each brand that boast the high-speed sync functions, the feature is usually found in the higher-end models, so check before you buy. Models that do feature HSS include the Pentax AF540FGZ, Nikon SB-900, Canon 580EXII, Olympus FL-50R and Sony HVL-F58AM.

1 Set up Place a glass tank onto a splash tray and insert a waterproof black background, then fill the tank two-thirds full of clean water. If I was outside, I'd fill the tank to the top as it wouldn't matter if the water overflowed. Next, clip a piece of white card to one side of the tank, and another at a 45° angle to act as a reflector for the flash.

2 Adjust camera settings Position your tripod in front of the tank, the viewfinder level with the water line. Select aperture-priority mode, dial in f/5.6 (ISO 250) and half press the shutter to take a meter reading. I then switch to manual and increase the shutter speed by six stops (eg 1/30sec to 1/1000sec), so only the flash output illuminates the image.

F5.6 ISO 250

-3..2..1..0..1..2:3

Av

RAW+L ONE SHOT

[65]

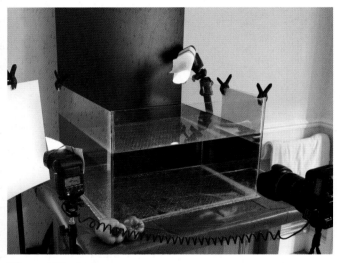

3 Set up the flashes Position a flash towards the white card on the left, which will act as a reflector, and attach a small piece of card to the right side of the flash to prevent light from directly hitting the glass or background. Set the flash to E-TTL and high-speed sync mode and Master. Place a second flashgun with a makeshift paper snoot (again, set to high-speed sync) at the rear of the tank and angle it towards where you plan to drop the pepper in the water. Set it to Slave mode so that it's triggered by the master flash. Next, hold a ruler in the water where you expect the peppers to fall, and use manual focusing to pre-focus on the area.

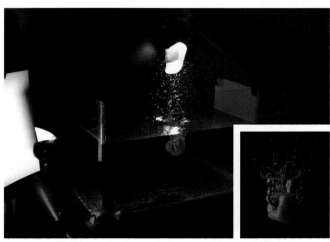

4 Take a test shot Drop the pepper and trigger the shutter via a remote release. Try to catch the pepper just below the surface. On viewing my result, there's not enough light, so I first move the master flash closer to the reflector, and the reflector closer to the tank. If your image is too bright, do the reverse. It will take a bit of trial and error to get it right.

5 Adjust settings Once you've got a good shot with great splash detail, open the file in Adobe Camera Raw and adjust the Exposure as needed. I increase the **Exposure** by +1, **Blacks** to +7 and decrease the **Contrast** to -19. To get rid of unwanted splashes, select the **Brush Tool** and, holding down **Alt**, take a selection from the background and paint over the droplets.

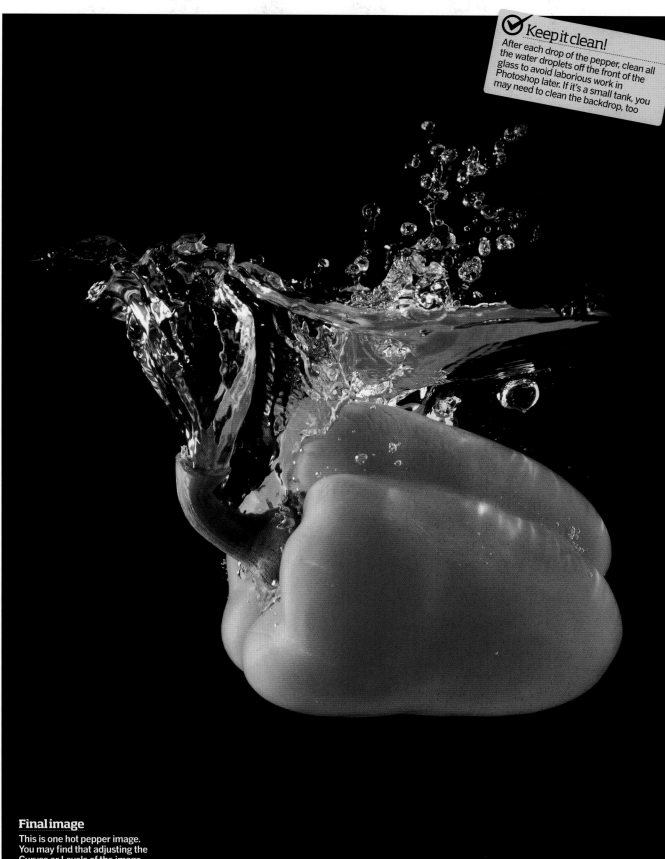

Keep it clean!
After each drop of the pepper, clean all the water droplets off the front of the glass to avoid laborious work in Photoshop later. If it's a small tank, you may need to clean the backdrop, too

Final image
This is one hot pepper image.
You may find that adjusting the
Curves or Levels of the image
will give it extra punch, too.

OUTDOOR

INDOOR

LIGHTING

CREATIVE

PHOTOSHOP

Lord of the rings

>**TIME:** 30 MINUTES >**EQUIPMENT:** CANON EOS 550D WITH CANON EF 28-70MM AND TRIPOD

Daniel Lezano: One of the easiest in-camera creative effects to try is the zoom burst, which involves you changing the focal length of the lens – in other words, turning the zoom ring – during a long exposure. This can lead to amazing results as the image captures the effects of the 'zooming' motion. Look for subjects with lots of contrast and colour, such as stained-glass windows, fairground rides and neon signs, or try shooting through tree branches. While it's possible to handhold the camera, you'll produce far smoother zoom effects if you use a tripod. Not having to hold the camera also makes it much easier for you to recompose the scene should you not be happy after reviewing the images. You'll also find it easier to zoom the lens smoothly and make any necessary adjustments to the camera settings. You can use pretty much any zoom lens, but a standard zoom that covers from wide-angle through to short telephoto is the best choice.

Setting up your camera

M Set your camera to manual mode so you can control the aperture and shutter speed. The exposure time needs to be long enough to let you capture an effective zoom burst, but not too long that you finish zooming the lens too early as this can overexpose the image. Start with an exposure around 0.5 seconds, then extend it to one second or more if needed. Use a mid-aperture setting of f/11 to f/16, if possible, for optimum sharpness. If you need to increase or decrease the exposure, raise or lower the ISO rating so you retain the optimum aperture and shutter speed. We'd avoid going above ISO 800 due to the risk of noise. In daylight, you will most likely need an ND filter to reduce the amount of light entering the lens. A 0.6ND (two-stop light loss) or 0.9ND (three-stop light loss) should be sufficient. For these stained-glass window images, we used a Canon EOS 550D with 28-70mm zoom and an exposure of 0.7 seconds at f/22 (ISO 100).

1) Zoom speed When you're zooming the lens, you want to have as smooth an action as possible. Don't jerk the zoom ring, but instead smoothly rotate it. How quickly you rotate it depends on the lens's focal length and the exposure time, and is something you can determine by viewing the result on the LCD monitor. Zoom too slowly and the burst effect is minimal; too quickly and you'll record nothing but a series of streaks. Don't start zooming until after the exposure has started so that you can capture the scene as well as the zoom-burst effect. If you're already zooming when the exposure starts then you'll only record the streaks.

2) Zoom direction The direction you choose to 'zoom' during the exposure will drastically affect the result. You can zoom from the wide end to the telephoto end, or you can start with the lens at a tele setting and zoom back towards the wide-angle. Try out both directions and see which result you prefer.

3) Zoom duration Depending on the subject, a nice technique to try is to stop zooming towards the end of the exposure so that you effectively record the scene both at the start and at the end of the exposure with the streaks linking the two. This adds an interesting three-dimensional feel to the images. This set of images shows the difference between zooming when the exposure ends or stopping before the exposure ends.

1) Zoom speed

Too slow

Too fast

2) Zoom direction

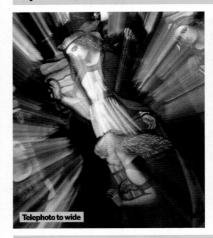
Telephoto to wide

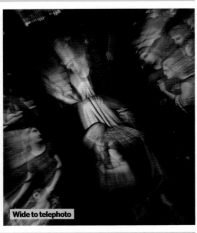
Wide to telephoto

3) Zoom duration

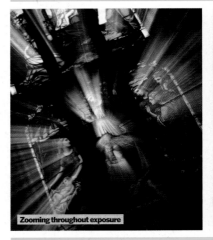
Zooming throughout exposure

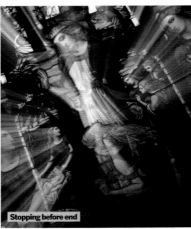
Stopping before end

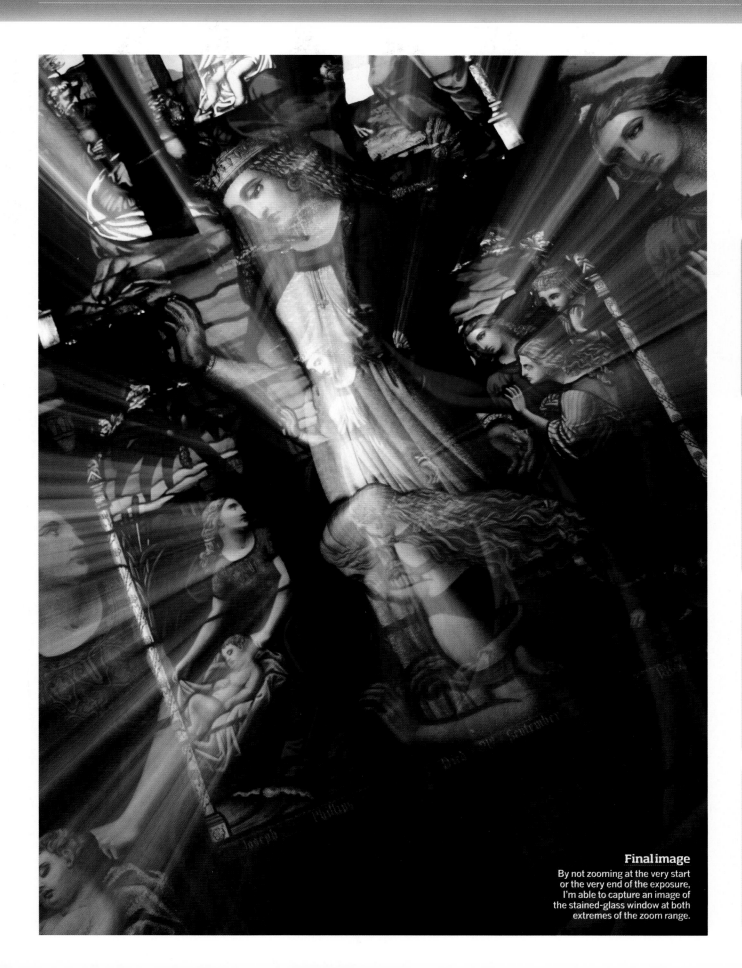

OUTDOOR

INDOOR

LIGHTING

CREATIVE

PHOTOSHOP

Final image
By not zooming at the very start
or the very end of the exposure,
I'm able to capture an image of
the stained-glass window at both
extremes of the zoom range.

Weedy wonders

>TIME: 20 MINUTES **>EQUIPMENT:**
CANON EOS 550D & 50MM F/1.8 **>ALSO
USED:** WEEDS, DIFFUSER & PHOTOSHOP

 Caroline Wilkinson: This is such a simple still-life technique it's silly, but its success does depend on a few factors and there are certain technical tips we can give you to help you get your best results. The actual process is really easy: lean a diffuser in a doorway so it's backed by natural light, or have someone hold it for you. Try to avoid leaning it against a window as you'll get shadows behind it from the window frames. If you don't have a diffuser, stick a piece of A3 copier paper to a windowpane instead. You'll be limited by the size of your subjects, but you'll get similar results. Now pick your weeds. Take a quick walk to see what you can find – the more simple their shape, the better. Thistles are ideal as their outline is graphic, but there are loads out there and you can try them all to see what works for you.

Regardless of how bright the sun is, you are better off mounting your camera on a

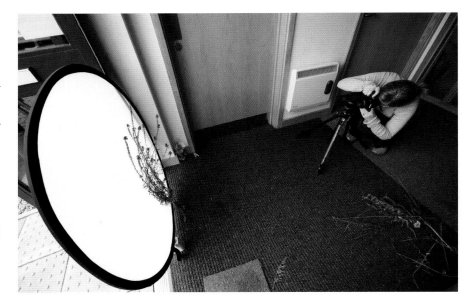

tripod. It is a little restrictive when you want to try different perspectives and compositions, but as natural light fluctuates, you may find your shutter speed drops below a safe handholding speed without you noticing, especially if you move close to the subject, resulting in blurred images.

As some subjects may be larger than others, you may find that you have to back up or zoom your lens out a lot further to get the whole subject in the frame. In doing so, you'll probably get the edges of the diffuser in the picture, too, but don't worry, that's unavoidable and can be edited out later.

CAMERA SETTINGS

Av **Exposure:** Set your camera to aperture-priority mode so you can control depth-of-field. Select a mid-aperture of f/5.6. Your camera can stay on multi-zone metering, but you'll find that because you're backlighting the subject and there's a lot of white in the frame from the diffuser, it will probably fool the metering system into underexposing the scene. To combat this, override the exposure by dialling in one or two stops of positive exposure compensation.

Focusing: As your camera's AF system needs contrast to focus, you may find that it hunts for something to lock on to if the focus point/s fall on the white background instead of the subject. If this happens, set your camera to single-point AF and either manually select the right focus point that falls over the subject or set it to the centre point, lock focus and then recompose before taking the shot. Alternatively, focus manually.

While it's good to shoot from different viewpoints, angles and compositions, remember that as you change your position, the plane of focus may alter and therefore your level of depth-of-field, so you may need to stop down the aperture to get the depth-of-field you need.

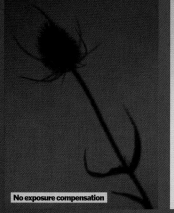
No exposure compensation

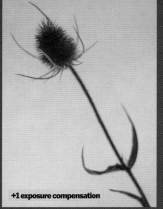
+1 exposure compensation

1 Adjust exposure If you've shot in Raw, you can use your Raw editing software to brighten the image, but if you've captured JPEGs, open your image in Photoshop, then apply an Exposure adjustment layer (*Layer>Adjustment Layer>Exposure*). Slightly move the *Exposure* slider to the right to bleach the background – don't do it too much otherwise you'll start to lose the small details.

2 Tweak Levels Open the image in Photoshop if you haven't done so already and then apply a Levels adjustment layer (*Layer>Adjustment Layer>Levels*). In the control panel, drag the black point towards the centre of the histogram to darken the subject. You'll find the midtone point automatically moves, too, so draw that point towards the black one slightly to bring back some detail and improve the results.

3 Clean up Nearly done. If you have objects in the frame that you want to get rid of or you need to extend the white background, select the *Clone Tool* and in the options bar, set the *Opacity* to *100%* and select a medium-sized brush with *Hardness* of *0* to keep the edges soft. Hold down *Alt* to take a sample from the image, then 'brush' over the area that you want to fill in with the sampled information.

OUTDOOR

INDOOR

LIGHTING

CREATIVE

PHOTOSHOP

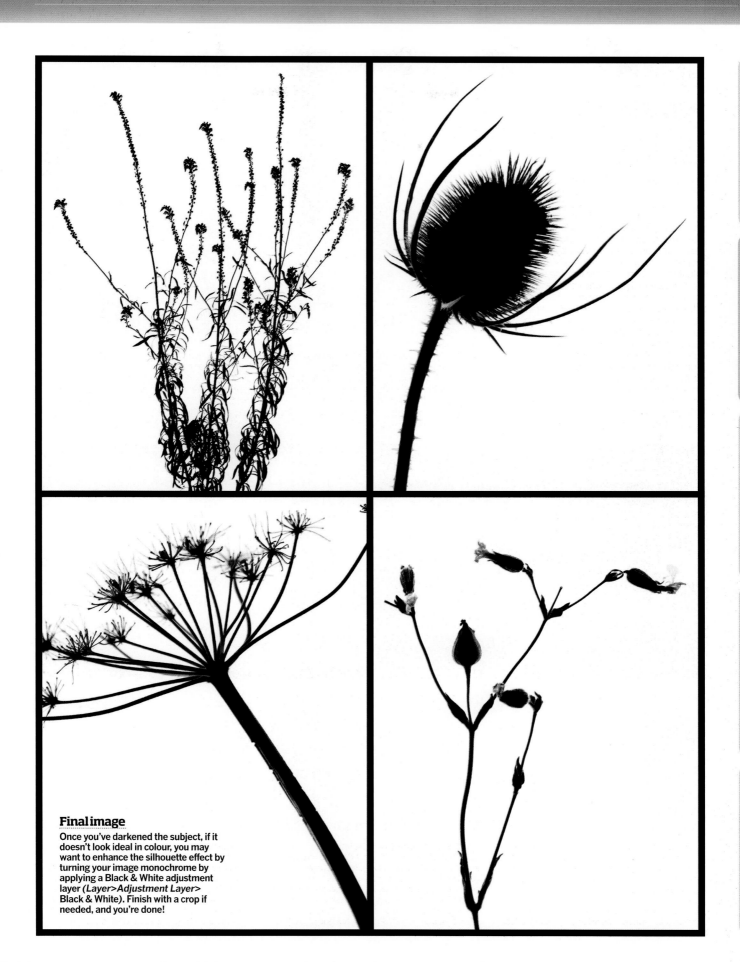

Final image
Once you've darkened the subject, if it doesn't look ideal in colour, you may want to enhance the silhouette effect by turning your image monochrome by applying a Black & White adjustment layer *(Layer>Adjustment Layer> Black & White)*. Finish with a crop if needed, and you're done!

OUTDOOR

INDOOR

LIGHTING

CREATIVE

PHOTOSHOP

Create a junk still-life

>**TIME:** ONE HOUR >**EQUIPMENT:** CANON EOS 5D MK II WITH CANON EF 100MM MACRO LENS >**ALSO USED:** TRIPOD, FLASHGUN WITH SYNC CORD OR WIRELESS TRIGGER, RUSTY SCREWS, NUTS & BOLTS, PLAIN CARD, PAPER AND PHOTOSHOP

John Patrick: Many of us will admit to having old rusty junk in our sheds and garages – the kind of things we keep just in case we should ever need them, but inevitably never do. I took shots like this when my kids were very young and wanted something I could do in short spells. They're great for a little project when you only have an hour or so to spare here and there. There's not much in the way of specialist kit needed, either, with a single off-camera flash and some bits of paper being all you need for DIY macro lighting. Let's give it a go…

Technique watch

Basic lighting with flash
The slight drawback of using a simple flashgun rather than studio lighting is that there's no continuous modelling light to help you set up. It's easy enough to fine-tune flash with test shots, though. Set your camera to manual (I started with 1/125sec, f/4 and ISO 100) and leave the flash on auto. With these settings, your camera should automatically meter and adjust the flash as you move it around. This lets you experiment with flash positions and distances from the subject without having to change settings. In general, the closer the flash, the softer the light will appear. Keep taking test shots until you're happy with the result.

1 Choose a subject Start by picking out a few items to use in your shot. As well as overall shape, have a close look at the texture, as this will really show up at macro scale. Rust and flaking paint work well, as does wear and pitting on metal surfaces. Even a bit of natural grime and dirt can add interest. Old bits of wood or paper with a slight texture are good choices as a base, but it can be fun to simply experiment with whatever's laying around, too.

2 Set up Start by arranging the items roughly in position on the base. You don't need to stick rigidly to the rule-of-thirds, but don't arrange things too symmetrically. Set the camera up on a tripod, have a look through the lens and move stuff around until you're roughly happy with the composition. Then place the flash unit near the subject, just in front and off to one side is a good start. It helps if you can find a base that is big enough to lie the flash on.

3 Fine-tune the light The lighting can be improved by using homemade accessories to fine-tune it. I bend some black card slightly so it stands up on its own, and place it in front of the flash to narrow the light stream, then add a piece of white paper to fill the shadows slightly. Tinfoil is a good reflector, too, and you can also get interesting results from coloured paper. I place a piece of black card behind the subject as a background as well.

4 Precisely focus Macro photographers usually focus manually, and move the camera back and forth to fine-tune the area that appears sharp; but here, you could move the base instead. Just slide the board or paper until it's in focus! It's easier than moving the camera, and you can rotate it, too, so more than one item is in focus. If you think of focus as a slice that cuts through the items you've arranged, you'll soon get the hang of sliding them around to line up various items with the plane of focus.

5 Final adjustments It's attention-to-detail time. If things aren't quite lined up, nudge the screws until they are. Look through the viewfinder and remove any distracting items of fluff or dirt with a paintbrush. It's also worth experimenting with aperture (higher f/numbers giving greater depth-of-field and vice-versa) to see what suits the shot best. As movement will be magnified, use a remote release or self-timer to minimise the risk of images being blurred by shake.

OUTDOOR

INDOOR

LIGHTING

CREATIVE

PHOTOSHOP

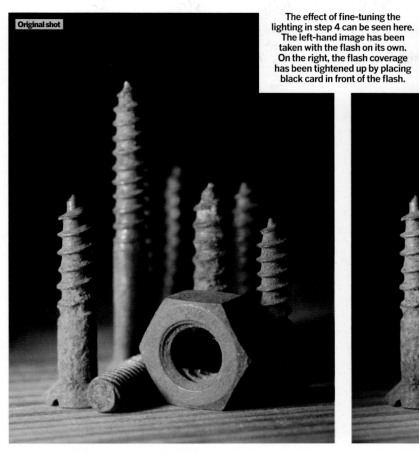

Original shot

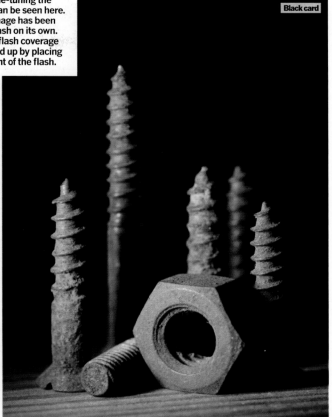

Black card

The effect of fine-tuning the lighting in step 4 can be seen here. The left-hand image has been taken with the flash on its own. On the right, the flash coverage has been tightened up by placing black card in front of the flash.

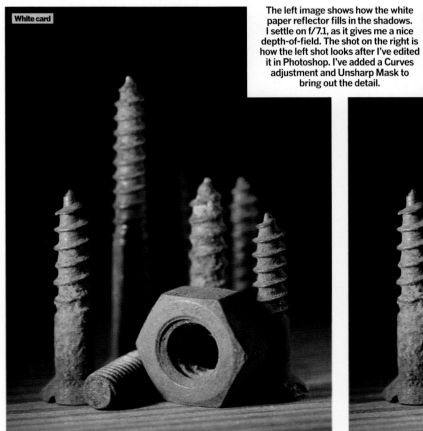

White card

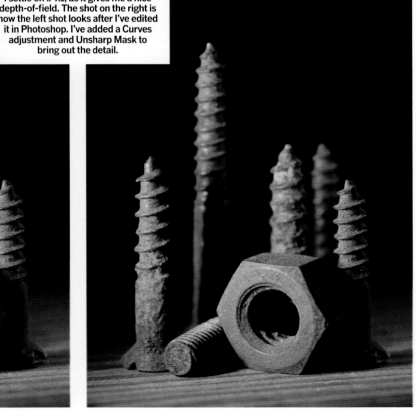

Photoshopped

The left image shows how the white paper reflector fills in the shadows. I settle on f/7.1, as it gives me a nice depth-of-field. The shot on the right is how the left shot looks after I've edited it in Photoshop. I've added a Curves adjustment and Unsharp Mask to bring out the detail.

OUTDOOR

INDOOR

LIGHTING

CREATIVE

PHOTOSHOP

Capture colourful smoke trails

> **TIME:** 45 MINUTES > **EQUIPMENT:** NIKON D300 WITH SIGMA 105MM MACRO > **ALSO USED:** FLASHGUN, TRIPOD AND INCENSE STICK

Caroline Wilkinson: In these tough economic times, what better way to while away cold nights than trying to shoot smoke trails using inexpensive incense sticks? The set-up and technique is really simple, but getting quality images is a little trickier, with patience and trial and error required.

Before setting up, close all doors and windows to avoid any drafts; too much air flowing around a room can cause the smoke to bellow out of frame. Incense comes in various styles, sizes and shapes, so try a variety to see what works best for you. We'd advise staying away from the large sticks as they tend to fill a room with smoke, cones can work well, but burn quickly, and discs burn and sputter, producing a good amount of smoke for silk-like trails, rather than traditional smoke patterns. Whichever you try, make sure it's incense that you like the smell of, as you may go through a whole packet before getting a decent trail!

The key to great smoke trails is movement and lighting. Secure the incense to a table in front of some black fabric, which will act as the background. For your lighting, you need to ideally use off-camera flash, or studioflash with a softbox, as it freezes the trails, but if you're using continuous light (like a lightbox) make sure it's bright enough to generate a shutter speed of at least 1/160sec to capture the smoke. The smoke trails are best lit from underneath, facing up towards the tip of the stick and behind the smoke for a backlit effect. Varying the angle of the flash can provide different dimensions to some trails – but be watchful that the light doesn't flood the lens or illuminate the backdrop by keeping plenty of distance. While first instincts might be to keep the incense steady, giving the table a slight tap can create attractive swirls rather than a traditional straight trail. Tap it too hard, though, and you'll have to wait for the incense to settle.

Once you've got your smoke trail, there are a few things you can do in post-production to make it look even more interesting, like adding colour. To do this, add a Gradient Map (*Layer>New Adjustment Layer>Gradient Map*), select your desired colour and change the *Mode* to *Overlay* or *Soft Light*.

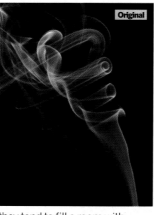

Original

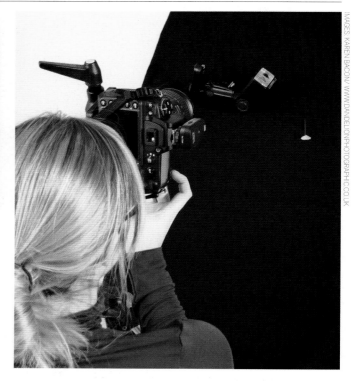

Camera settings

(M) **Exposure & focusing:** Set your camera to manual mode and, if you're using flash, your camera's sync speed to at least 1/160sec and the aperture to f/8 to f/11. Use an aperture wider than f/8 and you'll struggle to get the smoke trail in focus. Keep the ISO rating as low as possible, because smoke trails by nature already look noisy and you want to keep this to a minimum for maximum image quality. Focus manually on the tip of the incense and compose the shot so it's easy to crop the incense stick out later.

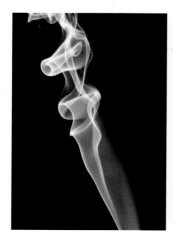

X **Overexposure:**
If the power of your flash is set too high or your aperture is too wide, you may find the smoke trail is overexposed and you lose some of the delicate details that will make the shot.

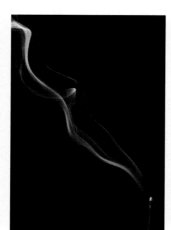

X **Lacking interest:**
If the air is too still, the smoke column usually rises straight. To make it swirl for a more interesting picture, very gently tap the table the incense stick is sitting on.

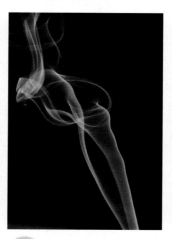

X **Too close to the background:**
Make sure there's enough distance between the flash and the background to avoid detail being revealed in the backdrop when you take the photograph.

X **Refine the focus:**
If you try to use autofocus, you'll find that the camera hunts for something to lock onto. You are best manually focusing on the incense tip and cropping the image later.

OUTDOOR

INDOOR

LIGHTING

CREATIVE

PHOTOSHOP

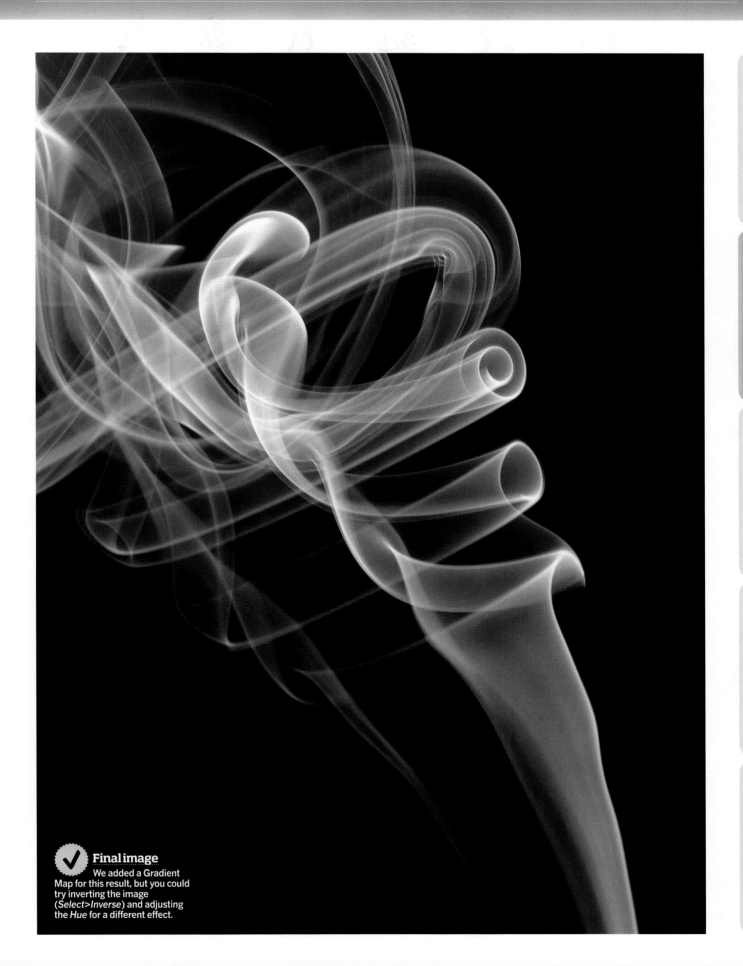

Final image
We added a Gradient Map for this result, but you could try inverting the image (*Select>Inverse*) and adjusting the *Hue* for a different effect.

OUTDOOR

INDOOR

LIGHTING

CREATIVE

PHOTOSHOP

OUTDOOR

INDOOR

LIGHTING

CREATIVE

PHOTOSHOP

Step-by-step tutorials

LIGHTINGPROJECTS

SWITCH ON YOUR FLASHGUN, STUDIOFLASH OR YOUR FLASHLIGHT FOR IMAGINATIVE RESULTS

OUTDOOR

INDOOR

LIGHTING

CREATIVE

PHOTOSHOP

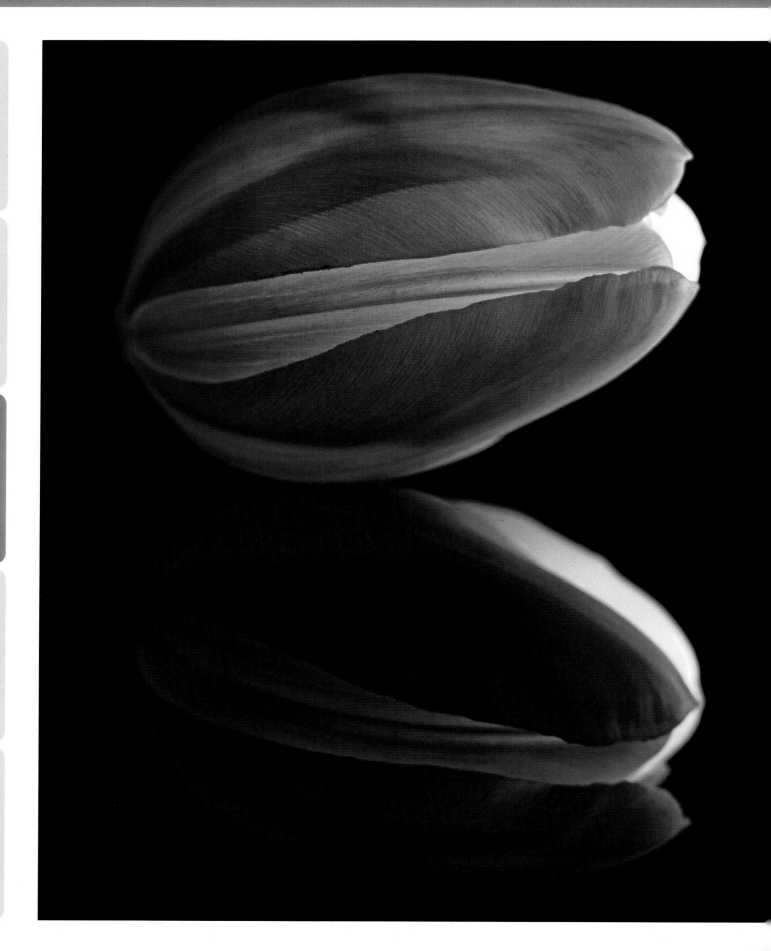

Get a blooming marvellous still-life

>TIME: 45 MINUTES **>EQUIPMENT:** CANON EOS 40D WITH CANON EF 100MM F/2.8 USM MACRO
>ALSO USED: MANFROTTO 190XPROB TRIPOD WITH 488RC4 HEAD, REMOTE RELEASE AND PHOTOSHOP

Helen Sotiriadis: The cold, dark winter days are great times to explore indoor macro photography and low lighting. All you need is a dark corner of a room, a macro lens (or any lens with a close focusing distance) and a little imagination, to transform everyday household objects into works of art. There is no need for fancy lighting either, if used creatively – torches, LED lights or desk lamps are all you need.

Low-light close-up photography has its fair share of challenges. It's essential that you keep the camera absolutely still because of the long exposure times and close proximity to your subject, so it's vital that you use a tripod, along with a remote release or your DSLR's self-timer, so you don't jog the camera when releasing the shutter button. Intense contrast in your composition will also mean that you'll have to either override your camera's automatic settings, compensating the exposure by a couple of stops, or manually set the aperture and speed. After the shoot, take time with a bit of strategic post-processing and you'll transform your decent shot into a striking image.

OUTDOOR

INDOOR

LIGHTING

CREATIVE

PHOTOSHOP

OUTDOOR

INDOOR

LIGHTING

CREATIVE

PHOTOSHOP

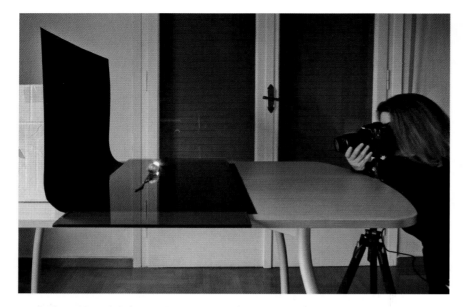

Is an LED torch essential?

You may be asking yourself why we suggest you use an LED torch rather than the standard torches that can often be found. LED torches are usually far more powerful and even a small LED light can illuminate all but the largest prop. LED torches often come with a swivel head that allows the beam to be focused on a single spot or spread over a wider range. Finally, you'll notice the colour of the LED beam is much whiter than the older-type bulb torches, which helps with adjusting White Balance in post-processing.

1 Set up I lay a large sheet of black paper against a cardboard box, filled with a few books to keep it stable, for a backdrop. If space is limited, you can lean your paper against the wall instead of a box. A sheet of dark tinted glass serves as a reflective base and also steadies the paper.

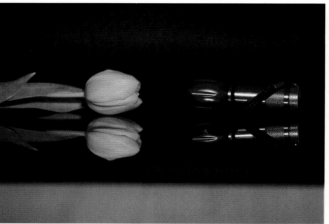

2 Set up lighting I then place an LED torch across from a beautiful white tulip so that its beam shines directly into the flower, making it appear as if it is glowing from the inside. The light also intensifies the texture of the petals. After a few test shots, consider removing any leaves if they are cluttering the composition and distracting the eye from the petals.

3 Set camera settings Keeping your camera stable on a tripod means you can lengthen the exposure time and use ISO 100 to avoid noise. As I'm shooting the tulip image in the dark with only the LED torch as a light source, it's much easier to compose and manually focus on the flower with the lights on and then turn them off when I'm ready to shoot in the dark.

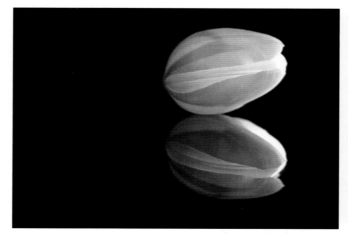

4 Adjust lighting With the lights off, experiment with the torch's position to keep the light in the centre of the flower, illuminating the petals nearest the camera. The multi-zone metering isn't much help: here I'm using aperture-priority mode and f/2.8, giving me a shutter speed of 1/10sec, overexposing the petals and burning out its detail.

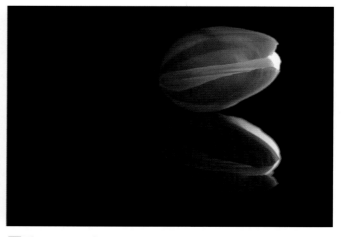

5 Fine-tune settings I switch to manual mode, keeping it set to ISO 100 and f/2.8. I start with my shutter speed at 1/10sec, and fire several shots, gradually increasing the shutter speed until the petals are properly exposed. The best results are at 1/30sec. Also experiment with the White Balance, I find the Daylight preset makes the most of the cool-blue light.

OUTDOOR

INDOOR

LIGHTING

CREATIVE

PHOTOSHOP

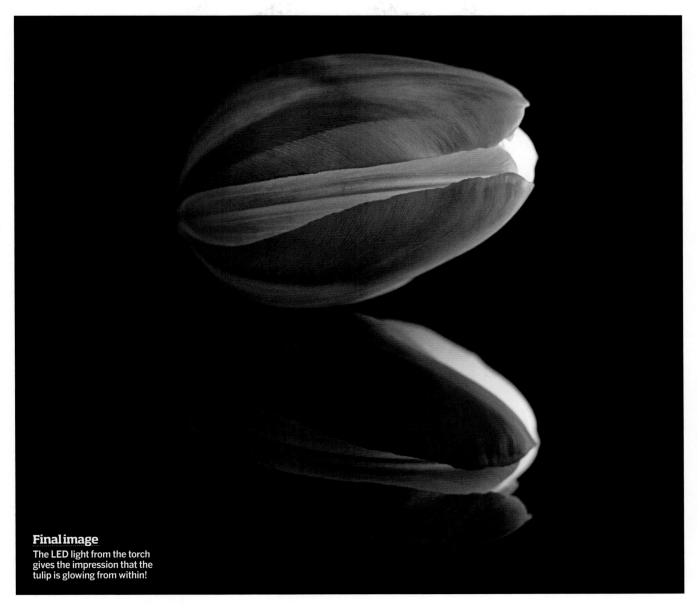

Final image
The LED light from the torch gives the impression that the tulip is glowing from within!

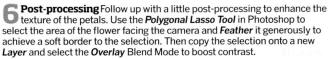

6 **Post-processing** Follow up with a little post-processing to enhance the texture of the petals. Use the *Polygonal Lasso Tool* in Photoshop to select the area of the flower facing the camera and *Feather* it generously to achieve a soft border to the selection. Then copy the selection onto a new *Layer* and select the *Overlay* Blend Mode to boost contrast.

7 **Crop image** I feel the composition is unbalanced in its original format and would be enhanced with a square crop, so I use the *Crop Tool* to select my new frame shape. I then use the *Spot Healing Brush Tool* to eliminate any specks of dust that inevitably appear on the reflective glass, before flattening the layers (*Layer>Flatten Image*) and saving my file.

OUTDOOR

INDOOR

LIGHTING

CREATIVE

PHOTOSHOP

Use daylight to shoot a high-key portrait

>TIME: 45 MINUTES **>EQUIPMENT:** NIKON D800 WITH 50MM F/1.8 **>ALSO USED:** COLLAPSIBLE REFLECTOR, PHOTOSHOP

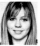 **Caroline Wilkinson:** Bright, fresh – even romantic – are all words that have been used to describe high-key portraits; shadowless images with an emphasis on highlights. But if you don't take a stylistic approach and use the correct technique, your final image might be more akin to a passport photo with a smile. This type of lighting suits the soft features of females and babies, and the bleaching effect hides a multitude of sins as it evens out skin tone, washes out blemishes and hides wrinkles.

If you were to use studioflash for this effect, you'd set up the lights to overexpose a white background and to fill in shadows on the model's face. But you can get equally good results with natural light and a reflector by sitting your subject in front of a window or open doorway and metering for their skin. You don't need a bright day, though it's easier if it is – this image was taken inside on an overcast day; you just need to be careful not to let your shutter speed get too slow. Pick a window or door facing east or west in the morning or afternoon; light from a north-facing window is usually ideal any time of day. Lastly, ask your subject to wear summery, soft colours like light pink and white.

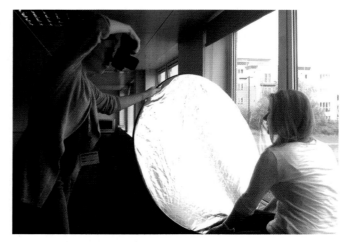

1 Pick your window Choose a window large enough to give you enough background, with the view outside of the window clear and distant. If you have foliage or buildings nearby, your background will be coloured, not white. I used a large north-facing window, but had the subject sit on the windowsill so more of her torso is illuminated. I stood on a chair to get a more flattering downward viewpoint – take care if you do the same. You may need a reflector to bounce some light on to your model's face.

2 Dial in your settings Set your camera to shoot in Raw in case you need to recover detail in the highlights. In aperture-priority mode, dial in a starting aperture of f/5.6 and ISO 200. Switch to single-point AF and set the metering mode to spot. Compose your portrait, focusing on the eye closest to the camera to take an exposure reading. If the shutter speed is 1/60sec or slower, you need to open the aperture, increase the ISO rating, or both, to avoid camera shake. Once you're happy, take a test shot.

3 Add exposure compensation You may find that the background isn't bleached enough; if so, dial in one or two stops of positive exposure compensation. Always be aware of your shutter speed – increasing the exposure will lengthen your shutter speed. The amount of exposure compensation you add is down to personal taste: do you want wraparound highlights or just a glowing backdrop but still with a defined outline of the subject? Experiment until you get the effect you want.

4 Post-processing There shouldn't be much that needs to be done in Photoshop, other than maybe a slight contrast boost using Levels, maybe a bit of highlight recovery in Adobe Camera Raw if you've overexposed the image too much, and some sharpening. I converted my image to black & white, too, by adding a Black & White adjustment layer (*Layer>New Adjustment Layer>Black & White...*). Use the channel sliders, particularly the Red and Yellow, to adjust contrast and lighten skin tone.

Common errors to watch out for...

⊠ **Metering** If you use multi-zone metering, the camera will take an average reading of the whole scene to get the 'correct' exposure. By using spot metering and taking a reading from the subject's skin, the face is correctly exposed but the background will be overexposed, as it's already brighter than the subject.

⊠ **Focusing** Always make sure the eye closest to the camera is in focus, especially if you have to open up the aperture for minimal depth-of-field. Use the LCD monitor between shots to zoom in to the eyes to make sure they're sharp – especially if shutter speeds are low. Don't let it drop lower than 1/60sec as it will be very difficult to avoid camera shake.

⊠ **Background** Objects such as trees by the window will give you a coloured background and restrict the light, resulting in longer exposures. If you don't add enough exposure compensation, you may find that areas of colour appear from distant objects. Increase the exposure if it doesn't ruin your lighting, or paint over these areas later in Photoshop.

Final image
Stunning portraits can be achieved with just your camera, some window light and a reflector. Try it today!

OUTDOOR

INDOOR

LIGHTING

CREATIVE

PHOTOSHOP

Master the secrets of classic film noir lighting

>TIME: ONE HOUR **>EQUIPMENT:** CANON EOS 5D MK II WITH CANON EF 70-200M F/2.8L
>ALSO USED: STUDIOFLASH, WIRELESS TRIGGER, REFLECTOR AND LIGHT METER

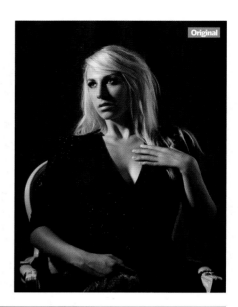
Original

 Bjorn Thomassen: When photographers think of the 'Golden Age' of Hollywood, most recollect the likes of Rita Hayworth, Elizabeth Taylor and Vivien Leigh, not as on-screen sirens, but as iconic subjects of dramatic Hollywood portraits. The classic Hollywood portrait of the 1940s in particular was typified by its high contrast black & white images, created using strong directional light, with strategically placed shadows to add depth and drama. Today, Hollywood lighting is considered an art form that many still love to recreate – including us. While its style might be seen as dated, it's an immensely useful technique to learn.

Compared to the portraits we shoot today, posing is quite rigid and, as it's not the most flattering style of lighting, it's best suited to people with good skin. The slightest imperfection will be amplified. Being able to control and focus the light is key, as you need to be very targeted with where the light falls. Here, I've used a studioflash with a medium reflector dish and barndoors attached to direct the light, but taping thick black card to all four sides of your flash can work just as well. The hard light from the studioflash is then tempered by the light bouncing off the reflector on the opposite side, before reaching the model. A second light is also used on the opposite side to accent the edges of the subject.

While most Hollywood portraits are against a black background, some images show texture in their backdrop, which is why we've chosen to use a carefully hung white background to show you how to create this effect should you want to use it. One of the reasons we're using barndoors, too, is to stop the spill of light on to the background, as without it the white backdrop will turn black, but still retain some tonal detail.

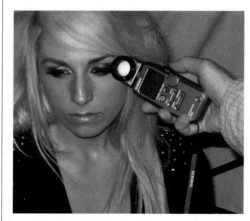

Camera settings

M **Metering & exposure:** The aperture you use depends on how much background detail you want in focus, how close the subject is to the backdrop and on the power of your lights. Here, the model is about a metre away, so f/5.6 provides enough depth-of-field to render her in focus but blur the backdrop. Hold the light meter by the face, but pointing towards the light source – not the camera – so it can accurately measure the amount of light falling on the subject. Now adjust the power of the studioflash until you get the aperture you want. With the camera in manual mode and the flash sync speed set, dial in your appropriate aperture and take your shot.

Lighting set-up

Place the main light close to the subject to have better control over the fall-off of the light: you want to avoid it illuminating the subject's lap. Position the main light 90° to the camera, pointing down 45° on the subject. Place the model in a ¾ pose, so that the side of the face receiving the most light is turned away from the camera. By doing this, it casts a triangular shadow on the cheek closest to the camera, which is characteristic of the lighting style. The plane of the face needs to be relative to the main light for the shadow to be cast correctly. Every set-up is different, but when positioning the reflector to soften the main light and act as a fill-in, remember the law of reflection and avoid placing it too close to the model, as it may counteract the striking modelling and shadows you've created. Mine is placed approximately four feet away from the model. To add more dimensionality to the image, an accent light has been added three feet away from the subject and angled upwards at 30°, so light falls on to the opposite edges of the model. The set-up works on a lighting ratio of 3:1, as the accent light shouldn't overpower the main light.

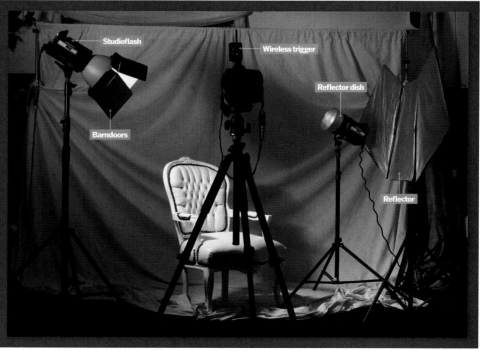
Studioflash · Wireless trigger · Reflector dish · Barndoors · Reflector

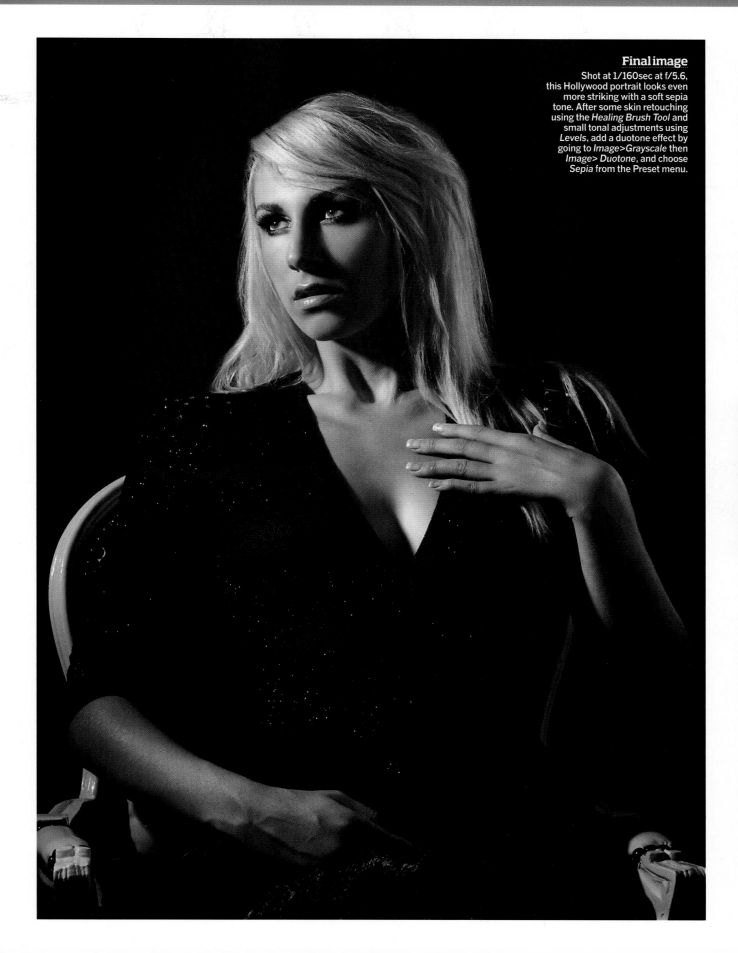

Final image
Shot at 1/160sec at f/5.6,
this Hollywood portrait looks even
more striking with a soft sepia
tone. After some skin retouching
using the *Healing Brush Tool* and
small tonal adjustments using
Levels, add a duotone effect by
going to *Image>Grayscale* then
Image> Duotone, and choose
Sepia from the Preset menu.

OUTDOOR

INDOOR

LIGHTING

CREATIVE

PHOTOSHOP

Create a graphic portrait

>TIME: ONE HOUR **>EQUIPMENT:**
NIKON D300s WITH SIGMA 10-20MM F/3.5
>ALSO USED: LASTOLITE HILITE, TRIPOD,
TWO STUDIOFLASH HEADS, PHOTOSHOP

 Caroline Wilkinson: The simple lines
and shapes of a silhouette are what
makes them so appealing, but as simple
as the images are and the technique may
seem, getting a decent result is trickier than you
might think. Aside from the lighting and exposure,
as you're stripping the subject of character and
features, the geometry of the pose and outline it
creates has to be spot on to create any visual
interest. Profile poses are a good place to start as
they can accentuate curves, but also look for ways
to stop your subject looking too static, such as
adding movement and using dynamic shapes or
graphic props. Finally, ask your subject to wear
black. And remember, if you don't have a studio,
you can apply the same principles to shooting
against a large window in direct sunlight.

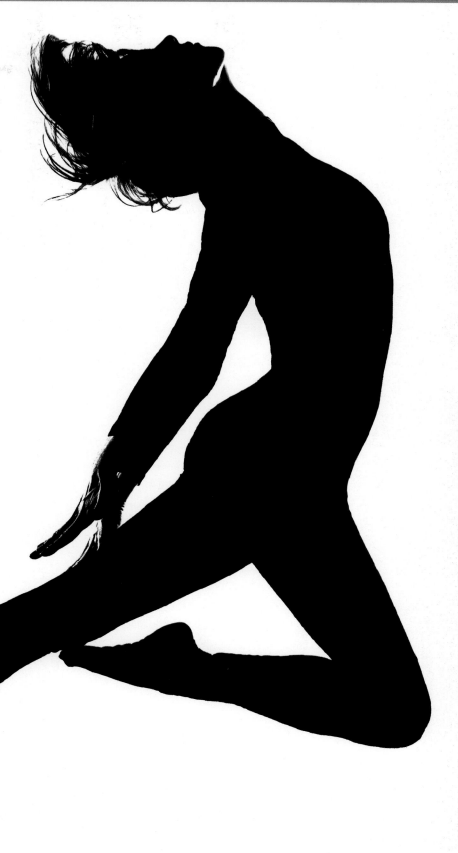

OUTDOOR

INDOOR

LIGHTING

CREATIVE

PHOTOSHOP

OUTDOOR

INDOOR

LIGHTING

CREATIVE

PHOTOSHOP

Set up Place two studioflash heads, set to a mid-power, pointing in either side of a Lastolite HiLite, and have the subject stand in front of the background. Simple. While a Lastolite HiLite is the ideal tool for the job, you can create a similar effect by placing two studio lights, set to full power, behind and directed at a white paper or fabric backdrop. To avoid the light spilling on to the subject standing in front of the background, attach spills to the studioflash heads to contain the light and try to block any space around the background.

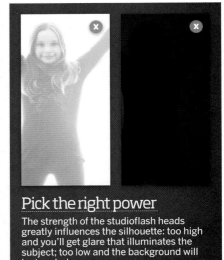

Pick the right power

The strength of the studioflash heads greatly influences the silhouette: too high and you'll get glare that illuminates the subject; too low and the background will be too dark.

Settings & technique

Set your camera to manual mode, its lowest ISO rating, White Balance to Auto and image quality to Raw+JPEG. You'll need to dial in your camera's flash sync speed (in our case, that's 1/250sec, but check your camera's manual for details). Set an aperture of f/11 or f/13 to give optimum sharpness. Ask your subject to stand a couple of feet in front of the backdrop for a test shot. If they're illuminated, try turning the studioflash's power down or if the background is too dull, turn it up. Focusing can be a problem if you're working in low light, so try to place the autofocus point over an area of contrast, such as the edge of the body against the backdrop. Alternatively, focus on the subject and switch from AF to manual to stop it hunting between shots. If your subject moves closer or further away from the camera, you may need to refocus.

1 Improve the contrast Even if your exposure is spot on, the background may look dull. Open the image in Adobe Camera Raw and push the *Brightness* and *Contrast* sliders between *+80* and *+100*, with a small tweak to the *Clarity* for sharpness. Then, in Photoshop, improve the result by adjusting the contrast via *Layer> New Adjustment Layer>Levels*. Finally, crop and convert the image to black & white (*Layer> New Adjustment Layer>Black & White...*).

2 Extend the background If you used a Lastolite HiLite, you may find that you need to extend the background a little. In Photoshop, duplicate the image by dragging the layer down to the *Create a New Layer* icon at the bottom of the Layers palette. Select the *Brush Tool* and hold down *Alt* to change the cursor into an eyedropper: click on an area of white to take a colour sample, release *Alt*, and 'paint' over the areas where the background's not in the frame.

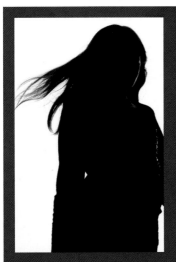

✔ **Add movement** If your subject has long hair, consider introducing a fan to add movement to the image. It immediately stops the shot from looking too static.

✔ **Strike a pose** Use repeated patterns and shapes to add interest. Try to contain the viewer's eye within the frame and subject by connecting lines.

✔ **Jump** Ask the subject to leap or jump for an energetic image: keep an eye on the pose to make sure that there's space around the limbs for a defined outline.

✔ **Be abstract** Concentrate on the composition and zoom in on the curved lines of the body or details like the feet for less conventional but alluring images.

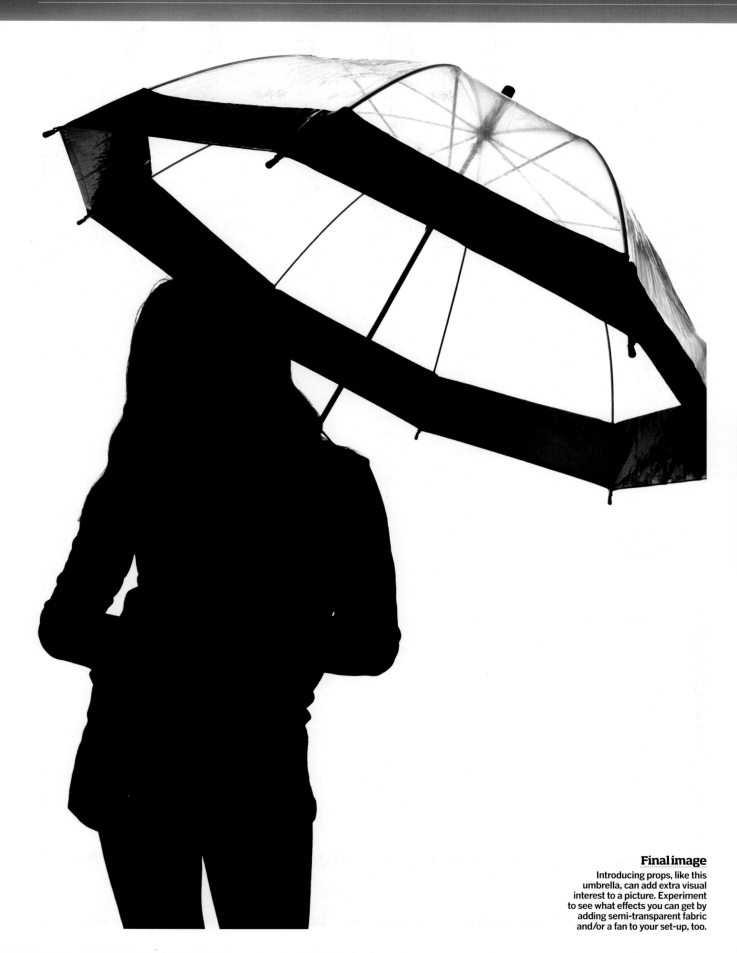

OUTDOOR

INDOOR

LIGHTING

CREATIVE

PHOTOSHOP

Final image
Introducing props, like this umbrella, can add extra visual interest to a picture. Experiment to see what effects you can get by adding semi-transparent fabric and/or a fan to your set-up, too.

Create a colourful backlit still-life

>TIME: 30 MINUTES **>EQUIPMENT:** CANON EOS 550D WITH CANON 50MM F/1.8 **>ALSO USED:** TRIPOD, LIGHTBOX & SWEETS

Ross Hoddinott: When it is cold and damp outside, it can be hard to get enthusiastic about venturing out to take pictures. The warmth of your living room is seductive, but don't just put your feet up in front of the TV – you can stay in the comfort of home and still keep your camera busy! If you enjoy shooting close-ups and still-lifes, why not shoot attractively backlit images with the aid of a lightbox? A lightbox is perfect for illuminating miniature subjects, making it quick and easy to capture eye-catching results. Opt for translucent subjects, like glass, leaves, plastic, sliced fruit or ice. Don't underestimate the impact of colour either; the more colourful, the better. Clean, simple arrangements often produce the best results – for example, patterns created by repeating shapes or colour. Among the list of good potential backlit subjects are sweets. Lollipops and boiled or jelly sweets are perfect. Backlighting accentuates their colour and, as long as you are imaginative with your arrangement, eye-catching results are guaranteed. You only require a very basic set-up to capture great shots. A standard or short telephoto lens in the region of 50mm to 100mm will do the job nicely. If you need to get closer still, attach a close-up filter, extension tube or, if you own one, use a macro lens.

Essential kit: lightboxes

In the days of film, the majority of enthusiast photographers owned a lightbox of some shape or size. They allowed photographers to view and scrutinise their slides and negatives using a loupe. However, with the advent of digital capture, the popularity of lightboxes has naturally plummeted. They still remain a good investment, though, providing a great light source to creatively backlight small, translucent subjects. Find good quality lightboxes of varying sizes at www.lightboxuk.net and www.lightboxes.co.uk and opt for one which is A3 or larger. Expect to pay in the region of £100 for a good quality A3 lightbox. Alternatively, save a few quid and make your own – it's actually very easy. Simply make a frame from wood of your desired size – you could even consider using an old drawer. Inside, position an appropriate number of fluorescent fittings – ideally a high-frequency type. Drill holes for ventilation and also create a hole to thread a flex out and attach a plug. Buy a sheet of 3-5mm opaque Perspex (ideally pre-cut to the size you require) and attach this to your frame. As with anything electrical, don't attempt constructing a lightbox unless you feel 100% confident in what you are doing. Also, don't ever leave a lightbox unattended while switched on. Simpler still, you could just suspend a piece of opaque Perspex over a lamp, or bright light source, in order to create a temporary, makeshift lightbox.

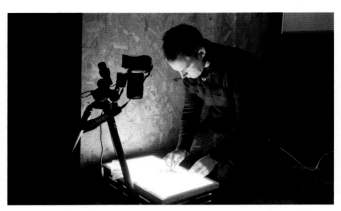

1 Set up It is usually most convenient to place your lightbox on the floor. This will allow you to position your camera parallel overhead using a tripod. Presuming you wish to keep your subject sharp throughout, opt for a small aperture of f/11 or f/16. With the lightbox providing the primary light source, it is typically best to keep room lights switched off.

2 Perfect exposure If there are gaps around your subject, the intensity of the light shining through may fool your camera's metering into thinking the subject is brighter than it is. As a result, there is a risk of underexposure. By viewing the histogram, you will spot any errors. If images are too dark, apply positive (+) exposure compensation: +1.5EV is a good place to start.

3 Experiment Try different subjects, arrangements and concepts. Often you will find your ideas evolve and develop with each frame you take. In this instance, I opted to shoot colourful boiled sweets. I removed the wrappers and divided them into colours, before using a rolling pin to break them into small, photogenic fragments.

4 Fine-tune your composition You should have at least one focal point in your image. Placing a complete sweet on an intersecting third creates a more stimulating composition than having it perfectly central, so consider its position and how it's framed by the broken fragments. You might also want to introduce different colours, too, for more eye-catching results.

OUTDOOR

INDOOR

LIGHTING

CREATIVE

PHOTOSHOP

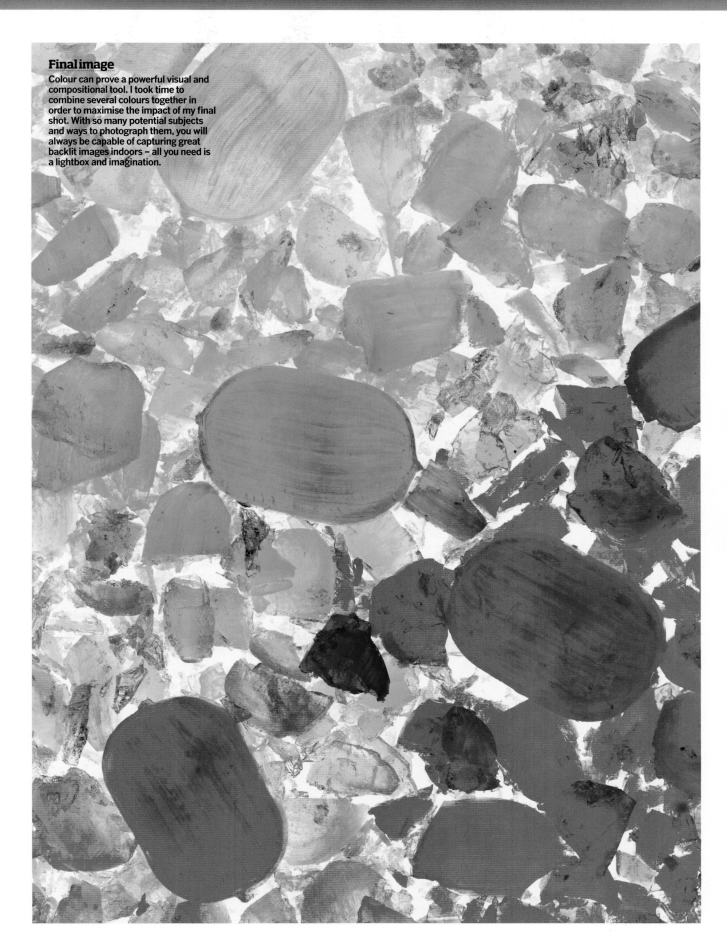

Final image
Colour can prove a powerful visual and compositional tool. I took time to combine several colours together in order to maximise the impact of my final shot. With so many potential subjects and ways to photograph them, you will always be capable of capturing great backlit images indoors – all you need is a lightbox and imagination.

OUTDOOR

INDOOR

LIGHTING

CREATIVE

PHOTOSHOP

Beaming brilliant!

>TIME: 45 MINUTES **>EQUIPMENT:** NIKON D300 WITH NIKKOR 50MM F/1.8 **>ALSO USED:** ELINCHROM D-LITE 4IT HEAD, CRAFT KNIFE, CARDBOARD, TINFOIL AND PHOTOSHOP

Caroline Wilkinson: Finding a creative way to use studioflash is easy with the plethora of lighting accessories on offer, but what if you only have a basic lighting kit – there's only so much you can do, right? With a single Elinchrom D-Lite 4IT head and spill to work with, and a pile of junk, I was challenged to find a way of lighting a portrait creatively, so I opted for a spotlight effect. Wanting to avoid my subject looking like a deer in headlights, I positioned the model at a 45° angle to the camera. It's a much more flattering pose than having your subject square to the camera, so try applying it to any portrait for an instant improvement. By the end of this step-by-step you might be thinking, 'Crikey, how makeshift can you get?', but at least we've proven that anyone can try out this technique with something as simple as a cardboard box. I challenge you to give it a go!

1 Cut a hole in cardboard Find a way of channelling the light. I cut a small circle in a large piece of cardboard and attach it to a light stand in front of the flash head to shape the light onto the white background. It doesn't work very well as there is too much ambient light, reducing contrast.

⚠ Warning: Fire hazard Turn off the modelling light at regular intervals, and when not in use, so it can cool down. Cardboard and an overheating light can be a fire hazard!

2 Create a funnel I need to block the ambient light, so I wrap a funnel of card around the flash head, but this doesn't give a clean enough circle. Instead I opt for a cardboard box, line it with tinfoil to reduce the chance of it catching alight, and attach it to the head with parcel tape.

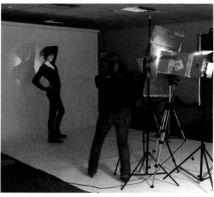

3 Adjust lighting I reposition the light stand in front of the box to create the spotlight and turn up the power of the modelling light. The spotlight is much stronger, but fills too much of the camera's frame. To make the circle smaller, I move the light stand closer to the model.

4 Set camera settings With my camera set to manual, I dial in the flash sync speed of 1/250sec (check your manual for your camera's) and f/20. Play around with the studio light's power until you get enough light to illuminate the model and have a stark line around the spotlight.

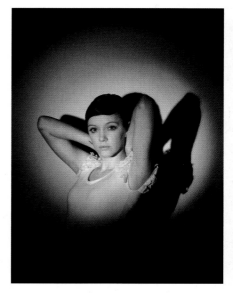

5 Position your model I position the model in the centre of the light and move around with my camera handheld. Get your model to stand as close as they can to the backdrop to reduce shadows.

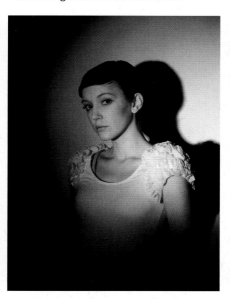

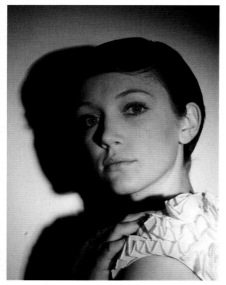

6 Try shooting different poses As only the head and shoulders of the model are lit, I try to make the pose as dynamic as possible via strong eye contact with the camera and the position of her arms. Some shots work better than others, but I try to create shapes such as triangles and avoid straight lines. Shots that showed most of the spotlight circle and with her arms above her head were the most interesting.

OUTDOOR

INDOOR

LIGHTING

CREATIVE

PHOTOSHOP

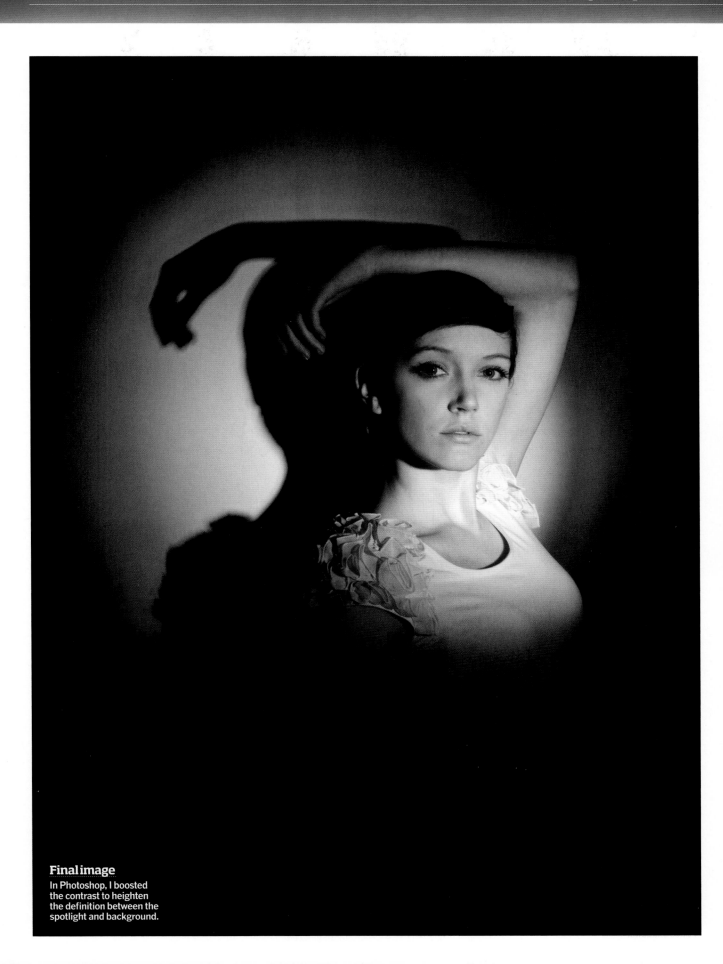

Final image
In Photoshop, I boosted the contrast to heighten the definition between the spotlight and background.

OUTDOOR

INDOOR

LIGHTING

CREATIVE

PHOTOSHOP

TRY 5 ISSUES FOR £5

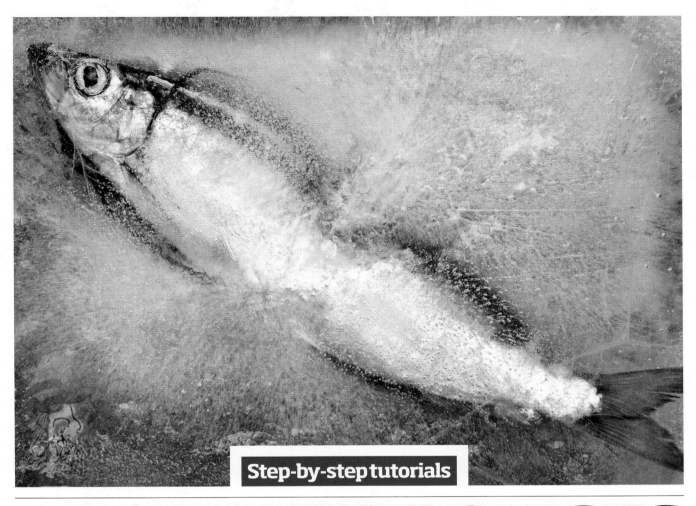

Step-by-step tutorials

CREATIVEPROJECTS

IMPROVE YOUR PHOTO SKILLS WHILE CAPTURING INVENTIVE AND IMAGINATIVE IMAGES

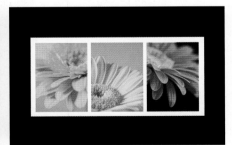

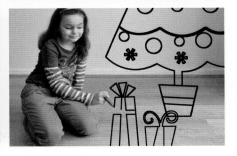

OUTDOOR

INDOOR

LIGHTING

CREATIVE

PHOTOSHOP

Day into night!

>TIME: ONE HOUR **>EQUIPMENT:** CANON EOS 5D MK II WITH CANON 24-70MM F/2.8L **>ALSO USED:** TRIPOD, KOOD ND8 FILTER, RED FABRIC AND PHOTOSHOP

Paul Ward: Mention the words 'long exposures' and images of traffic trails speeding past an open shutter or nightscapes saturated in the glow from streetlights may spring to mind – but long-exposure shots work brilliantly during the day, too, thanks to ten-stop ND filters that create eerie, ethereal shots. Take, for example, the huge trend towards blurring water with a long exposure and an ND filter; an ever-growing number of landscape photographers are shooting coastal seascapes in this way that, when converted to mono, look beautifully moody. The technique also works to create gritty, ghostly images, as I have done here.

My chosen location and the type of image I wanted to achieve couldn't be more different. I headed into Birmingham looking for a suitable urban scene. Inner-city areas are great for gritty locations, but you have to steer clear of busy spots because security guards dislike tripods. Your best bet is to look for quieter areas away from bustling shops and you'll soon come across the right location. After a few minutes, I discovered an interesting spiral staircase with an urban feel. So, at 2pm on an overcast day, I set out to produce an eerie long-exposure image using the minimum of kit and the help of a friend. My idea was to have him run up and down the stairs to create a ghostly figure and, to add colour impact to the image, drag behind him some bright-red fabric that I'd bought earlier in a market for £1.

OUTDOOR

INDOOR

LIGHTING

CREATIVE

PHOTOSHOP

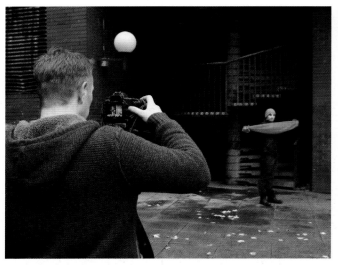

ND filters

ND filters reduce the amount of light passing through the lens, without altering colour balance. There are two main types of ND filters: standard ND filters, which have constant density throughout and ND grads, which have a dense area and a clear area. For this technique you must use the standard ND filter. They are available as screw-in filters or slot-in types. ND filters come in varying densities: an ND2 reduces light by one stop, an ND6 by two stops and an ND8 by three stops. We'd recommend an ND6 or ND8.

1 Take a test shot Once I find a suitable location, I set up a tripod and fire off a few test shots, adjusting my position until I am satisfied with the composition. Choosing stairs in a shaded area is the ideal solution to help shoot long exposures during daylight hours.

2 Fit an ND filter To make sure I can set a slow enough shutter speed in daylight, I fit a Neutral Density (ND) filter to my lens. I use an ND8, which effectively cuts out three stops of light as this should broaden the choice of exposures I can use. (See box out for details on ND filters).

3 Set aperture and shutter speed With my camera in manual mode, I select a small aperture of f/22 to keep the scene sharp and set the shutter speed to six seconds. My friend Simon walks up the stairs holding the fabric. The exposure is too long, and so the fabric is too faint.

4 Adjust shutter speed I shorten the shutter speed to 2.5 seconds and this gives a better result, with the red fabric appearing brighter and fuller. However, Simon isn't walking fast enough, so his face, although blurred, is visible, while the red streak is too defined for my liking.

5 Double up shots I'm happy with my exposure and ask Simon to walk faster to make sure he isn't visible, but 2.5 seconds isn't enough time for him to reach the top of the stairs. So, with my tripod locked in position, I take two shots of Simon on the different stair levels which I merge later.

6 Paste images together I open both images in Photoshop. With the first image, I choose *Edit>Select All*, then *Ctrl + C*, and close the file. I choose file two and go to *Edit>Paste*, to add the first image. I use the *Eraser Tool* over the background image to reveal the fabric, then *Layer>Flatten Image*.

7 Reduce saturation To darken the background and enhance the impact of my red fabric streaks, I click *Image>Adjustments>Saturation* and then reduce the saturation to about halfway, so that the colours are dull. I then select the *History Brush* and 'brush' back in the red of the fabric streak.

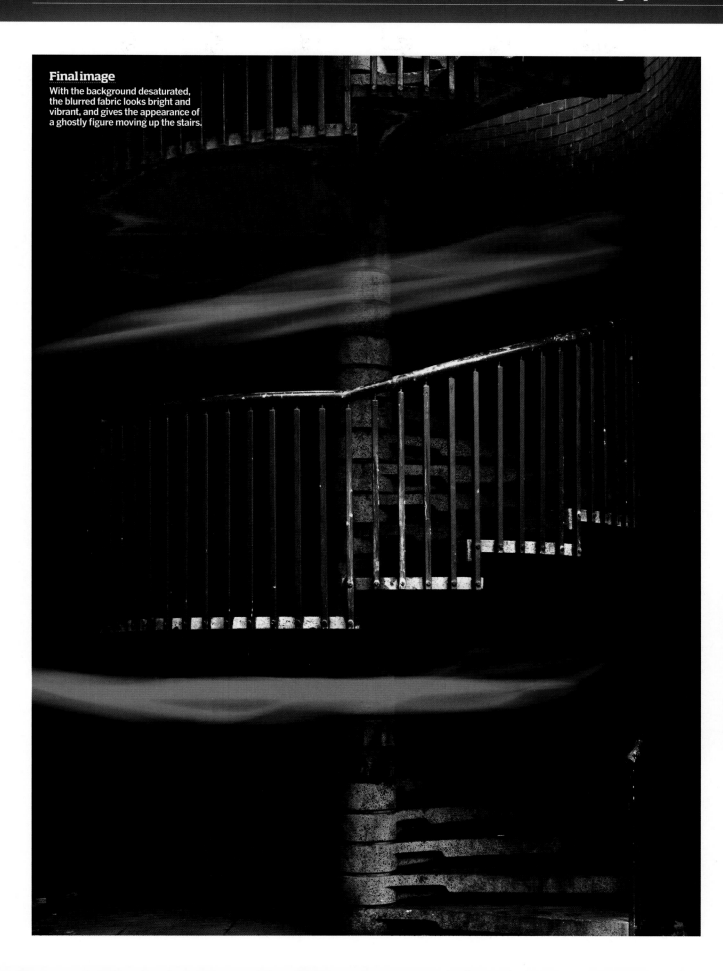

Final image
With the background desaturated, the blurred fabric looks bright and vibrant, and gives the appearance of a ghostly figure moving up the stairs.

OUTDOOR

INDOOR

LIGHTING

CREATIVE

PHOTOSHOP

OUTDOOR

INDOOR

LIGHTING

CREATIVE

PHOTOSHOP

Catch of the day!

> **TIME:** 24 HOURS TO FREEZE THE OBJECT; 30 MINUTES TO CAPTURE THE IMAGE
> **EQUIPMENT:** NIKON D700 WITH SIGMA 105MM F/2.8 MACRO
> **ALSO USED:** TRIPOD, PYREX DISH, FISH AND ADOBE LIGHTROOM

Ross Hoddinott: When poor weather and short winter days can curtail opportunities for photography, with just a little bit of imagination, it is possible to manufacture great images at home. Freezing an object in ice might not be an innovative idea but, done well, the results can look striking… and it is easy to do. Freezing an autumnal leaf is popular, but it can look a little cliché. If you want to be more original, why not freeze a colourful feather, sweets or a flower? You could even freeze an alarm clock or watch, to play on the idea of 'freezing time'. Or how about suspending a small bottle of gin or whisky in an ice block? Once you get your thinking cap on, you won't be short of themes or ideas. Food is another subject that can work well. With this in mind, I decided to try freezing a fish – bought from the local market for a couple of quid – in order to create an arty still-life.

1 Find a dish In order to create your ice block, you need a clear, freezer-proof dish. Here, I use a Pyrex dish but, depending on the subject, you may need to find something deeper. Place it in your freezer and ensure that it is level.

2 Start freezing It is best to create layers of ice. Begin by adding a centimetre or two of distilled/filtered water, and let it freeze before adding another layer. This prevents your subject from sinking to the bottom of the dish. It also allows me to position the fish precisely.

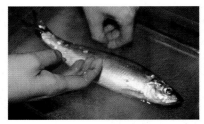

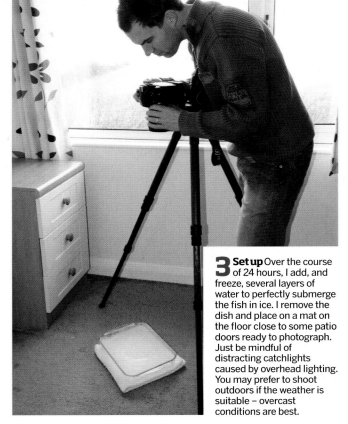

3 Set up Over the course of 24 hours, I add, and freeze, several layers of water to perfectly submerge the fish in ice. I remove the dish and place on a mat on the floor close to some patio doors ready to photograph. Just be mindful of distracting catchlights caused by overhead lighting. You may prefer to shoot outdoors if the weather is suitable – overcast conditions are best.

Technique watch

Tone using Adobe Lightroom
My idea was to create an arty still-life, so although I was happy with my colour image as it was, I felt it could still be improved and decided it was the type of image that would suit monotoning. There are various ways to do this in Photoshop – the most used being via *Image>Mode>Duotone* and selecting a second colour. However, Lightroom users can tone their images with a single click of the mouse – perfect if you're not one to spend time in front of your computer.

Under the Quick Develop tab, select one of the Presets from the drop-down menu and preview the effect. You'll find that toning can dramatically alter the look and feel of your images. In this instance, Antique Grayscale, Cyanotype and Sepia worked best – giving my image an aged look – but there are dozens to choose from.

Although the presets are good in Lightroom, it is still often necessary to make a few small tweaks to the Contrast and Vibrance sliders. The developing process is quick using Lightroom. In fact, I created three nicely toned images in under five minutes.

Final image
I like the colour shot but converting to a toned mono image adds the finishing touch. As you can see, there's nothing fishy about this fuss-free technique!

4 Take a test shot With the freezer dish in place, it is time to begin taking pictures. Using a tripod, carefully position your camera overhead. With a 105mm macro lens, I isolate the head, as I think this will create the most striking result. However, the image is too dark – a result of the white ice fooling my camera's multi-zone metering into underexposure.

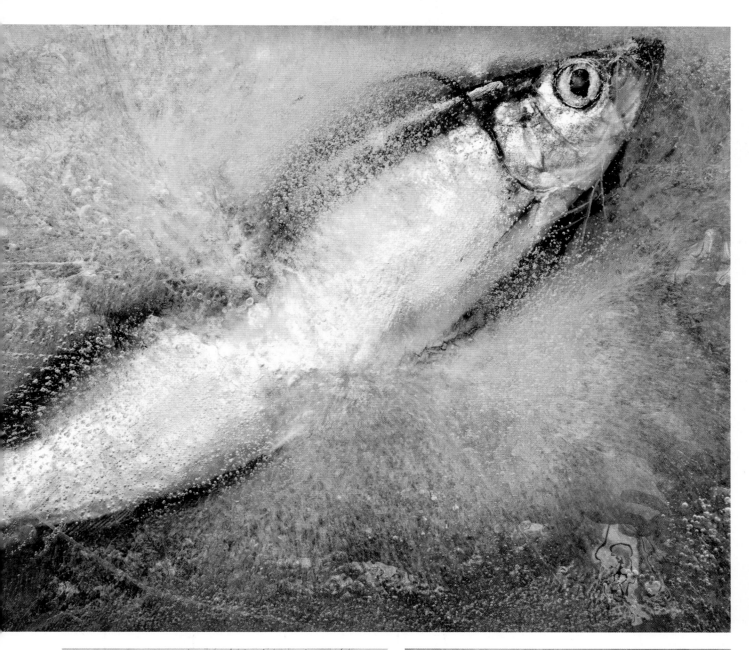

OUTDOOR

INDOOR

LIGHTING

CREATIVE

PHOTOSHOP

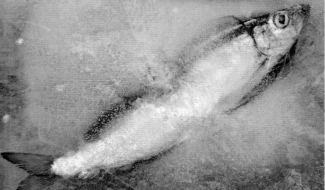

5 Adjust exposure Using the exposure compensation facility, I apply positive compensation of +1EV. This achieves the correct exposure and the result looks better. However, I am concerned that the thick ice is disguising too much of the fish's detail.

6 Find the right composition I pour warm, but not boiling, water over the ice to melt it slightly. Not only does this reveal more of the fish's colour, detail and form, but it also creates interesting cracks in the ice. I then alter my composition in order to include the entire fish – placing it diagonally across the frame to create the most striking composition.

Shoot a low-key still-life

>**TIME:** ONE HOUR >**EQUIPMENT:** NIKON D300 WITH NIKKOR 50MM F/1.8
>**ALSO USED:** TRIPOD, BLACK CARD, A TALL BOX AND PHOTOSHOP

Caroline Wilkinson: A friend of mine recently moved into her first home and asked if I would shoot some flower pictures to put on her new, very bare bedroom walls. She wanted images that picked out the colours of her furnishings to hopefully bring the room together and make it look a little more complete. The décor was sumptuous, with black and purple being the predominant colours, so a low-key still-life of a purple-toned chrysanthemum – her favourite flower – seemed an ideal fit. Wanting to take a picture that made full use of its graphic and almost symmetrical features, I decided to take a bird's eye view and place it centre in the frame. For the low-key effect, I needed to find a way of controlling how and where the window light fell on the flower's head to create contrast, but also to stop it exposing the area surrounding the flower in order to keep the tones predominantly dark. To create two accompanying pictures to hang either side of the main image, I wanted to use a similar technique on a rose, but controlling the light so it only illuminated parts of the flower for a dark, painterly finish. Finding a purple rose and chrysanthemum is not the easiest of tasks either, and I had to compromise on the colour, knowing I could alter it in Photoshop later, and instead opt for the best-looking specimens that were fresh and open.

Photographing the rose...

The rose image is done in much the same way as the chrysanthemum, but lit from the side instead. Cut an opening in the front of a wine box, lined with black paper, so you can shoot the flower. Also cut flaps in the side of the box to control how much of the window light falls on the rose, and where, by opening and closing the flaps. The final rose shot is taken in manual mode at 1/15sec at f/7.1 (ISO 200). I change the flower's colour in the same way as the chrysanthemum's. However, I also add a touch of the Dry Brush filter (***Filter>Artistic>Dry Brush***) to add to the painterly quality and 2px of Gaussian Blur to soften the image (***Filter>Blur>Gaussian Blur***).

Before | After

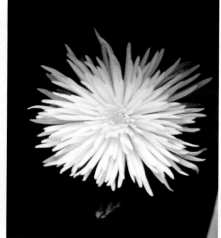

1 Set up To make the chrysanthemum look like it's emerging from darkness, position it inside a box lined with black paper at a height almost level with a window so that natural light can fall on to the flower. To secure the flower inside the box so it stands straight, cut a hole in a sheet of card the diameter of the box and slot it inside. Set up you camera so that you shoot down on to the flower.

2 Play with exposure Set the camera to aperture-priority mode and dial in a mid-aperture to ensure the whole flower head's in focus. If you find that the background is also exposed, deliberately underexpose the image to get the effect you want by adding a stop or two of negative exposure compensation. For more control, you could also switch to manual mode and opt for a slower shutter speed.

Too low

Too high

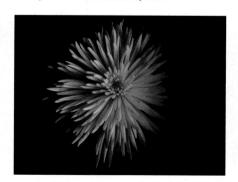

3 Adjust set-up I start with an exposure of 1/25sec at f/7.1 (ISO 200). I adjust the height of the flower to see the effect it has on the lighting, contrast and exposure. I discover that placing the flower so that its head is just above the top of the box allows too much light to hit it, separating it from the background, while pushing it down into the box means that it's too dark and lacks contrast.

4 Adjust shutter speed The shot should have enough light falling on the head to create some soft contrast, but not enough to stop the black blending with the flower's petals. To get this effect, place the flower just below the top of the box and adjust the exposure as necessary. I stay with f/7.1 and ISO 200 and try different shutter speeds; 1/15sec worked best.

5 Post-process the image Open the image in Photoshop and duplicate the layer (***Layer>Duplicate***), so you're not working directly on the image, and then select the ***Brush Tool***. Take a colour sample from the black background by holding down **Alt** and paint over any leaves or faded parts of the background with a large, soft brush to achieve one even colour.

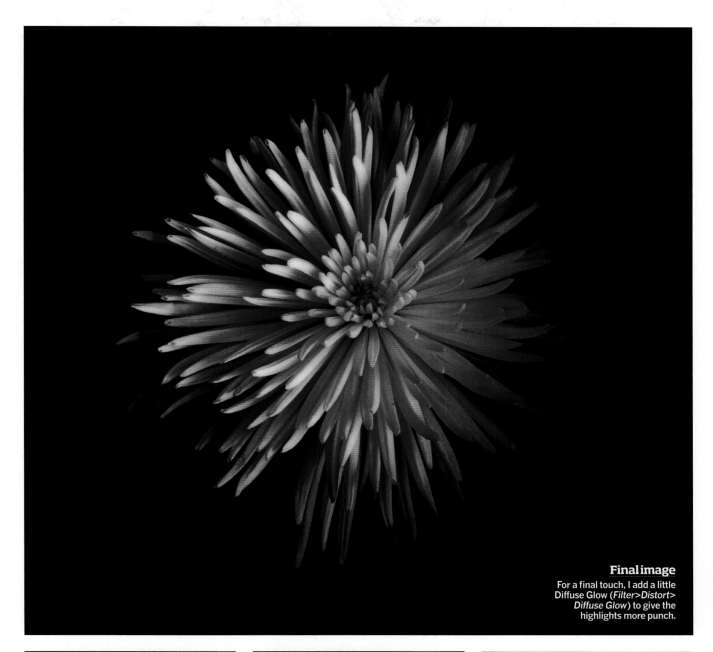

Final image
For a final touch, I add a little Diffuse Glow (*Filter>Distort> Diffuse Glow*) to give the highlights more punch.

6 **Reveal more detail** Select the flower by clicking on *Select>Color Range* and then, using the *Eyedropper Tool* from the dialogue box, click on areas of the flower, so it adds to the colours it's selecting. Then move the *Fuzziness* slider all the way to *200%* so that it picks up the details of some petals that have blended with the background. Click *OK*.

7 **Change the colour** As the background is selected, click *Select>Inverse* to target the flower. Then go to *Layer>New Adjustment Layer>Color Balance* to create an adjustment layer from your selection and move the colour sliders, targeting the *Highlights*, *Shadows* and *Midtones* separately. For the purple tone, move the sliders towards *Red*, *Magenta* and *Blue*.

8 **Finishing touch** To finish the project off, I print the images on Innova matte photo art paper and have them framed. Three images always look better than one or two, so I flip the rose picture in Photoshop (*Edit>Transform>Flip Vertically*) and use the same picture twice, either end of the chrysanthemum. The shelf and frames were bought from Ikea.

Merging pen and pixel!

>TIME: 20 MINUTES **>EQUIPMENT:**
PHOTOSHOP CS & FLATBED SCANNER

Daniel Lezano: Sometimes it's nice to create an image that leaves people wondering how it was done. It's not always the result of a complicated set-up or elaborate manipulation; it could be a really simple technique, as in this case. The only extra kit I used other than my camera outfit was a flatbed scanner and the ability to put pen to paper! Within a few steps you can make it look as if someone is drawing an image in the air, simply by using Photoshop Layers and a Blend Mode. It's great fun! Try drawing gigantic flowers in a garden or stick people walking down a street. It's time to switch on the imagination!

1 Draw your image On a white piece of paper, draw the image you want to add and scan it into your computer. Use black when sketching this image as any other colour will darken by the end of the Photoshop process and will end up looking a bit strange once on the final image.

Transform your photo

Photoshop's Transform tools (*Edit>Transform*) are incredibly useful. They enable you to change an image's shape, angle and dimensions, depending on which function you choose: Distort, Perspective, Skew, Warp, Scale or Rotate. The Free Transform command, on the other hand, allows you to scale, rotate and flip an image in one function. If you want to do this without contorting the image, hold down *Shift* while transforming to keep the image proportionate. Then press *Enter* to commit.

2 Put the images together Open the file in Photoshop and drag it, or cut and paste it, on top of your main image to automatically create a new layer. At this stage, don't worry about the position or size of the sketched image as we'll be altering that later. If you want several elements to the picture, it's best to scan them in separately for more flexibility later.

3 Merge the two layers together For Blend Modes, go to *Layer>Layer Style>Blending Options*. Here, I used the Multiply Blend Mode, but the Lighten mode will do the same job of removing the white to leave the drawing's black outline. As you can see, the subject's pen isn't in line with the sketch, but this can be easily remedied later.

4 Position the drawing I want to use the tree as a background image; to make it bigger I use the Free Transform tool (*Edit>Free Transform*) to increase the scale: by not holding the Shift key, I was able to stretch the height and alter the width separately. *Edit>Transform>Scale* will do the same thing. I then deselect the image and position it using the *Move Tool*.

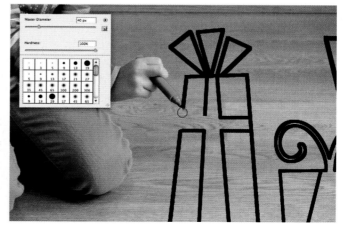

5 Create the illusion I want to add some presents to the picture, so I repeat steps one to four. To make it look like the subject is still drawing the image, shrink and position the sketch so a line of it appears to meet with the subject's pen. Finally, using the *Eraser Tool* – set to a hard, large brush – remove a bit of the line to give that illusion.

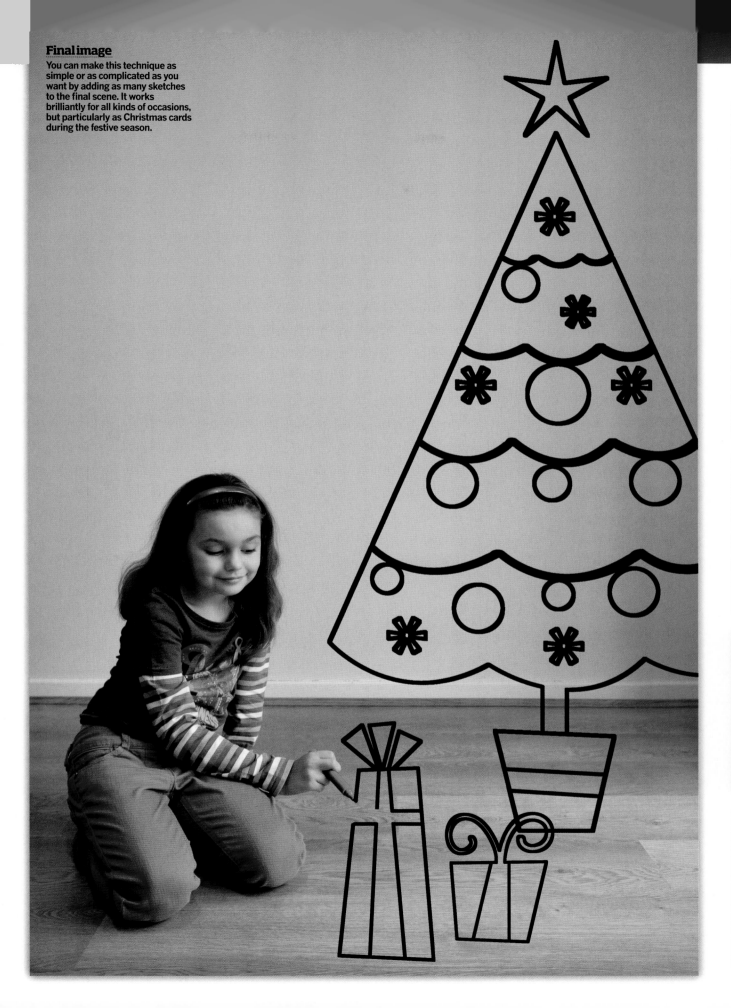

Final image
You can make this technique as simple or as complicated as you want by adding as many sketches to the final scene. It works brilliantly for all kinds of occasions, but particularly as Christmas cards during the festive season.

Triptych with flowers

>**TIME:** 45 MINUTES >**EQUIPMENT:** CANON EOS 400D WITH CANON EF 100MM F/2.8 MACRO >**ALSO USED:** TRIPOD, HAMA LED MACRO LIGHT, COLOURED CARD AND PINBOARD

Caroline Wilkinson: It's shameful how I've never seen many of my shots on anything other than my computer screen. And my guess is the feeling of 'too many images and not a clue what to do with them' is familiar to most photographers. Creativity normally ends with the click of 'Save' in Photoshop, but rarely results in a way of presenting your shots outside the mundane 10x8in print. But that's about to change!

Venture into the depths of your hard drive and drag out some shots that have never seen the light of day or try shooting some new ones with this tutorial in mind. Presenting your shots as a triptych (in three panels) or a diptych (in two panels) can refresh old images and make use of forgotten shots. Look for groups of images of the same colours, subjects or themes, such as cities or still-lifes. You could also try dividing a single landscape shot into three sections and follow the same steps to give the shot a new look. Here, I've chosen to match the colour of the background and flowers for a monotone-colour triptych.

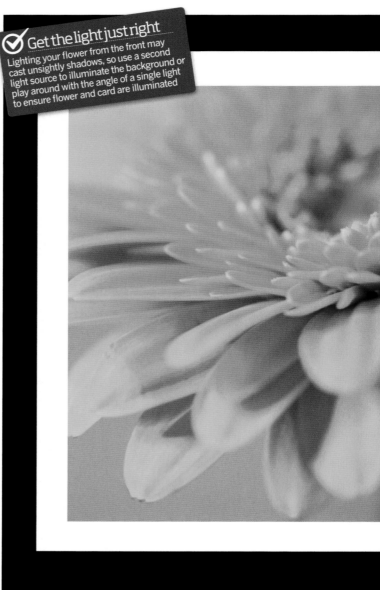

Get the light just right
Lighting your flower from the front may cast unsightly shadows, so use a second light source to illuminate the background or play around with the angle of a single light to ensure flower and card are illuminated

1 Match your card and flowers Buy the card first and then visit a local florist to select your subjects, trying to match the card to the colour of the flowers. Gerberas and roses are very photogenic, but for unusual, arty images why not go for more exotic specimens, such as bird of paradise or orchids?

2 Set up I set the flower in a vase, with the card attached to a pinboard, and angle a Hama macro light above and to the side to create some contrast. As the room has plenty of natural light, I don't need a second light source but, if you feel your first light source is not powerful enough, use an angle poise lamp.

3 Experiment with apertures Set aperture-priority mode so you can control the depth-of-field – the shutter speed won't matter as you're using a tripod. I vary the settings between f/3.5 and f/6.3 and experiment with the angle of the light to avoid casting shadows.

4 Adjust White Balance Repeat steps two and three with all your cards and flowers, then open the Raw files in Photoshop. You may find the colours are not true to life due to the temperature of the lighting you've used, so tweak the WB before you convert your Raw files.

5 Resize your shots Do any necessary tweaks, then resize each of your three final shots separately by clicking *Image>Image Size* and changing the width to 5in. Save the images and then close them. Then open a new file *File>New* and set a *Paper Size* (in this case A3).

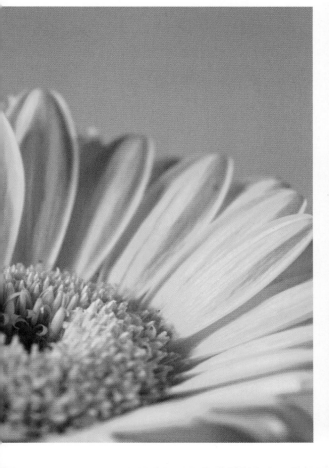
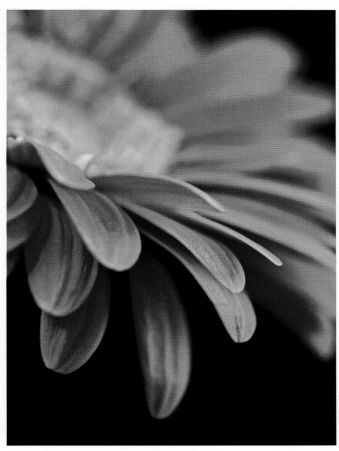

Final triptych
To give a thick border, I fill the *Background Layer* with *Black* using the *Paint Bucket Tool* and the border layer with *White*. Why not give it a go?

6 **Position your shots** Click *Rulers* under the *View* menu. Leave empty space around the image as a frame by dragging the ruler's guides to leave a 3in border at the top and bottom, 2in at the sides and one in the middle of the canvas, which you'll use to align your images.

7 **Drag images to canvas** Add a final guide at the centre of the canvas then go *View>Snap* and check *Guides*. This will allow you to slot your images to the lines you've created like a magnet. Open your images and drag them to your canvas using the *Move Tool*, so they snap to the grid.

8 **Add a black border** Next, add four more guides approximately 1-2cm from the images, then add a new layer and resize it to fit to these guides. Click *Edit>Stroke* and set to *10px*. To remove the guides go to *View>Show* and deselect *Guides*.

Original image

Free software

Poladroid Image Maker
The only thing you need to create fantastic and convincing Polaroid-like images is the free application available from www.poladroid. net, and either a Mac or PC (the application is available for both Windows and Mac). It's a drag-and-drop application that turns any digital image, in JPEG format, into a 400dpi print-ready file, complete with Polaroid-style border and the characteristics of a Polaroid instant image. It is possible to create a Photoshop action yourself that does the same thing, but you really need to know what you're doing to produce convincing results – and why bother when this freebie will do the job for you?!

Create your own Polaroids

>**TIME:** 20 MINUTES >**EQUIPMENT:** POLADROID IMAGE MAKER APPLICATION & APPLE MAC COMPUTER >**ALSO USED:** DIGITAL IMAGES

 Lee Frost: Polaroid instant photos are legendary – everyone's heard of them. If you grew up in the 1970s, as I did, you'll remember the characteristic 'click-whirrr' of the camera in action, and then everyone crowding around the newly ejected print to watch the image magically appear before their eyes. I still use Polaroid cameras today – vintage SX-70s picked up for peanuts on eBay. It's not the fact that I can see the results immediately that attracts me (digital SLRs are far more capable), but rather the distinctive look that Polaroid prints have – the slightly weird colours, the softness of the image, the shady corners and wonderful cross-hatched white border. Fortunately, you no longer need a Polaroid camera or Polaroid film to create this look: a free download from www.poladroid.net will recreate it for you. Here's how…

1 **Download Poladroid** Get the software to your Mac from www.poladroid.net. There's nothing to pay, no membership or commitment required – just click **Download**, wait for it to finish and drag the icon into your Applications folder.

2 **Launch the application** Double-click the Poladroid icon. A Polaroid camera will appear on your desktop. All you need to do now is drag and drop a JPEG onto the camera and the software will go to work.

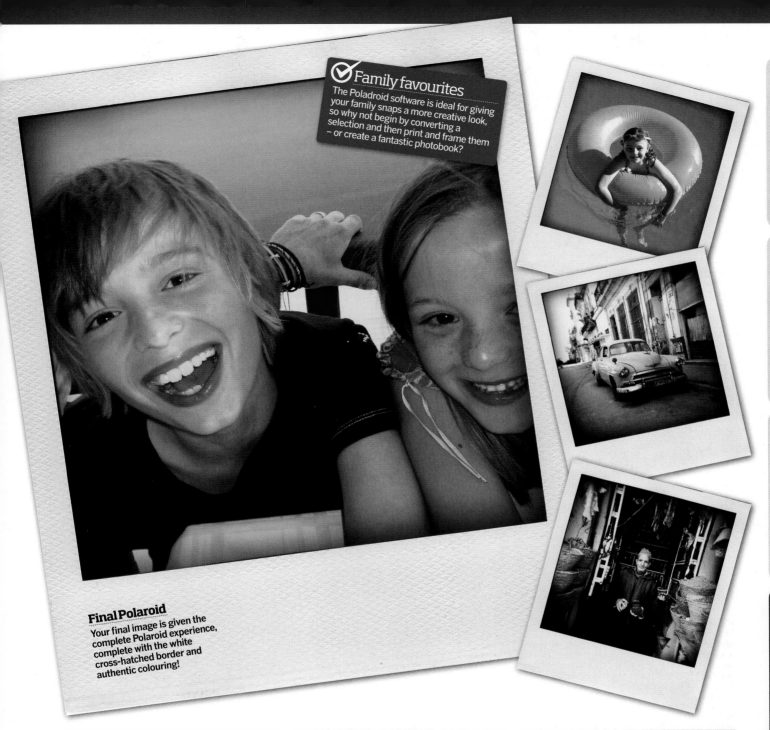

OUTDOOR

INDOOR

LIGHTING

CREATIVE

PHOTOSHOP

Family favourites

The Poladroid software is ideal for giving your family snaps a more creative look, so why not begin by converting a selection and then print and frame them – or create a fantastic photobook?

Final Polaroid

Your final image is given the complete Polaroid experience, complete with the white cross-hatched border and authentic colouring!

3 Wait for your image to develop First you hear the 'click, whirr' of a Polaroid camera, then a small Polaroid print is ejected from it onto your desktop. In true Polaroid fashion, you have to wait for the image to appear before you!

4 Open your image When the image is fully developed, a red crayon mark appears on the print to indicate it's ready. A JPEG icon appears on your desktop with pola.jpg at the end of its name. Double-click it to see your image.

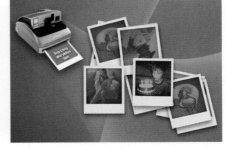

5 Create more shots You can create up to ten Poladroid images then you have to quit the software and reopen it. This is because Polaroid film cartridges contain ten shots, so the software mimics how you'd use a real Polaroid camera!

Step-by-step tutorials

PHOTOSHOP PROJECTS

OUR EASY TO FOLLOW PHOTOSHOP STEP-BY-STEPS WILL HELP YOU TRANSFORM YOUR IMAGES

OUTDOOR

INDOOR

LIGHTING

CREATIVE

PHOTOSHOP

OUTDOOR

INDOOR

LIGHTING

CREATIVE

PHOTOSHOP

Create a miniature scene

Sometimes you just want to have a bit of fun with your pictures and you'll soon have your friends scratching their heads with this illusion

Luke Marsh: The introduction of the Lensbaby optic gave miniaturisation – once the preserve of pros with big budgets – a well-earned comeback in recent years. And where there's a popular in-camera technique, it's never long before we try to replicate it in Photoshop. This digital technique is a simple combination of Photoshop's Lens Blur filter and a Layer Mask applied to a portion of the image. The best images to use are those our brains process as normal scale in terms of large and small subjects next to one another, such as people next to buildings, a house dwarfed by mountains, or in this case, boats moored in a harbour. So how does it work? Well, it's all to do with how we perceive depth-of-field. When we see scenes from a distance our eyes keep the entire scene in focus. However, if we try to focus on a subject a very short distance in front of us, it's impossible to keep the scene behind it sharp. What the blur is doing is mimicking this phenomenon and by doing so is fooling the brain into thinking that the boats are very close, but because we can also see all the boats, the brain's assumption is that they must be very small, like a toy set. Confused? I know I am!

Hot key Q

Q = Quick Mask
Activate Quick Mask mode by pressing **Q**. It allows you to highlight areas of an image that will then become marquee selections once you exit the mode by pressing **Q** again. The Brush is the suggested tool for this mode, as by using varying sizes and hardness, you can achieve very accurate selections.

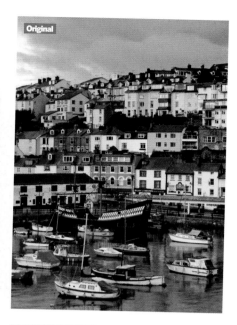
Original

1 Create a duplicate layer With the file open, go to *Layer>Duplicate Layer...* to create a copy of the original. Add a Layer Mask by going to *Layer> Layer Mask...>Hide All*. The Layer Mask icon in the Layers palette (circled) should appear black. Once edited, this allows the top layer to blur while viewing a portion of the original beneath.

2 Add a Reflected gradient Select the *Gradient Tool* and change the gradient *Type* to *Reflected* by clicking on the fourth icon along in the options bar (circled). Now press the *Q* key (see panel) to change to Quick Mask mode. When active, the words 'Quick Mask' appear at the end of the image file name at the top of the window.

3 Make a mask While holding the *Shift* key to ensure a straight line, draw a gradient at the bottom of the image by dragging up or down, and letting go once finished. It may take a few attempts to get right, so you may need to go to *Edit>Undo* (*Ctrl + Z* for PC/*Cmd + Z* for Mac) to undo the masked area and then try again.

4 Edit the Layer Mask With the mask made, press *Q* again to leave this mode – you will now have a marquee selection. To add this selection to the Layer Mask, make sure the Layer Mask thumbnail is selected (circled). Then go to *Edit>Fill...*, select *White* and click *OK*. To remove the selection, go to *Edit>Deselect*.

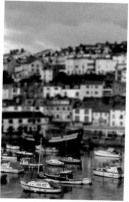

5 Apply Lens Blur Click back on to the image thumbnail and go to *Filter>Blur>Lens Blur...* In the window that opens first, ensure that the *Depth Map Source* is set to *Layer Mask*, then change the *Blur Focal Distance* to around *30*. You will need to adjust this figure depending on where your focal point is in the image.

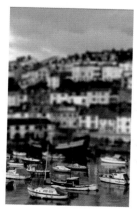

6 Increase the blur Finally, to improve the miniature effect, increase the blur amount by adjusting the *Radius*. You'll need to use quite a lot of blur – no less than 60 – but the trick is to use the optimum amount for your specific image without overdoing the effect. It might take a bit of trial and error to get it right.

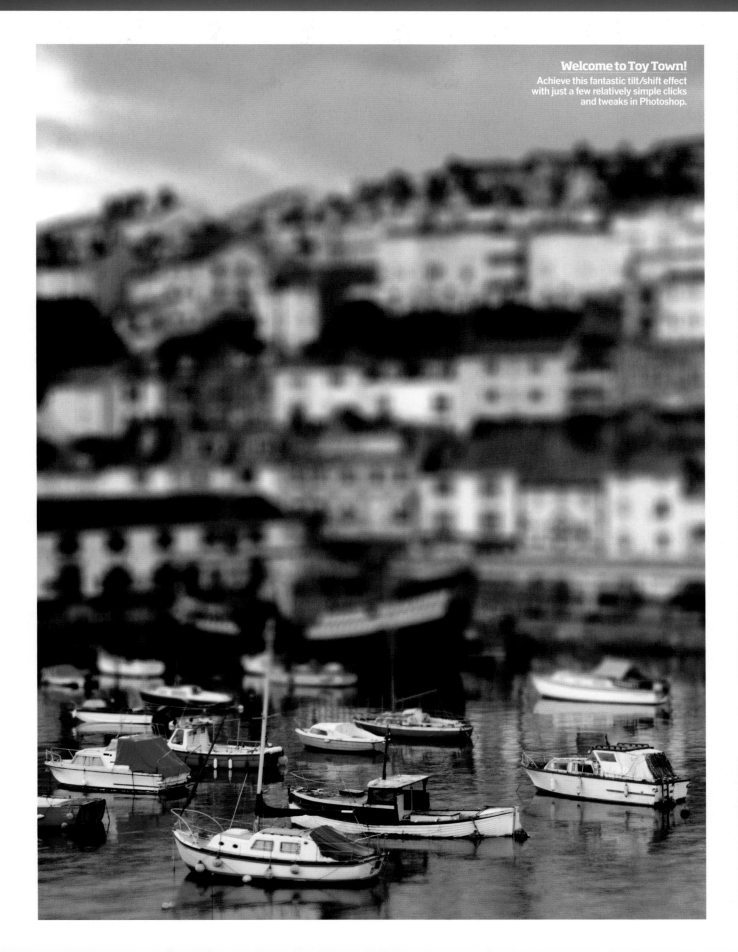

Welcome to Toy Town!
Achieve this fantastic tilt/shift effect
with just a few relatively simple clicks
and tweaks in Photoshop.

OUTDOOR

INDOOR

LIGHTING

CREATIVE

PHOTOSHOP

OUTDOOR

INDOOR

LIGHTING

CREATIVE

PHOTOSHOP

Add texture to photographs

Mastering the fundamentals of Layers, Layer Masks and Blend Modes create new possibilities for post-production. Find out how to combine all three to apply textures and add impact to your pictures

Caroline Wilkinson: Adding texture to a photograph can produce beautifully artistic effects and, while the results may look complicated, it's relatively simple to achieve a strong finish. The principle behind it is mastering how to blend layers together by becoming accustomed with the various methods of doing this, as each one produces a different end result.

Textures aren't something that should be used recklessly: it's easy to allow them to overwhelm a perfectly good picture. Your choice of texture should work with the image to enhance its mood, colour and, ultimately, impact. However, picked carefully they can add character to an ordinary snapshot and improve a picture's appeal tenfold.

To truly understand how this technique works, we'd advise you read the latest *Photoshop for Photographers* MagBook, which explains in-depth how Layers, Layer Masks and Blend Modes work together. As an outline, though, when applying a texture, make sure it's on top of the image layer in the Layers palette for it to affect the image. You can then use the Opacity slider at the top of the Layers palette to control the transparency of the texture and/or apply a Blend Mode from the drop-down menu at the top of the Layers palette. In general, I've found that Multiply, Screen, Soft Light and Overlay work the best when merging layers. There are no rules for how many layers you should use, but the more you do apply, the more the original character of the image will be altered.

How to use

Layer Masks
A Layer Mask allows you to hide detail from the layer it's applied to, revealing the image beneath without erasing it. When the Layer Mask is selected, simply add the Black paint to the mask over areas where you want to hide image detail and change to White to restore the detail. Use the **X** key to quickly switch between the colours.

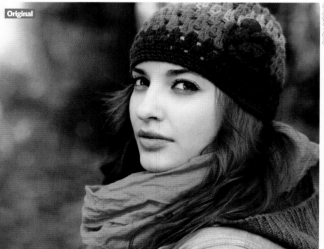

Original

ISTOCKPHOTO

Hot key

Changing Blend Modes
To quickly apply your chosen Blend Mode, hold down **Shift** and press **+** and **–** keys to move up and down the list, respectively, until you reach the one you want. Or, for an even quicker way, press **Alt/ Option, Shift** and the letter for that particular blend mode, eg **O** for Overlay or **S** for Soft Light.

Final image
Choosing textures that enhance the warm colours of the original image complement the picture as well as give a painterly effect.

1 Open your image Duplicate your photograph (*Layer>Duplicate Layer*) and open your first textured layer. I've used a picture of sandstone as the colour complements the autumn tones and the cracks make good texture. Click on and drag the textured image layer on to the image layer using the *Move Tool.*

2 Transform the texture Go to *Edit>Free Transform*, hold *Shift* to constrain the proportions and drag a corner point outwards to meet the sides of your image. Press the *Tick* to commit to the adjustment. Change the texture layer's *Blend Mode* to merge it with the image layer. Here, *Overlay* was used to boost saturation.

3 Add a Layer Mask As the texture flows over the face, it can start to obscure the features. Apply a Layer Mask to the texture layer by clicking on *Create layer mask* at the bottom of the Layers palette. Select the *Brush Tool* and set a soft-edge brush with a *Opacity* set low then, using *Black* paint, brush over the face to reduce the texture.

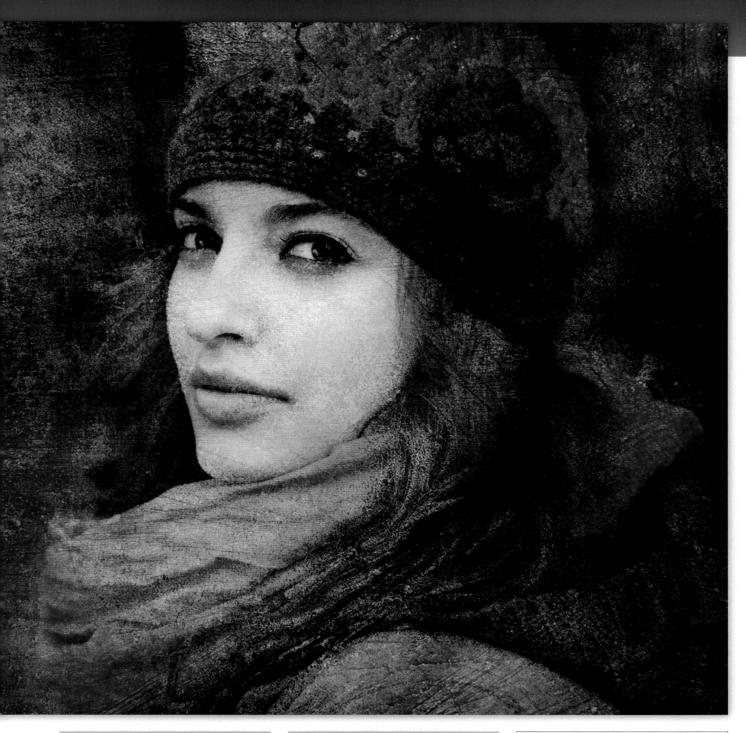

OUTDOOR

INDOOR

LIGHTING

CREATIVE

PHOTOSHOP

4 Add more texture Repeat steps one to three with another texture and try out the different Blend Modes to see their effects. Here, *Multiply* was used to emphasise the lines in some tree texture. If the resulting texture is still too strong, try adjusting the layer's *Opacity* slider at the top of the Layer's palette.

5 Repeat the steps There's no rule for what textures work and how many you should use; the key is trial and error and building up the effect gradually. Here, four textures are layered, each with different Blend Modes and varying opacities. Moving the layers in different positions within the Layers palette can also change the result.

Where can you get textures?

The easiest way to get texture images is to photograph them yourself: it's so easy to do and you can find them anywhere, be it a brick wall, granite table top, scrunched up paper or flaky paint on a wall. Textures are everywhere. Your other option is to download them from the internet. Sites such as deviantart.com, textureking. com and amazingtextures.com are good sources, but a quick Google search will uncover hundreds of options.

Turn pictures into a sketch

Eager to try artistic effects on your images, but not sure how? Follow this tutorial to see your photograph transform into a detailed drawing

Luke Marsh Post-production of photographs needn't be limited to a clean-up or colour and tonal adjustments. CS and Elements have a host of filters that can use the information in the image to convert the picture into different styles, even mediums, for creative effect. For instance, unless you're talented with a pencil, chances are you wouldn't be able to create a detailed sketch of this standard from a photograph without the help of Photoshop. Try it for yourself with a portrait that has a simple, blurred background so as not to distract from the subject and sketch detailing.

Workflow tools

The filter gallery
If you go to *Filter>Filter Gallery...* you'll be presented with an options window for many of Photoshop's most creative filters. The filters are categorised into sections such as Artistic, Brush Strokes, Distort, Sketch, Stylize and Texture, and by clicking on the section folders, you can access the filters within them. Click on a filter icon and you are presented with a large preview of your image along with a set of controls allowing you to fine-tune the filter's effect. Take time to experiment with them all.

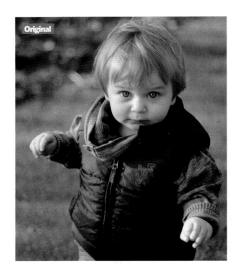
Original

1 Desaturate The first thing you need to do is desaturate the image. Go to *Image>Adjustments>Hue/Saturation* and move the *Saturation* slider to *-100%*. With the foreground and background colours set to black and white, go to *Select>All*. Now go to *Edit>Cut* and then *Edit>Paste* to remove the image from the background and paste onto a new layer.

2 Apply Graphic Pen Create a duplicate from the original image by going to *Layer>Duplicate Layer* and name the layer 'Graphic Pen'. Next, go to *Filter>Sketch>Graphic Pen...* and enter the *Stroke Length* as *15* and *Light/Dark Balance* as *60*, then set the *Direction* to *Left Diagonal*, and click *OK*. Change the layer's *Blend Mode* to *Multiply* and the layer's *Opacity* to *40%*.

3 Find the edges Duplicate the original image layer once more, this time naming the layer 'Find Edges', then drag the layer above the 'Graphic Pen' layer in the Layers palette. Next, go to *Filter>Stylize>Find Edges* to recreate the appearance of a pencil outline. As before, change the layer's *Blend Mode* to *Multiply* and reduce the *Opacity*, this time to *70%*.

4 Add pencil strokes To create drastic pencil strokes, first create a new layer by going to *Layer>New>Layer...*, naming the layer 'Pencil Strokes' and moving this new layer to the top of the Layers palette. Now go to *Edit>Fill...* and change *Use* to *Black* and click *OK*. Finally, add some noise with *Filter> Noise>Add noise*, entering the maximum value and ensuring *Monochromatic* is ticked.

5 Refine the strokes Open *Image>Adjustments>Levels...* and adjust the black and white sliders until the preview shows white dots on solid black. Next, go to *Filter>Blur>Motion Blur...* and change the *Angle* to *45°* and the *Distance* to around *300* pixels and click *OK*. Finally, change the layer's *Blend Mode* to *Overlay* and reduce the *Opacity* to *85%*.

6 Boost the contrast To increase the image's overall contrast without losing any sketch detailing, drag the remaining original image layer to the top of the Layers palette. Change the layer *Blend Mode* to *Overlay* and you'll see a vast improvement in contrast. The effect will appear harsh, so adjust the *Opacity* slider to between *40-50%* to reduce its strength.

7 Add a Layer Mask The problem at this stage is that the sketch is almost too perfect. Rectify this by spending some time hand-painting areas on a Layer Mask, making the image seem more like it's been drawn. The bulk of the image detail is stored on the 'Graphic Pen' layer, so click the layer and go to *Layer>New>Layer Mask>Reveal All* to add the Layer Mask.

8 Hide detail Select the *Brush Tool* and load the *Dry Media Brushes* set from the Brushes panel. Ensuring the foreground colour is black, I work around the edges, often reducing the opacity of the brush to around 50% for a more subtle effect. I also work on the jacket area and eyes, changing the brush colour back to white if I need to restore any areas.

OUTDOOR

INDOOR

LIGHTING

CREATIVE

PHOTOSHOP

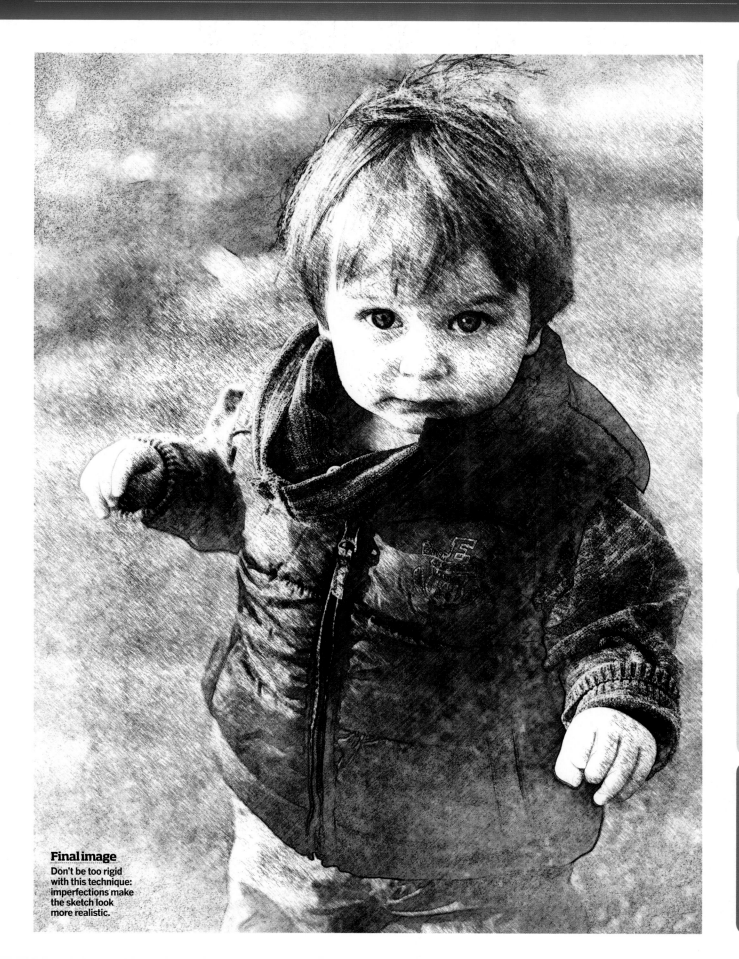

Final image
Don't be too rigid
with this technique:
imperfections make
the sketch look
more realistic.

OUTDOOR

INDOOR

LIGHTING

CREATIVE

PHOTOSHOP

Apply body art

Make your portraits a little more edgy and interesting with this simple step-by-step guide

Luke Marsh: Tattoos are one of those artistic accessories that you either love or you hate, but whatever camp you're in, you can't dispute that they add visual interest and a focal point to a picture. Tattoos are statement pieces, so applying one to a simple image, like this one, allows it to have unbridled impact. Careful consideration should be given to picking a suitable picture and the placement of the tattoo, as you want to enhance, not distract from, the rest of the image.

While the technique for applying the tattoo is quite simple, it will be much easier if your tattoo image is on a white background first as, if not, you will need to cleanly select it before placing it on the body, which can be tricky with intricate designs.

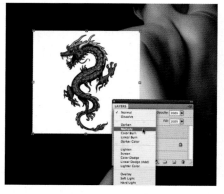

1 Combine the files The first thing to do is combine the two files you've chosen. With the tattoo image open, choose *Select>All* then go to *Edit>Copy*, copying the image to the pasteboard. Close the file and open your body image, and go to *Edit>Paste*, placing the tattoo image onto a new layer, above the body image. Now change the layer's *Blend Mode* to *Multiply*, making the white in the tattoo transparent.

2 Resize the tattoo Change the tattoo layer's *Opacity* to around *50%* to give the tattoo a far more subtle and realistic appearance. Now select the *Move Tool* and position the tattoo where you want it on the subject. Go to *Edit>Free Transform* and use the centre and corner tabs to resize the tattoo to suit your subject. Placing the cursor just outside any of the corner tabs will allow you to rotate the tattoo, should you wish to do so.

3 Edit the tattoo Limbs that overlap the tattoo can add depth to an image and realism to the effect. To help view the body clearly, hide the tattoo layer by clicking on the eye icon in the Layers palette. Here, the elbow area needs to be selected in order to isolate it from the tattoo. To do this, use the *Polygonal Lasso Tool* to work around the elbow, taking your time to get an accurate selection.

4 Add a Layer Mask Once the selection is made, add a Feather to 1px with *Select> Modify>Feather...* Now create a Layer Mask by going to *Layer>Layer Mask>Reveal All*, then go to *Edit>Fill...* and select *Use* as *Black* and click *OK*. These commands fill the selection with black on the Layer Mask and, subsequently, any of the tattoo underneath the black area is hidden, giving the illusion that the elbow passes in front of it.

5 Shape the tattoo To edit the tattoo image rather than its Layer Mask, click on the image thumbnail in the Layers palette. The main body contour on this image is the crease in the model's back, so this is where you'd expect to see the most distortion. Using the *Polygonal Lasso Tool*, make a rough selection along the crease and *Feather* the selection to *5px* to soften the transition of the Liquify effect you are about to apply.

6 Use Liquify Open the Liquify control panel (*Filter>Liquify...*) where you'll preview the image selection. Ensure *Show Backdrop* is ticked to see the body layer, then select the *Forward Warp Tool* in the top-left corner. Set the *Brush Size* to *250*, then both *Brush Density* and *Brush Pressure* to *50*. Now move the brush down along the crease to distort the tattoo, using *Edit> Undo* if you want to try again. Click *OK* when done.

IMAGES ISTOCKPHOTO

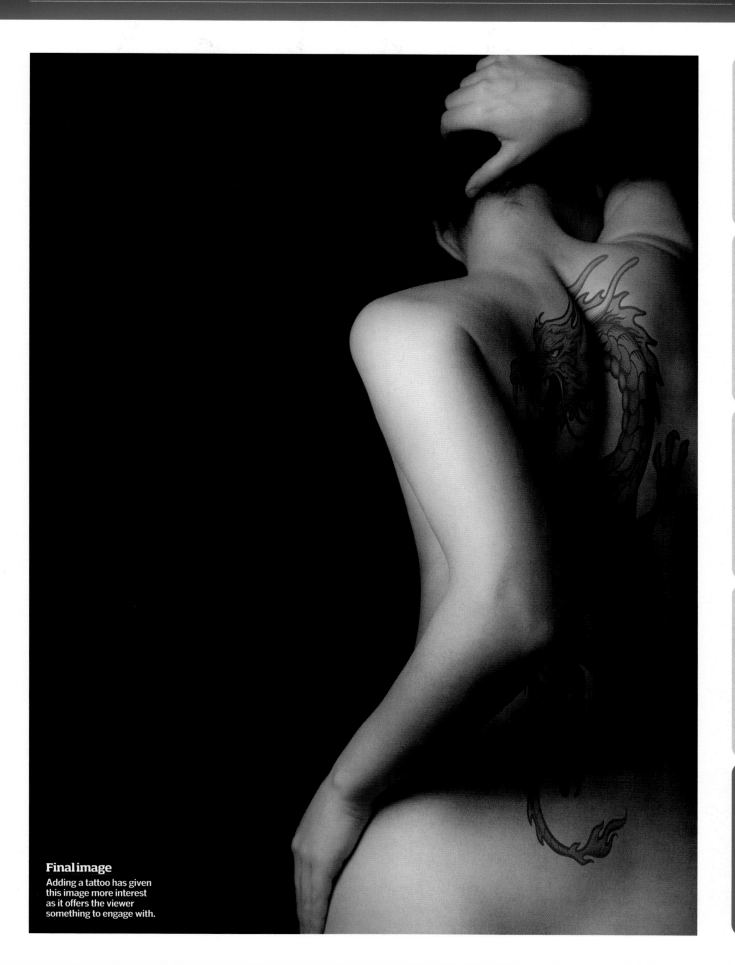

OUTDOOR

INDOOR

LIGHTING

CREATIVE

PHOTOSHOP

Final image
Adding a tattoo has given
this image more interest
as it offers the viewer
something to engage with.

Add colour to mono images

Dust off your colouring book skills to transform black & white images

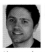

Jordan Butters: Most of us are not strangers to converting images to monochrome. The process can be completed in a matter of seconds with just a few clicks of your mouse. Performing the conversion in the opposite direction is not quite as straightforward, unfortunately, but it is still easily achievable. The main issue is that the colour information is no longer present in the image and therefore the only way to achieve this is to reintroduce the colours manually. This may sound a complicated process, but don't worry – you don't have to be Van Gogh to make this technique work, thanks to the different Blend Modes in Photoshop and Elements. The colouring process can be done in a few simple steps – however, the more care taken, the more convincing the final effect will be. You can apply this technique to images that were shot on black & white film, too – just scan in the photo and use the Dust & Scratches filter and the Healing Brush Tool to tidy up any marks first. As you'll discover, there's something enchanting about seeing an old image converted to colour and given a new lease of life.

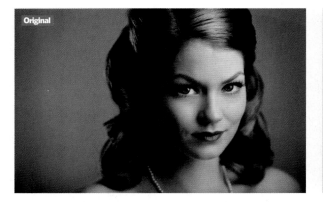
Original

Top tip…

Blend Modes
Your choice of Blend Mode will affect how each layer of colour is applied to your image. The most useful Blend Modes for this technique are Soft Light and Color. Some experimentation is often required when it comes to applying Blend Modes, as no two modes will offer the exact same effect when applied.

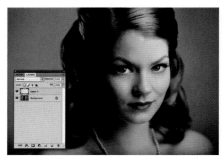

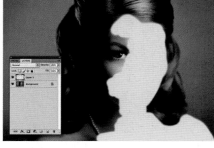

Final image
Adding different hues can make an image feel incredibly fresh and vibrant.

1 Create a new layer To begin, click on the *Create new layer* button in the Layers palette. This layer will contain the base colour for your subject's skin tone. Click on *Foreground color* in the toolbar and use the colour map to choose a suitable skin tone.

2 Add skin colour Select the *Brush Tool* and, in the Brush options at the top, set the *Hardness* to *50%* and pick an appropriate brush size. Begin painting over your subject's skin. Do not worry if you go outside of the edges or over facial features, as we will correct this later.

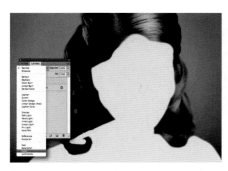

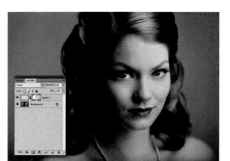

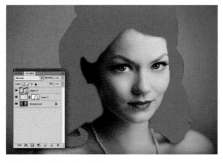

3 Change Blend Mode In the Layers palette, change the *Blend Mode* to *Color*. If the skin tone doesn't look realistic, adjust the *Opacity* slider in the Layers palette to desaturate the tone slightly. If this doesn't correct it, try a different foreground colour and repeat the previous step.

4 Add a Layer Mask Create a Layer Mask by clicking on the *Add layer mask* button and make sure that your foreground colour is set to *Black*. Use the *Brush Tool* on the Layer Mask to paint over any areas where you have coloured outside of the lines, including the eyes and mouth.

5 Paint in hair colour Click on *Create a new layer* again in the Layers palette and choose a foreground colour to suit your subject's hair. Once again, use the *Brush Tool* to paint the hair colour onto your image, again not worrying too much about going outside of the edges.

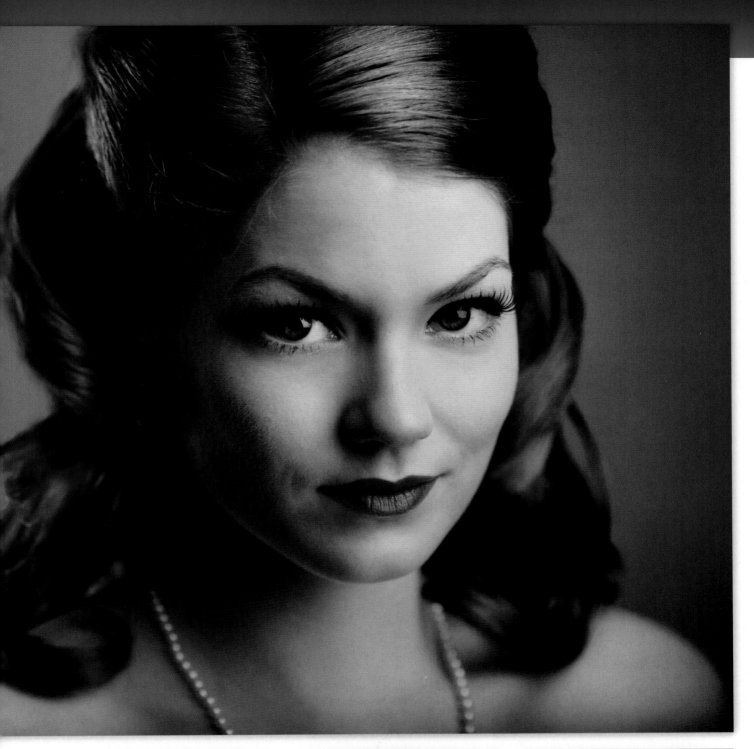

6 Change Blend Mode In the Layers palette, change the *Blend Mode* of this layer. The Blend Mode will depend on the colour of your subject's hair. It's worth trying both *Color* and *Soft Light* to see which produces the nicest effect, again adjust *Opacity* if needed.

7 Add a Layer Mask Add a *Layer Mask* to the same layer and brush out any areas of overspill. Repeat these steps for each section of colour, starting on a new layer each time and experimenting with the *Blend Mode* and *Opacity* for each layer until you're happy with the finish.

8 Experiment with colour Don't be afraid to have fun with the colours that you choose. Obviously certain things have to be the correct colour to look right, but there's no reason why you can't spice things up by experimenting with different background or clothing colours.

OUTDOOR

INDOOR

LIGHTING

CREATIVE

PHOTOSHOP

Create 'golden hour' light

A balmy summer's evening can give a supremely flattering glow to your subject. Recreate the look using Curves and the Burn Tool…

Luke Marsh: There's nothing quite like a glorious summer sunset to add ambience and colour to your portrait images. However, capturing such a backlit effect can be technically challenging with tricky metering and flare posing problems, but with this simple step-by-step you can transform daytime portraits with minimal effort.

You can try this technique on any outdoor portrait, but the effect will be more dramatic the cooler the original image tones are. You rarely see clouds when there's a burning sunset so if you can, pick an image with a generous expanse of clear blue sky in a summery location such as a flower-filled field or one with plenty of lush greenery. An image with shallow depth-of-field can also enhance the final hazy warmth of the image, though it's not essential.

Getting the Photoshop effect correct relies on you working well with Layer Masks, but the beauty of them is that they're fully editable so you can refine and retry the technique without damaging your original image. Use black paint and a soft brush on a Layer Mask to hide effects, and white paint to reveal them again, lowering the opacity for better control.

Hot key

Layer Masks
Click the *Layer Mask* icon at the bottom of the Layers palette. A thumbnail appears on the active layer in the palette.

Adjustment Layers
Click and hold on the *New Adjustment Layer* icon at the bottom of the Layers palette, scroll down the menu to find the desired adjustment.

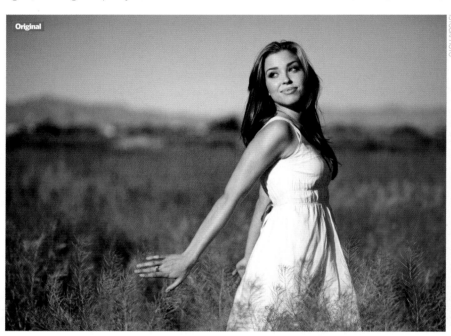
Original

ISTOCKPHOTO

1 Create the sun First, add the sun. To do this, create a duplicate of the original image; go to *Layer>New>Layer via Copy*, then open *Filter>Render>Lens Flare...* Select *105mm Prime* from *Lens Type* and position the small cross hairs on the thumbnail preview. Finally, enter an appropriate *Brightness* amount for the image.

2 Improve the face The flare strength means the subject's face appears very burnt out. To resolve this, add a Layer Mask by clicking the icon in the Layers palette. Select a soft-edged brush, set to *Black*, with an *Opacity* around *20%*, and paint over the subject to reduce the effects of the flare without removing it completely.

3 Sunset gradient In the toolbar, make sure the background colour is *White*, then click on the *Foreground color* icon. In the Color Picker, change to a sunset colour. Now click on the *Add new adjustment layer* icon in the Layers palette and select *Gradient...* Set *Style* to *Linear* and tick *Reverse*, so the gradient runs from top to bottom.

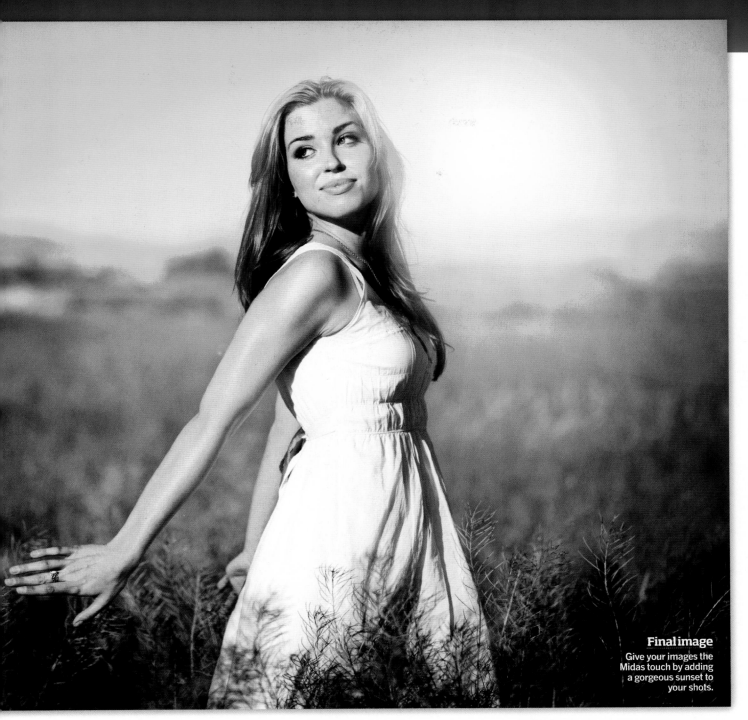

Final image
Give your images the Midas touch by adding a gorgeous sunset to your shots.

4 **Tweak the gradient** Change the *Blend Mode* to *Color*. To reduce the colour tint on the subject, use a Layer Mask, as in step two. A gradient adjustment layer has a Layer Mask by default, so click on it in the Layers palette, select a medium soft-edged brush, set to *Black*, with *Opacity* at *20%*, and begin work on the subject.

5 **Use Curves** Click the *Add new adjustment layer* icon and choose *Curves*... Now you can create an 'S' curve or choose *Strong Contrast* from the *Preset* menu and click *OK*. The effect can be harsh on the subject's face, so create a Layer Mask and reduce the effects by using the *Brush Tool* set to *Black*, as in the previous step.

6 **Burn the foreground** To finish, click on the duplicate image layer that holds the flare, ensuring the image thumbnail is active and not the Layer Mask. Select the *Burn Tool* and, using a large soft-edged brush with *Opacity* set to about *20%*, begin to work around the foreground of the image to darken it off, adding depth to the image.

Add a dispersion effect

Make your subject dissipate using this easy yet impactful technique to manipulate motion and make your action shots far more artistic

Jordan Butters: A fun part of editing and manipulating images is taking a picture beyond the boundaries of reality and this dispersion effect does just that. It allows you to make a moving person or object seem as if they are moving so quickly that they leave trails of colour and particles behind.

An important part of this technique relies on you picking, or shooting, the right type of image. For effective results, pick a picture with motion; it could be as simple as an action shot, someone jumping or hair blowing in the wind. You'll find the selection stage easier if your subject is set against a clean backdrop, too, such as a white wall or blue sky. You'll also need a selection of splat Photoshop brushes, which can be downloaded free from an online brush library, such as www.brusheezy.com.

Workflow tools

Brushes palette
The Brushes palette window allows you to tweak and manipulate preset brushes to suit your application. From the Brushes palette, you can change the direction and shape of the brush tip, vary the spacing, scatter, shape dynamics and texture, and even apply dual brushes at once. There is a handy preview window at the bottom of the palette for you to see how the adjusted settings affect the brush and its effect.

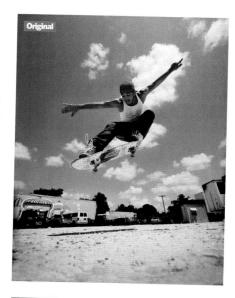
Original

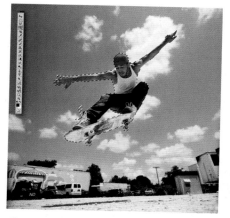

1 Separate your subject Draw around your subject using the *Quick Selection Tool* to select the background behind them. If you pick out an area you don't want selected, hold down the *Alt* key and go back over the area to deselect. Zoom in and reduce the brush size for detailed areas. Once happy, go to *Select>Inverse*.

2 Remove your subject Go to *Edit>Cut* to remove your subject. Select the *Clone Stamp Tool* and hold down the *Alt* key to set your reference point. Begin cloning out the silhouette until you are left with a clean backdrop; it need not be perfect, but the closer the better. Go to *Edit>Paste* to paste your subject onto a new layer.

3 Load the brushes Click on the *Add layer mask* button and select the *Brush Tool*. Go to *Window>Brushes* to bring up the Brushes palette and click on the small menu button at the top right to select *Load Brushes*. Locate the splatter brush set that you have downloaded on your computer and click *Load*.

4 Customise your brushes Scroll down to choose one of the new splatter brushes and select *Brush Tip Shape* on the left. Set the brush size using the slider and the angle of your brush by rotating the compass on the right. The angle of your brush should match the direction that your subject is moving in.

5 Start masking Making sure that your *Foreground color* is set to *Black*, begin clicking to mask areas of your subject, revealing the background behind. Repeat the previous step after each click to change the brush and vary the effect. Once happy with this stage, click on the *Create new layer* button in the Layers palette.

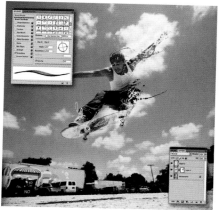

6 Add splats and trails Select the *Brush Tool* and once again go into the Brushes palette. Choose a splatter and set the angle of your brush. Before you apply each splat, use the *Eyedropper Tool* to pick a colour sample from your subject. Select the *Brush Tool* again and apply the splat, starting from the area of colour you selected.

OUTDOOR

INDOOR

LIGHTING

CREATIVE

PHOTOSHOP

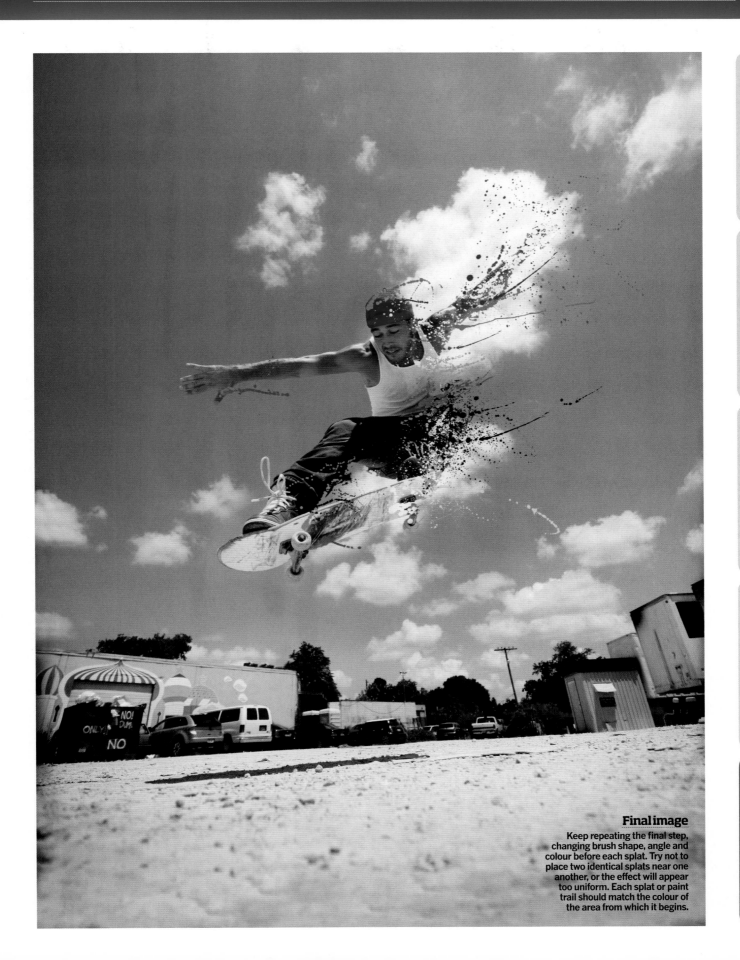

Final image
Keep repeating the final step, changing brush shape, angle and colour before each splat. Try not to place two identical splats near one another, or the effect will appear too uniform. Each splat or paint trail should match the colour of the area from which it begins.

OUTDOOR

INDOOR

LIGHTING

CREATIVE

PHOTOSHOP

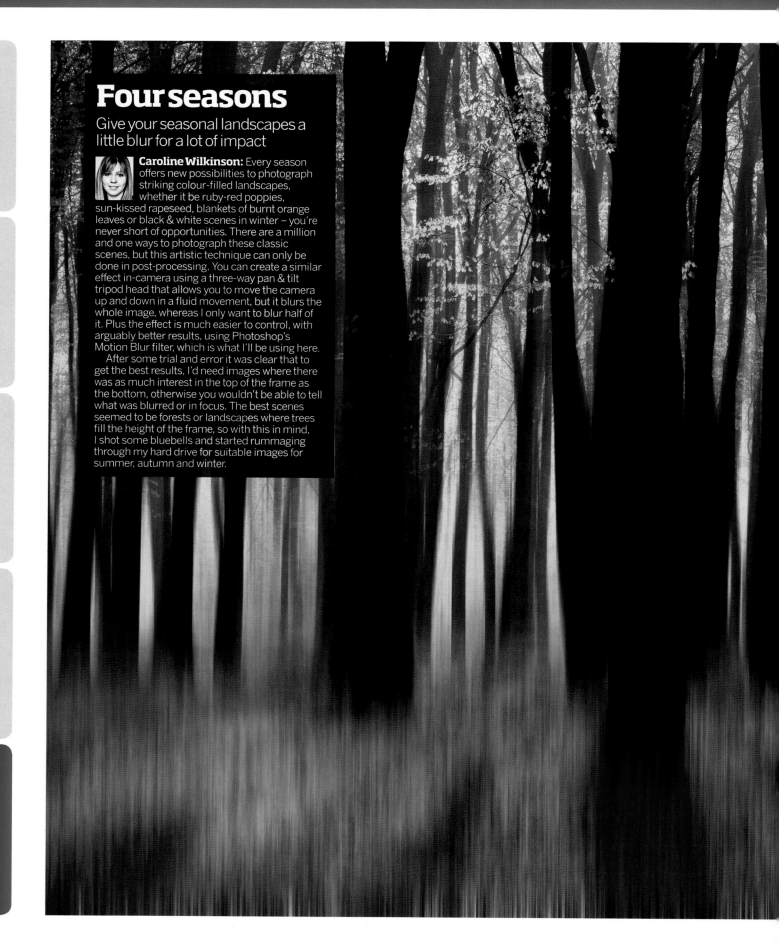

OUTDOOR

INDOOR

LIGHTING

CREATIVE

PHOTOSHOP

Four seasons

Give your seasonal landscapes a
little blur for a lot of impact

Caroline Wilkinson: Every season
offers new possibilities to photograph
striking colour-filled landscapes,
whether it be ruby-red poppies,
sun-kissed rapeseed, blankets of burnt orange
leaves or black & white scenes in winter – you're
never short of opportunities. There are a million
and one ways to photograph these classic
scenes, but this artistic technique can only be
done in post-processing. You can create a similar
effect in-camera using a three-way pan & tilt
tripod head that allows you to move the camera
up and down in a fluid movement, but it blurs the
whole image, whereas I only want to blur half of
it. Plus the effect is much easier to control, with
arguably better results, using Photoshop's
Motion Blur filter, which is what I'll be using here.

After some trial and error it was clear that to
get the best results, I'd need images where there
was as much interest in the top of the frame as
the bottom, otherwise you wouldn't be able to tell
what was blurred or in focus. The best scenes
seemed to be forests or landscapes where trees
fill the height of the frame, so with this in mind,
I shot some bluebells and started rummaging
through my hard drive for suitable images for
summer, autumn and winter.

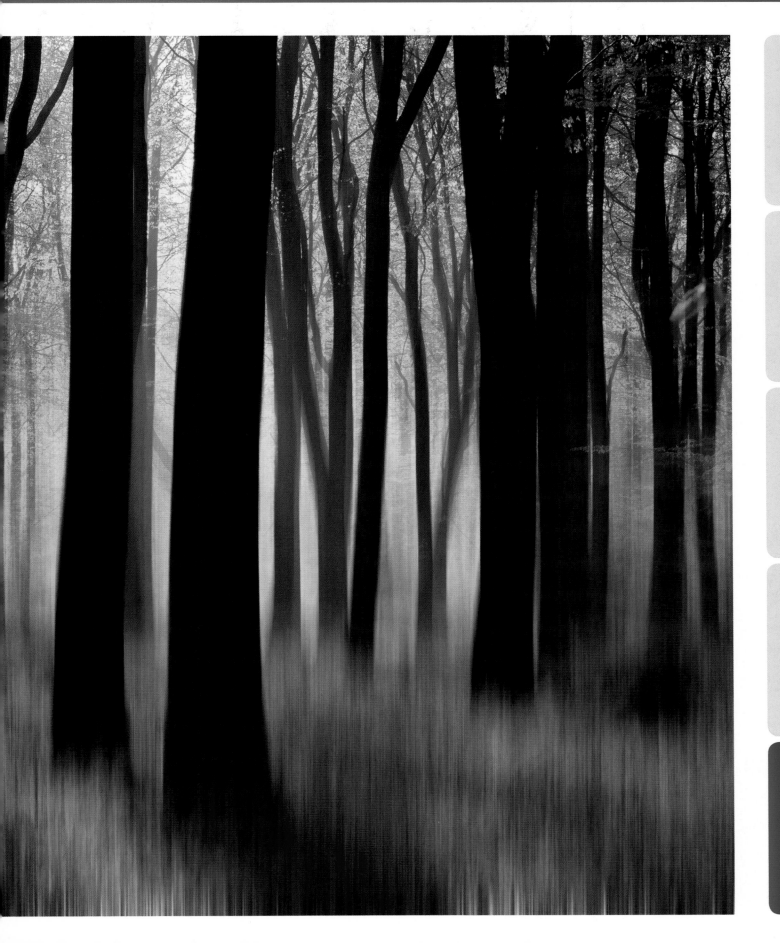

OUTDOOR

INDOOR

LIGHTING

CREATIVE

PHOTOSHOP

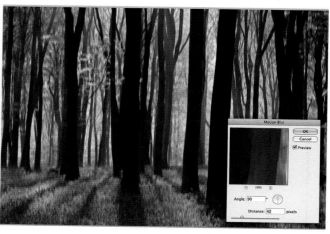

1 Duplicate your image Open your first image in Photoshop and duplicate the image by clicking on the Background Layer in the Layers palette, then going to *Layer>Duplicate Layer*, or by dragging the Background Layer down to the *New Layer* icon at the bottom of the palette. From now on you'll only be working on this duplicate layer.

2 Apply blur Select the new layer and then click *Filter>Blur>Motion Blur* to open the filter's dialog box. To apply the vertical blur, set the *Angle* to *90º* by either typing in the amount or moving the angle finder. You'll notice that by clicking and dragging on the angle finder, the direction of the blur will change in the preview screen.

4 Add a Layer Mask Click on the image layer and then on the *Add Layer Mask* icon at the bottom of the Layers palette to add the mask. You'll notice this adds a white box next to your image in the Layers palette. Then select the *Gradient Tool* from the toolbar or press *G*.

3 Find the right strength Adjust the *Distance* slider to increase the strength of the effect. The bottom of the image needs to be heavily blurred, but not to the point that the subjects are unrecognisable. It's different for every image, but I stop at 409 pixels. Click *OK*.

5 Apply a gradient Select the *Gradient Tool* and the *Layer Mask* (black lines will appear around the mask's corners when you've got it activated), hover over the image for a cross cursor to appear. Click at the top of the image and drag the cursor down to where you want the blur to start.

OUTDOOR

INDOOR

LIGHTING

CREATIVE

PHOTOSHOP

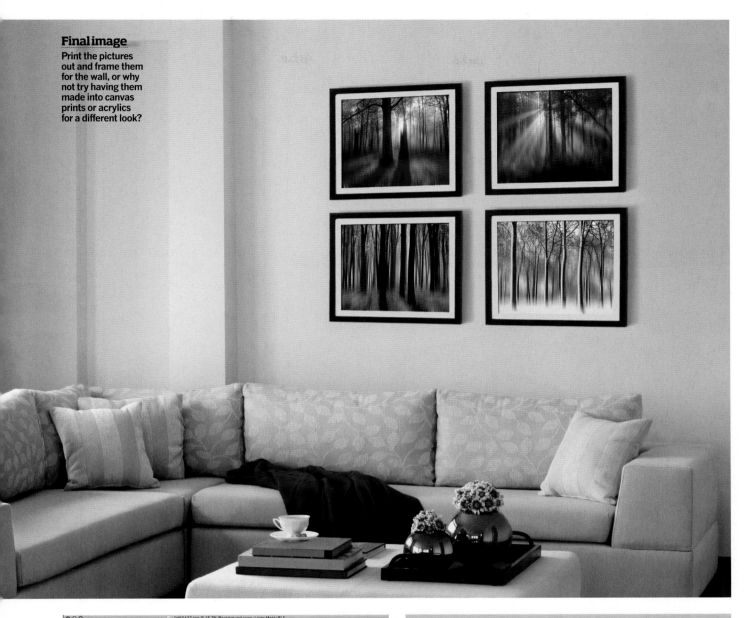

Final image
Print the pictures out and frame them for the wall, or why not try having them made into canvas prints or acrylics for a different look?

OUTDOOR

INDOOR

LIGHTING

CREATIVE

PHOTOSHOP

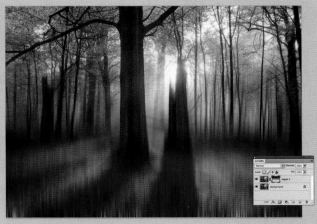

6 Edit the gradient You've now created a graduated Layer Mask that will hide some of the blur. You can change the graduation by clicking and dragging vertically down the image. You'll find the images look better if the blur is heavier at the bottom of the picture than the top.

7 Finishing touch Repeat steps one to six with the other three images of your choice. I've picked a colourful autumn woodland scene, bright sunshine passing through trees for summer and a black & white picture of a snowy forest. All four look striking on their own, but even better together.

OUTDOOR

INDOOR

LIGHTING

CREATIVE

PHOTOSHOP

Add a modern grunge frame

Framing a picture is the perfect finishing touch before printing. Find out how to apply unconventional frames for highly creative results

Caroline Wilkinson: Adding a frame to a photograph is really simple: in fact, it took longer to write this article than it did to create the effect. Typically, frames in Photoshop tutorials are plain, straight borders, sometimes with a title added at the bottom: classic, but arguably a little boring for edgier pictures. Grunge borders, on the other hand, add to the character of a photograph and you don't have to create them either – simply blend them with your image. Finding creative frames is fairly easy as you can download many for free or buy certain designs over the internet. There's not much to explain for this tutorial: it's that easy and the results speak for themselves. Pick a frame and give it a go…

Did you know?

If you have a frame from an old photograph or a Polaroid, you can scan it in to Photoshop and follow our step-by-step for applying it to a digital image. You can also find loads of borders by doing an internet search for 'free grunge borders' or download vector borders for a small fee at istockphoto.com

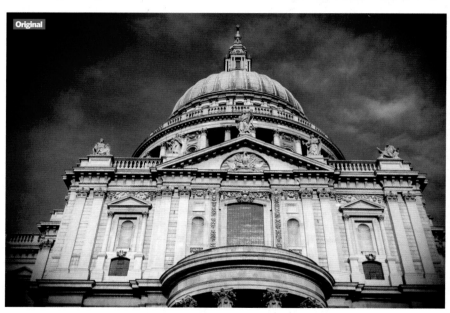

Original

Three simple steps to creating a frame

Draw your own Photoshop, especially CS5, has an extensive brush panel (*Window>Brushes*), which features a plethora of brush types and controllable characteristics. One way to create your own border is to draw it on to your picture. It's not the cleanest method and will look rough around the edges, but this can add character to an image. Have a play and see what effects you can create, but we suggest you combine different brush effects and work on an empty layer (*Layer>New Layer*) rather than the image, in case you want to edit or delete the border without affecting the original image.

1 Use the *Rectangular Marquee Tool* to select the inside of your image, leaving the width of the border you want from the edge. Then go to *Select>Inverse* and then *Select>Modify>Feather*, adding a feather of about *20px*.

2 Access the Brushes panel (*Window>Brushes*) and pick your style. We advise making the brush *Diameter* a bit larger than the width of your border so you can create it in a single stroke. Once you're done, go to *Select>Deselect*.

3 The border will probably be fairly clean at this point, which is fine if that's what you want. But if you want to make it look a little grungy, select a brush with *Scattering* and dirty up the edges slightly to get your desired effect.

1 **Open your image** Once you've completed the editing of your image, keep the file open. This type of frame works particularly well on images with a Lomo or vintage toy-camera look, like this one. Now open your chosen frame image and, using the *Move Tool*, drag the image on top of your processed photo. You'll see it automatically creates a new layer.

2 Transform your frame Go to *Edit>Free Transform* and, if you need to rotate your frame, hover the cursor over the corner widget until it bends, then click, hold and rotate. Next, to resize the frame, hold *Shift* to constrain the proportions and drag a corner widget outwards to meet the sides of your image. Press the *Tick* button to commit to the adjustment.

3 Reveal the image Now your frame fits your image, if you want to keep the frame black, change the layer *Blend Mode* to *Multiply* to eliminate any white in the layer, allowing the picture to show through the frame. You could leave it there if you want, but turning the frame white can sometimes add more impact. Go to the next step to see how.

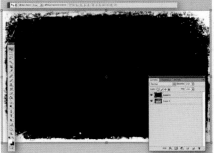

4 Turn it white If you've changed the *Blend Mode* to *Multiply*, change it back to its default *Normal*. Select the frame layer and go to *Layer>Adjustments>Invert* to change it from black to white. Change the *Blend Mode* to *Lighten* to reveal the image. If the centre of your frame layer isn't filled with black or white, there's no need to use a Blend Mode.

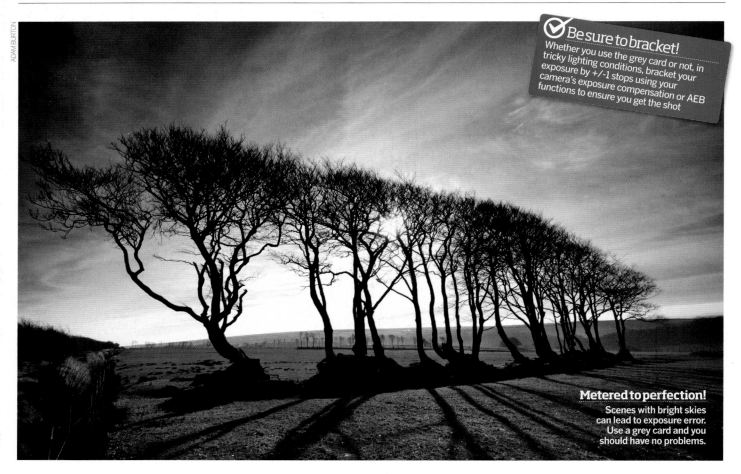

Be sure to bracket!
Whether you use the grey card or not, in tricky lighting conditions, bracket your exposure by +/-1 stops using your camera's exposure compensation or AEB functions to ensure you get the shot

Metered to perfection!
Scenes with bright skies can lead to exposure error. Use a grey card and you should have no problems.

How to use your metering & White Balance cards

The 18% grey card can be used to ensure perfect exposures when shooting in tricky lighting conditions. Both reference cards can also be used to set a custom White Balance. Depending on the camera you use, you need to take a White Balance reading off the grey or the white card (your camera's instructions will show you how)

DIGITAL SLRS USE SOPHISTICATED exposure systems and all work using the same assumption that the average of the scene that is being metered from is a mid-tone, or 18% grey to be exact; ie the average of all dark, light and mid-tones mixed together is 18% grey. It's the basis of all metering patterns and works surprisingly well, but while it's fine for the majority of shooting situations, it can lead to incorrect exposures when the scene or subject is considerably lighter or darker in tone than 18% grey. For example, very dark areas can fool the metering system into overexposure. Similarly, very light subjects, such as a snow scene, can fool the camera into underexposing them – making them appear darker than they are – as the light meter will take a reading designed to render them as a mid-tone. As a camera is trying to render an image 'grey', it's your job to ensure you compensate to keep the tones true to life. You can do this by using one of your DSLR's exposure override facilities, such as exposure compensation

or the AE-Lock button, or by metering from an area of the scene that has a mid-tone. And that's where our grey card comes in. Using it is very simple as our step-by-step guide below illustrates. Remember that you need to place the grey card in similar lighting to your scene: for instance, don't place it in a shaded area if your scene is bathed in sunlight. Also make sure that the card fills the metering area – we recommend you use spot or partial metering as the card won't need to fill the entire image area, but any is suitable. You can either lock the exposure using your camera's AE-Lock facility or note the aperture and shutter speed, and then switch to manual mode and set these (although this method isn't suitable to days where lighting is variable). The card has AF reference lines to help your camera's autofocus lock on to it. However, you don't necessarily need it to be in focus to work correctly. The grey card (as well as the white card) can be used to take a custom White Balance reading from too.

1 Getting started Place your grey card on the ground angled towards you and ensure it's located in a spot that is bathed in the same light as the majority of the scene you plan to shoot.

2 Take a meter reading Ensure that the entire metering area is filled by the grey card (in this instance we're using multi-zone metering) and lock the exposure with the AE-Lock button.

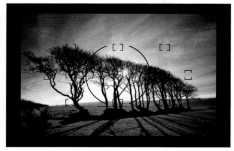

3 Compose & shoot With this exposure locked, you can compose your scene and take your shots. When you check it on your LCD monitor, the exposure should be perfect.